Genius Loci:
'the distinctive atmosphere or
pervading spirit of a place'

May you find it!

SCOTLAND THE BEST
100 PLACES

Published by Collins
An imprint of HarperCollins Publishers
Westerhill Road
Bishopbriggs
Glasgow G64 2QT
www.harpercollins.co.uk

1st edition 2014

A catalogue record for this book is available from
the British Library

ISBN 978-0-00-755937-4
ISBN 978-0-00-794327-2

10 9 8 7 6 5 4 3 2 1

Printed and bound in China

If you would like to comment on any aspect
of this book, please contact us at the above
address or online.

e-mail: collinsmaps@harpercollins.co.uk

 facebook.com/collinsmaps

@collinsmaps

SCOTLAND THE BEST
100 PLACES

Peter Irvine

INTRODUCTION

This book is about *'place'*, our sense of it and how it informs our awareness and perception of Scotland.

I've assigned 'The Best 100 Places' three categories: Magnificent Places, Reflective Places and Human Places devised by (The Scots) and for people. Small country, big choice in each!

Scotland the Best 100 Places is a photography book with contributions from some of Scotland's best and most notable photographers but it is also a useful manual: how you find the place in the picture and where you might contentedly walk, eat and sleep nearby.

We worked with the photographers, some from their galleries, collections and agencies and some commissioned, to select the pictures that best conveyed the essence of the place in question. As the essential character of these hugely different places varies, so does the approach to and the composition of the photograph. We decided not to restrict them to a particular format, shape or size, and in some cases we show more than one picture, to convey an outward appearance along with an interior detail or a contrasting aspect.

Researching my guidebook *Scotland the Best* I travel throughout the land, seeking out 'the best' places of all types. It's very selective and so are the venues to walk, eat and sleep at the back of this book, intending to reliably enhance your experience of visiting the place depicted.

For orientation, I've divided Scotland into the simplest categories – East, North, West and South. I know, of course, that in the East, Aberdeenshire is very different to the City of Edinburgh, and that Mull is very different to Glasgow in the West, but this book is not organized politically or even geographically, but as if it is in a world of its own.

Throughout, I've tried to take the most objective view, as if the reader or the visitor has landed in Scotland from another country (or planet) far away. Scotland attracts millions of visitors and there's a myriad of guides with suggestions of where one must go, mostly the same and the old. I've tried to imagine where you would go to have the best possible experiences in what seems likely to be your one and only lifetime.

Of course, my selection is entirely subjective. There are perhaps glaring omissions, (Edinburgh and Stirling Castles, Edinburgh Zoo), but I'm confident that these 100 places are all exceptional and that this has been captured in each of the photographs selected. Sitting in Charlotte Square Garden in August, or on the shore in Iona, or arriving by boat to Knoydart or Stromness and pausing for a moment … well, you know you're in a very good place, that it's good to be in Scotland and great to be alive.

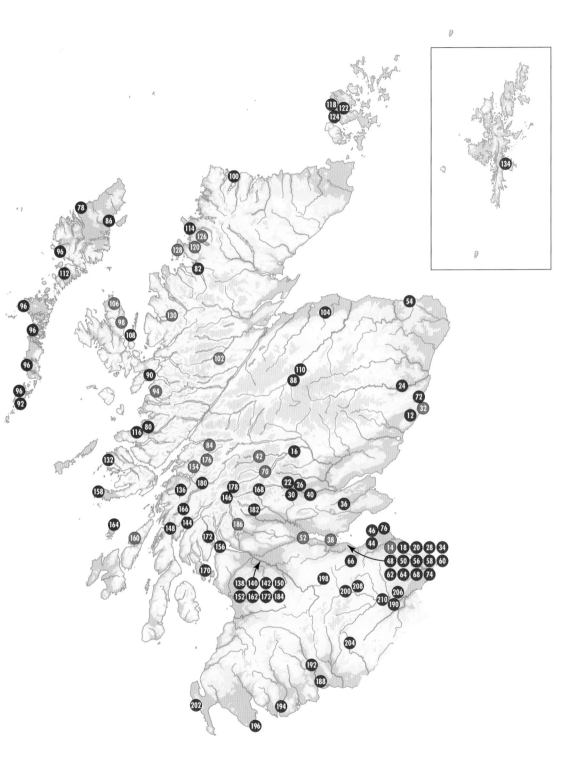

PHOTO CATEGORIES

There's an infinity of ways we might revere or experience a place but for this book, through the lens of our photographers, I have divided my widely diverse selection into three categories. The map here shows a more precise location for each place, with its page number.

MAGNIFICENT PLACES

The glorious scenery: places that we look at, perhaps gaze upon in wonder, probably from a distance. The experience is observational, detached, yet personal. You may walk in those mountains and feel them around you but often it's the immensity and omnipresence of landscape that moves you. There is much in Scotland to get lost in.

REFLECTIVE PLACES

Scenery is not always over there. Mostly we become part of it. The place we're in affects our mood, perhaps evoking emotions from melancholy through enchantment to joy, even inspiration. Places where we pause to reflect may be quiet or ancient or simply beautiful, but they help us muffle the noise from the rest of our lives, and restore and nourish the spirit. These are places to find yourself.

HUMAN PLACES

People make places for people; it's where we spend most of our time. We like to be with other people! Some public places make you feel better, some worse, depending on many human factors. Not all 'Attractions' are the most attractive; there's an endless list of hospitality places and events to choose from. In these photographs we have tried to capture those that are (reliably) exceptional; all made by Scots.

CONTENTS

EDINBURGH AND EAST OF SCOTLAND

HIGHLANDS, ISLANDS AND NORTH OF SCOTLAND

Overleaf – Glen Coe,
photographed by Russell Bain.
See page 84 for more details.

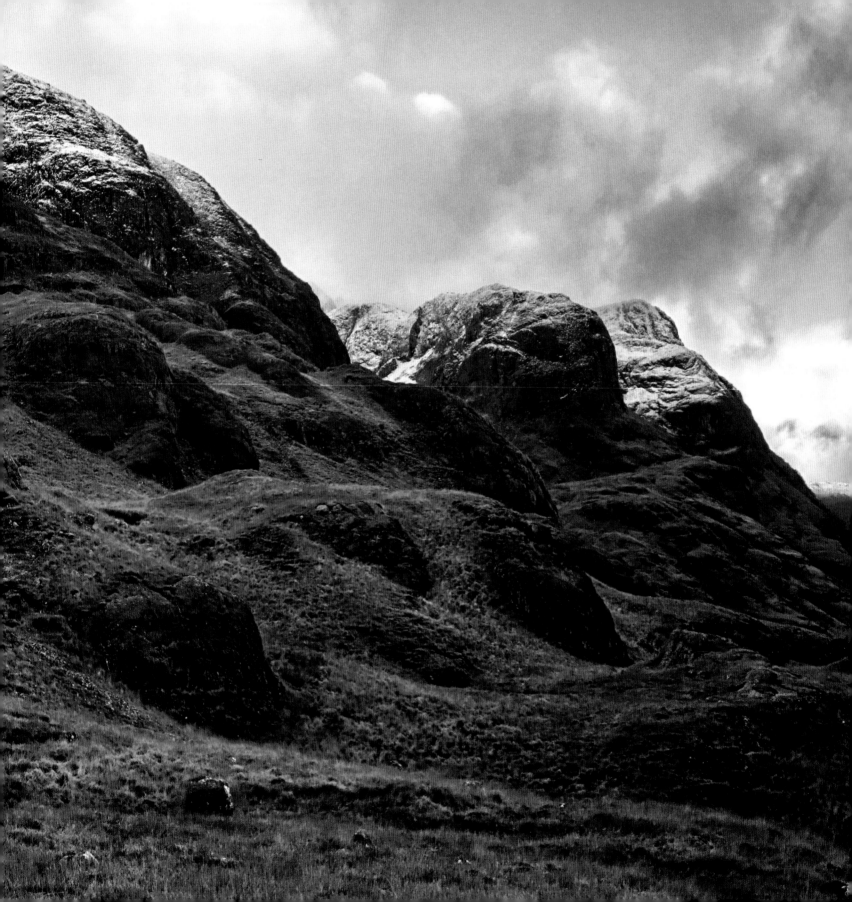

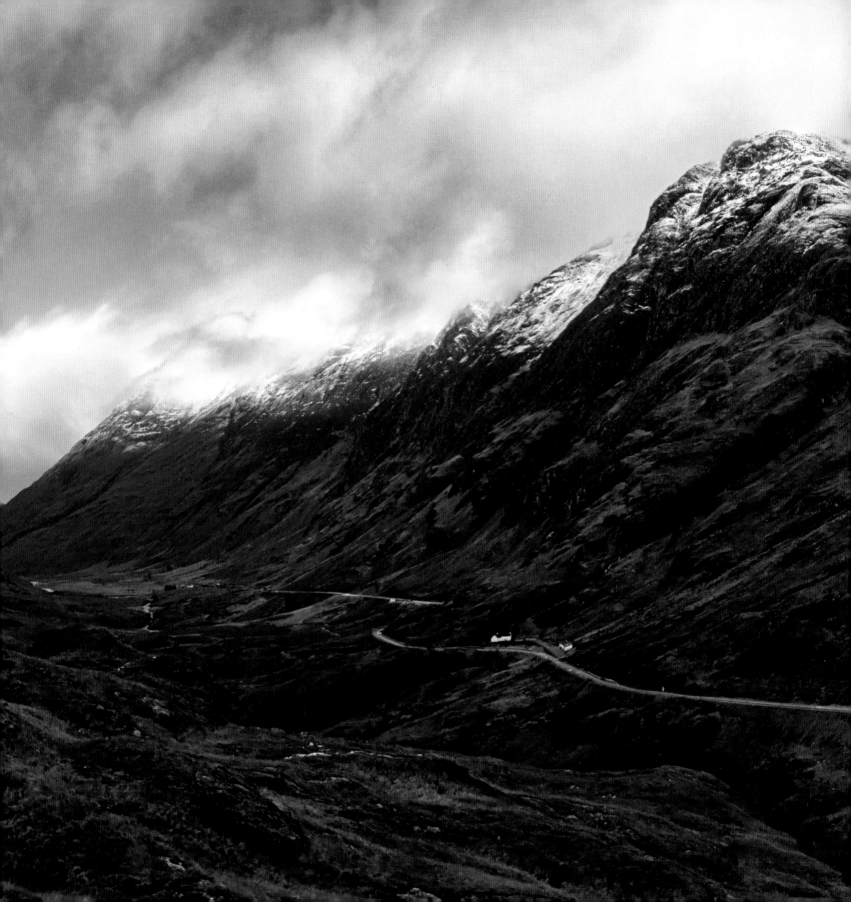

ARBUTHNOTT CHURCH
AND THE HOWE OF THE MEARNS
ABERDEENSHIRE

Lewis Grassic Gibbon's trilogy, *A Scots Quair,* and
especially its first part, *Sunset Song*, is widely considered
to be one of the great works of Scottish literature. The Howe
of the Mearns, the area of rolling agricultural countryside
between the Grampian Mountains and the coast is the
place he so effectively evokes in the time of innocence
before the wars. It seems hardly changed.

The fictional village of Kinraddie is clearly based on
Arbuthnott. The ashes of James Leslie Mitchell (Gibbon
was a nom de plume) are here in a corner of the graveyard:
'the kindness of friends, the warmth of toil, the peace of rest'
is the poignant inscription. The Howe of the Mearns and
the Victorian gems of Fettercairn and Edzell all have a
distinct atmosphere and are well worth a visit. You can
sense the Mearns.

PHOTOGRAPH PAUL TOMKINS

FIND | WALK | EAT | SLEEP PAGE 213

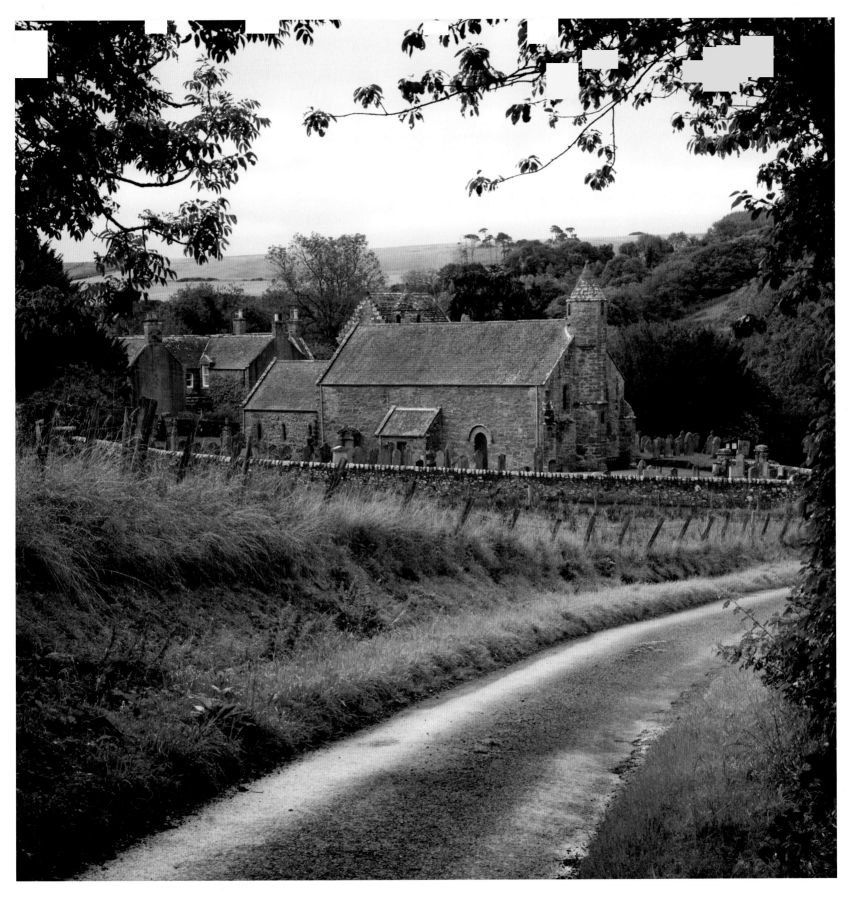

ARTHUR'S SEAT
EDINBURGH

There are few cities in the world that have a mountain in their heart. At 823 ft, it is more a hill but, as in Rio or Cape Town, Arthur's Seat has enormous presence. To walk there is like going into wild hill country; the panorama from the top is magnificent.

Arthur's Seat is the hill itself, but is also the general name for the extinct volcano's adjoining dramatic ridge, Salisbury Crags, which looks from certain perspectives like a 'Lion's Haunch'. It is said that James Hutton, generally regarded as the father of geology, invented the science here, and it's the Crags especially that still awaken a real sense of wonder.

PHOTOGRAPH **MAGGIE ROUXEL**

FIND | WALK | EAT | SLEEP **PAGE 213**

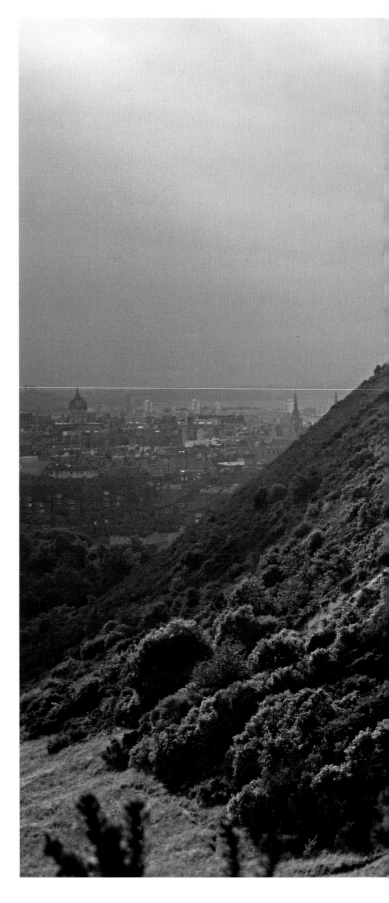

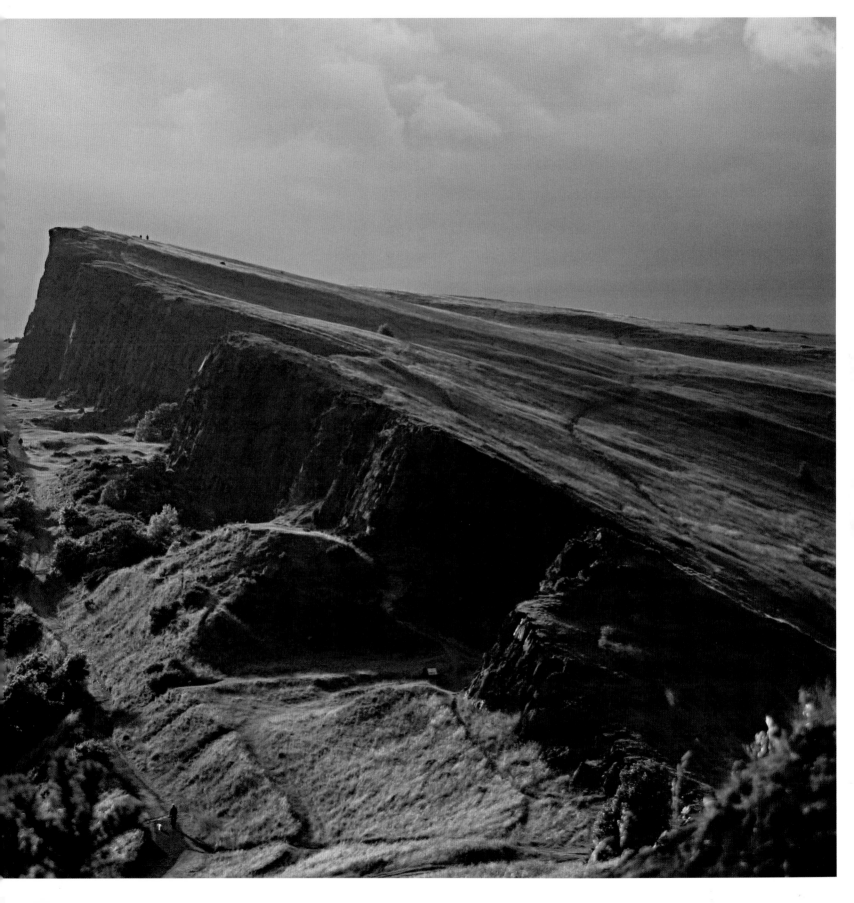

BIRKS O' ABERFELDY
PERTHSHIRE

Few woodland walks are as properly immortalized as
this one is. In 1787 Robert Burns walked up the Moness
Burn, stopped for a rest on a rocky shelf and wrote the
poem eponymic with the place ever since. Of course,
the romantic, pastoral lyric captures it perfectly:

'Now Simmer blinks on flowery braes,
And o'er the crystal streamlets plays;
Come let us spend the lightsome days,
In the Birks of Aberfeldy'

The walk here has been popular ever since, but it remains
one of Scotland's most iconic: the light filtered through
beech leaves and further up through birch (the 'birks'), the
cascading water, the views down the glen and of the Upper
Moness Falls at the top. If you've got or yearn for lightsome
days, find them here.

PHOTOGRAPH **PAUL TOMKINS**

FIND | WALK | EAT | SLEEP **PAGE 213**

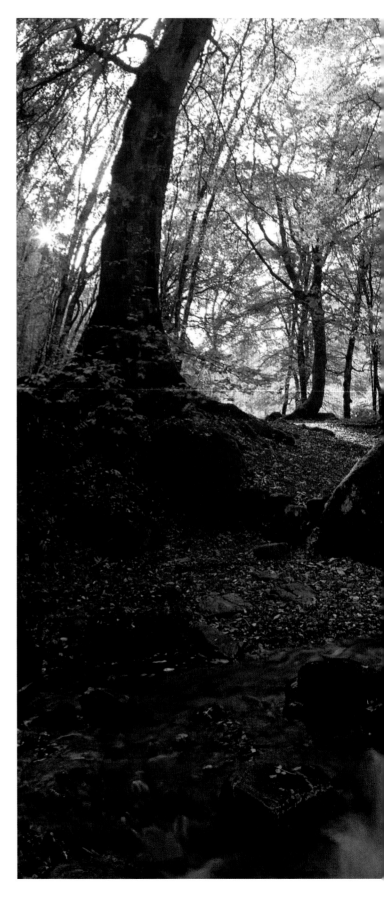

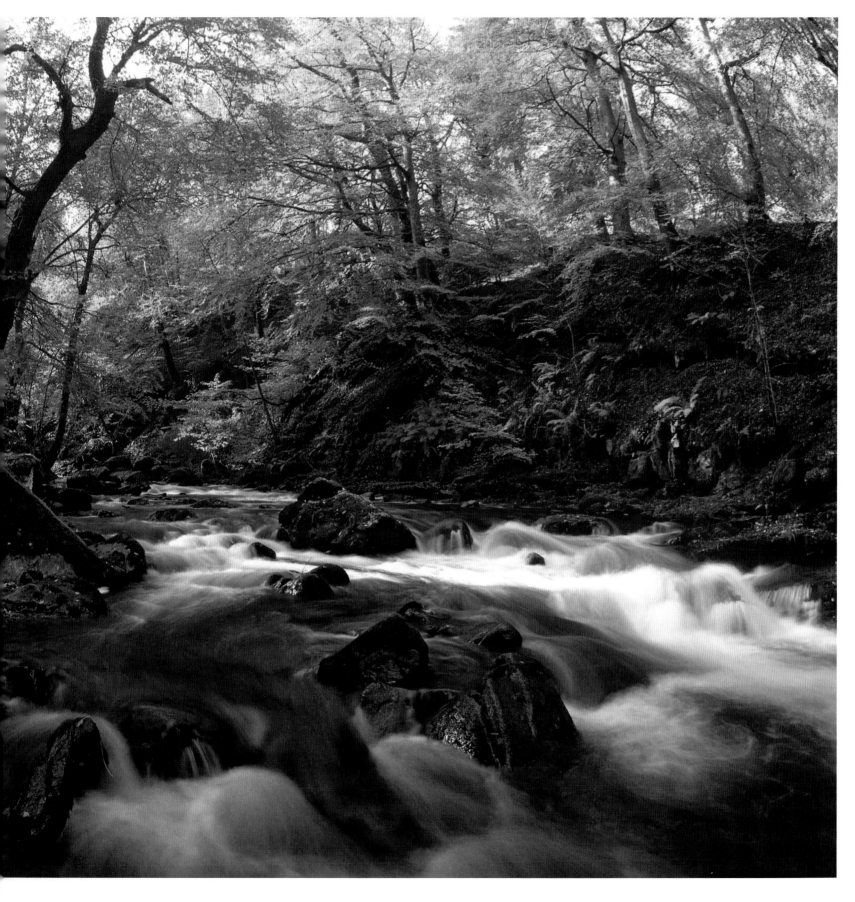

THE BOTANICS
EDINBURGH

The Royal Botanic Garden, Edinburgh: what's not to love? From morning till dusk in any season and possibly for a lifetime, you can inhabit these seventy hallowed acres; invariably you will feel … better.

Multiple are the horticultural and architectural high points, the epitome of which is the Tropical Palm House, a sheer delight to discover. Regulars continuously renew long-established attachments; and botanists have been coming here to Inverleith since 1820 (the Garden was originally established as a physic garden in 1670 in Holyrood Park) to study, gather and supplement the collection.

The plant houses, and the Inverleith House Gallery with its changing exhibitions are the indoor attractions and there's a shop and café/restaurant at the main (John Muir) Gateway. Mostly we wander! There's a surprising view of the Castle from the 'Terrace'.

PHOTOGRAPH **PETER CLARKE**

FIND | WALK | EAT | SLEEP **PAGE 213**

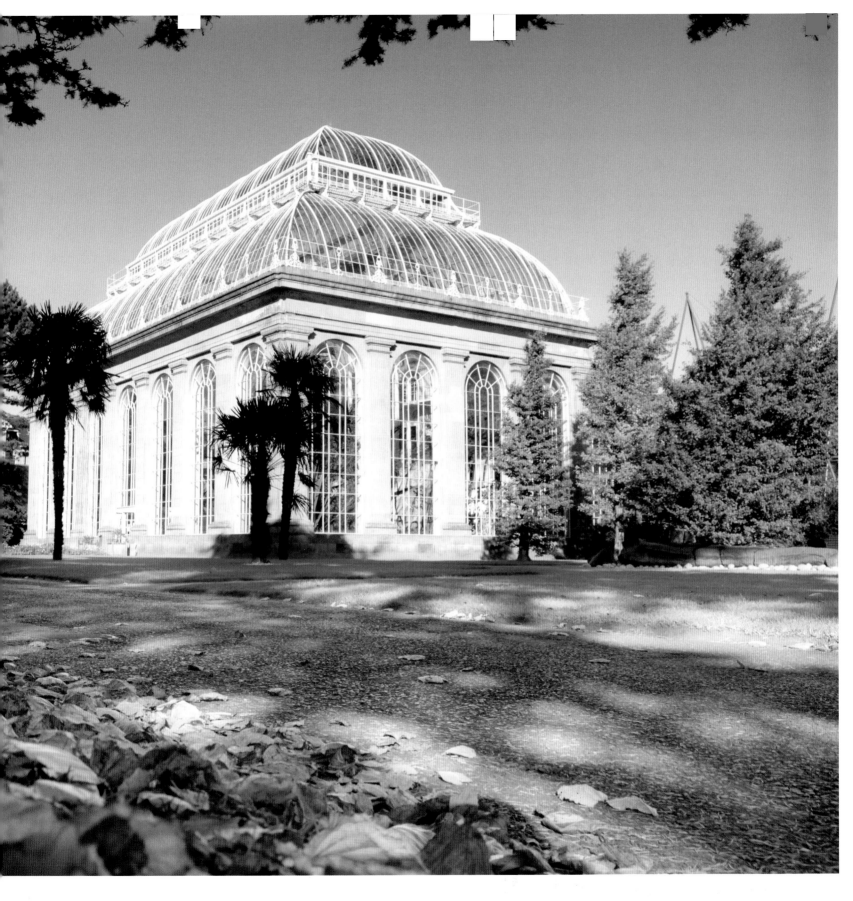

CALTON HILL ON DECEMBER 30TH
EDINBURGH

Edinburgh's Hogmanay claims to be the biggest New Year festival in the world. That's what I claim, anyway, and make no apologies, despite a personal interest, for including this picture of its opening event, the Torchlight Procession to Calton Hill, as one of the Best Places to be every year.

From Calton Hill, the city – from Arthur's Seat to Leith and the coast – twinkles below. You look back along Princes Street where a river of torchlight keeps coming, long after the head of the procession – the Vikings and the pipe bands – has arrived.

The festival is best known for the street party on Hogmanay itself, but on the 30th tens of thousands from over sixty countries march with torches from the Old Town to Calton Hill for a bonfire and fireworks, and a Son et Lumière. Pictures from Calton Hill are the first worldwide New Year celebrations to be broadcast every year.

PHOTOGRAPH **TONY MARSH**

FIND | WALK | EAT | SLEEP **PAGE 213**

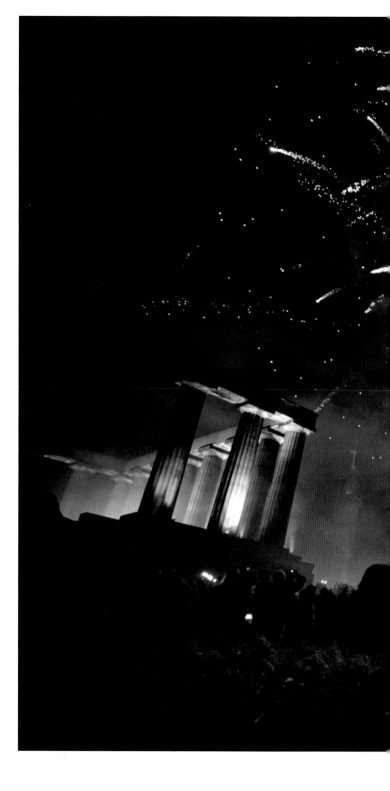

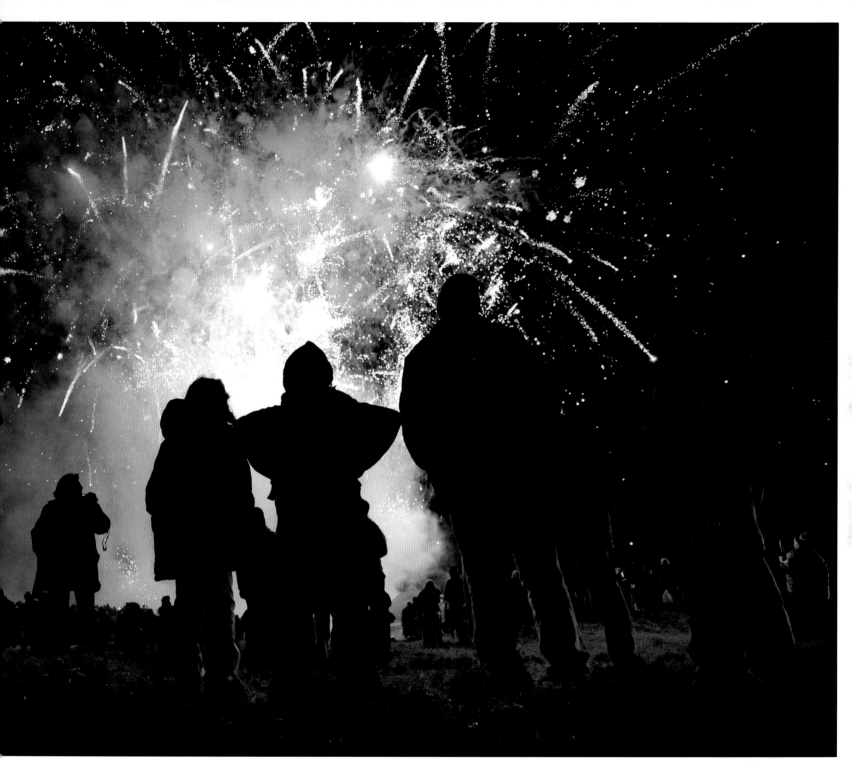

COMRIE CROFT
PERTHSHIRE

Comrie Croft is an exemplary eco-camping and farmhouse hostel that makes the most of a sylvan Perthshire location. Just outside Comrie, off the road to Crieff, there are walking, hiking, Munro-bagging, bike trailing and wild swimming possibilities all round, but the Croft's land itself, set on a gentle hillside among ferny woodland replete with trees, invites you to stay put. Home might be a Nordic Kata tent, the farmhouse itself or your own tent, wild in the woods. With a shop, bike hire, tea garden and games room, it's a very civilized billet. Around the mill pond, by open fires and a mountain above, Arcadia seems within reach.

PHOTOGRAPH KANE RUTHERFORD

FIND | WALK | EAT | SLEEP PAGE 214

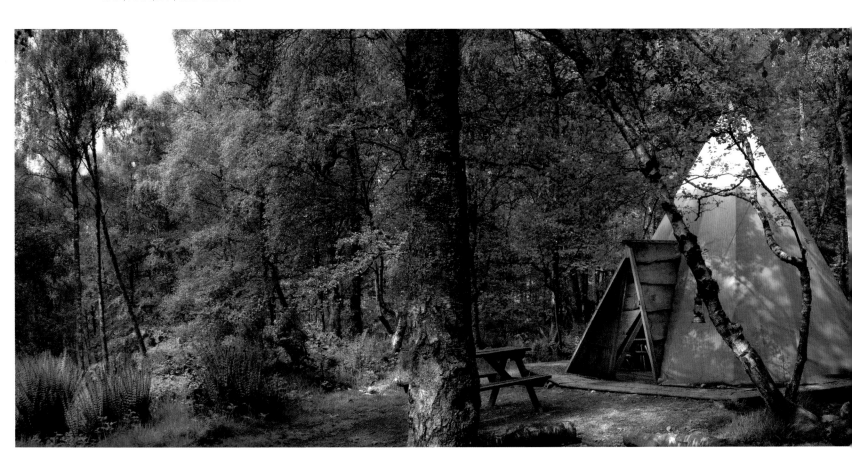

CRATHES GARDEN
DEESIDE

The Royal Deeside Road, which closely follows the river west from Aberdeen, offers many opportunities to appreciate why this river has a 'side' and why it has been so loved by Royals and lesser mortals so much. And Crathes Castle and Gardens and the estate that surrounds them are quintessential Deeside.

There is an agreeable formality to the 16th-century fairytale tower house with its winding staircases and painted ceilings but also to the walled garden, the sculpted yews and topiary dating from 1702. The garden is notable for its use of colour and the contrast between the themed areas of herbaceous propriety and the wild garden outside the wall. Gardeners drift around Crathes in a scented heaven.

PHOTOGRAPH KATHY COLLINS

FIND | WALK | EAT | SLEEP PAGE 214

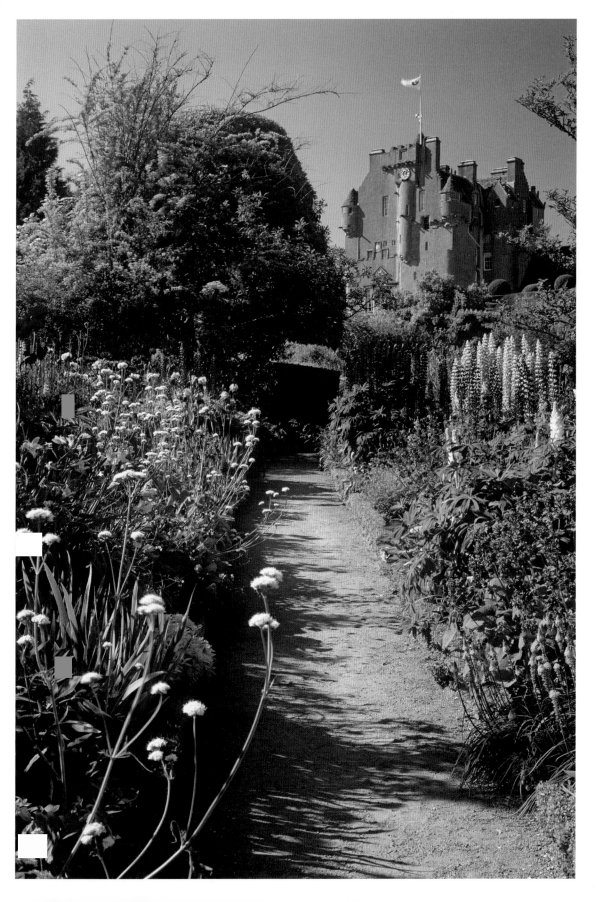

CRIEFF HYDRO
PERTHSHIRE

Not so much a hotel as a national institution, Crieff Hydro has remained in the same family since its inception as a 'hydropathic establishment' in 1868 and there is still something of its restorative and principled approach to hospitality that chimes with our health-obsessed times. The spa is from the first time round. Almost uniquely, there are no bars.

On an estate centred on a vast Victorian mansion overlooking the couthy Perthshire town, the Hydro is a village in itself, with contemporary lodges and cottages, stables, golf and over sixty organized activities for all ages. This is a 900-acre resort that has thought of everything, yet you never feel processed or packaged; its wholesomeness is unobtrusive. Crieff Hydro, perfect for families and a destination for all generations, is unlike anywhere else.

PHOTOGRAPH **PHOEBE GRIGOR**

FIND | WALK | EAT | SLEEP **PAGE 214**

DR NEIL'S SECRET GARDEN
EDINBURGH

Not so much a secret these days but this public garden
still seems like a private hideaway; it was a labour of love
when it was created by the good Doctor and still is, under
Claudia Poitier and a dedicated group of volunteers.
On Duddingston Loch, on the southern edge of Holyrood
Park, Edinburghers go past and don't know it's there.
With Arthur's Seat above and the loch through the trees,
you could be in Argyll; it always feels far away from the
city; a privilege to sit or stroll here. In a corner, the Curling
House has been restored. The Skating Minister of Raeburn's
most famous portrait presumably got his skates on here.
www.drneilsgarden.co.uk

PHOTOGRAPH **KANE RUTHERFORD**

FIND | WALK | EAT | SLEEP **PAGE 214**

DRUMMOND CASTLE GARDENS
PERTHSHIRE

Near Crieff, a mile from Muthill, deep in Perthshire, you approach along an avenue of splendid trees to these exquisite formal gardens first viewed from the terrace by the Castle. A boxwood parterre of a vast St Andrew's Cross in yellow and red (especially antirrhinums and roses), the Drummond colours surround an impressive sundial centrepiece.

Six gardeners keep every leaf in place. For some, to wander down the aisles of this precisely ordered world, is to be in a garden of Eden; anyone can see this is no ordinary allotment.

PHOTOGRAPH **KEITH FERGUS**

FIND | WALK | EAT | SLEEP **PAGE 214**

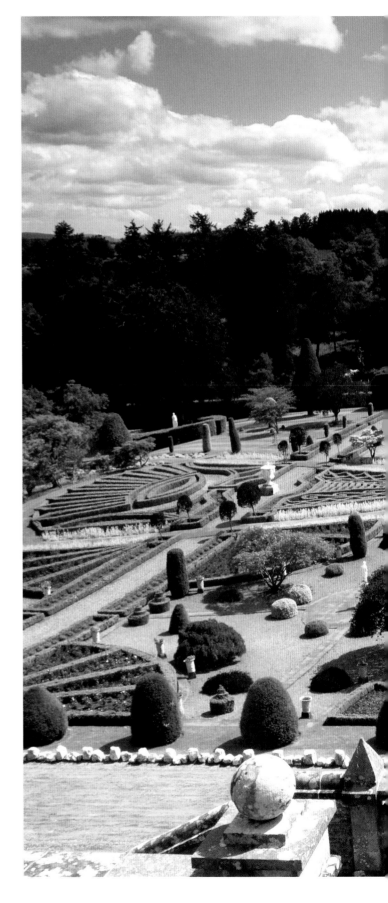

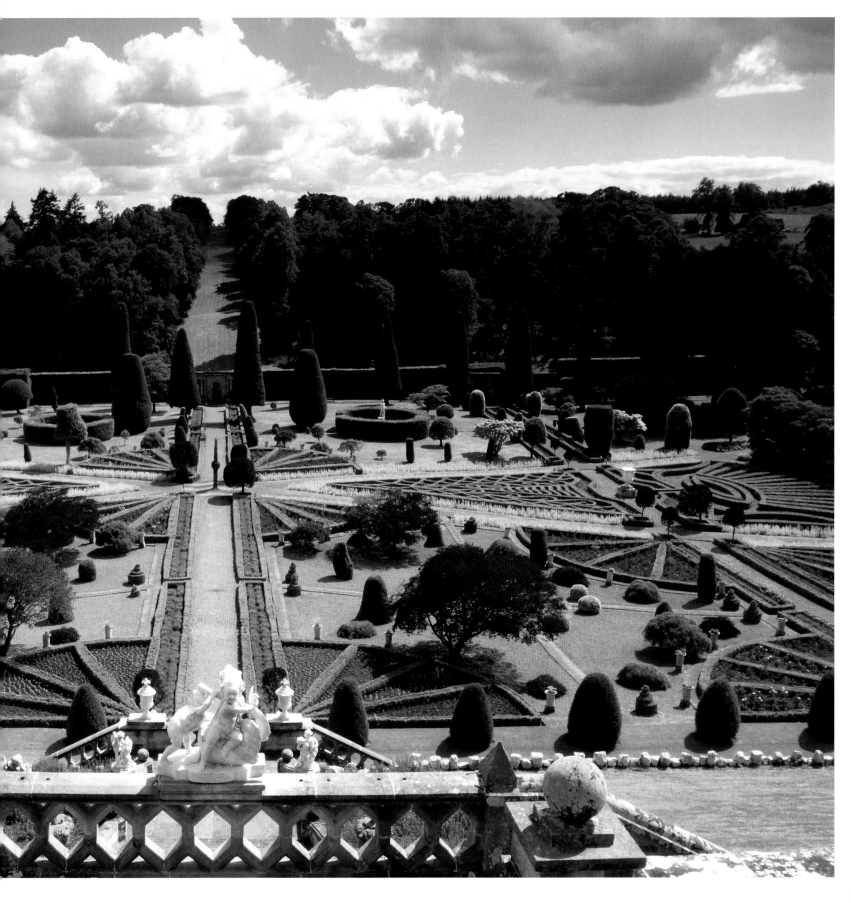

DUNNOTTAR CASTLE
ABERDEENSHIRE

Dunnottar, two miles south of Stonehaven on a rocky headland 160 ft above the North Sea, is a castle with presence, both in its spectacular location and in its place in Scottish history. Linked to the mainland by a narrow strip of land, it's a bracing and rewarding walk up there from Stonehaven Harbour.

Clearly Dunnottar's location has determined its original purpose and its destiny. Probably a settlement from 5000 BC, the surviving ruins, neglected until 1925, date mainly from the 15th and 16th centuries. Fulfilling its impregnability, Dunnottar famously held out against Cromwell's army for eight months. It played a part in Scottish skirmishes and affairs until Jacobite times in the 18th century.

Dunnottar and Slains Castle further north (of Aberdeen), near Cruden Bay – and also on a high cliff top looking into the sea – are Scotland's classic coastline fortresses. Your experience of history here is personal, irrespective of your knowledge or your guide.

PHOTOGRAPH EUAN MYLES

FIND | WALK | EAT | SLEEP PAGE 214

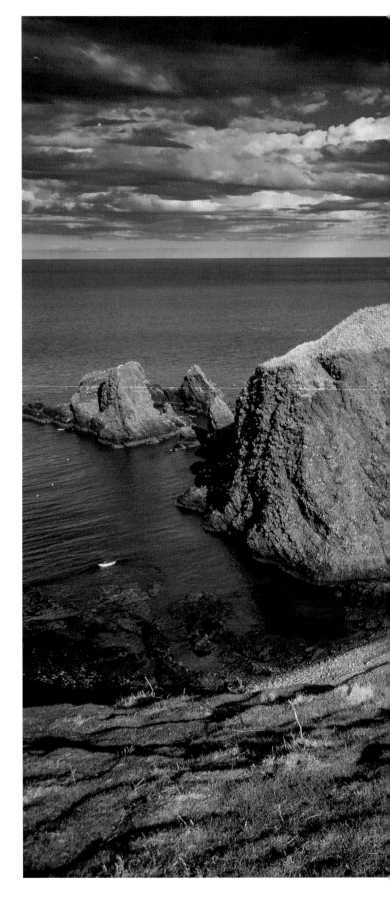

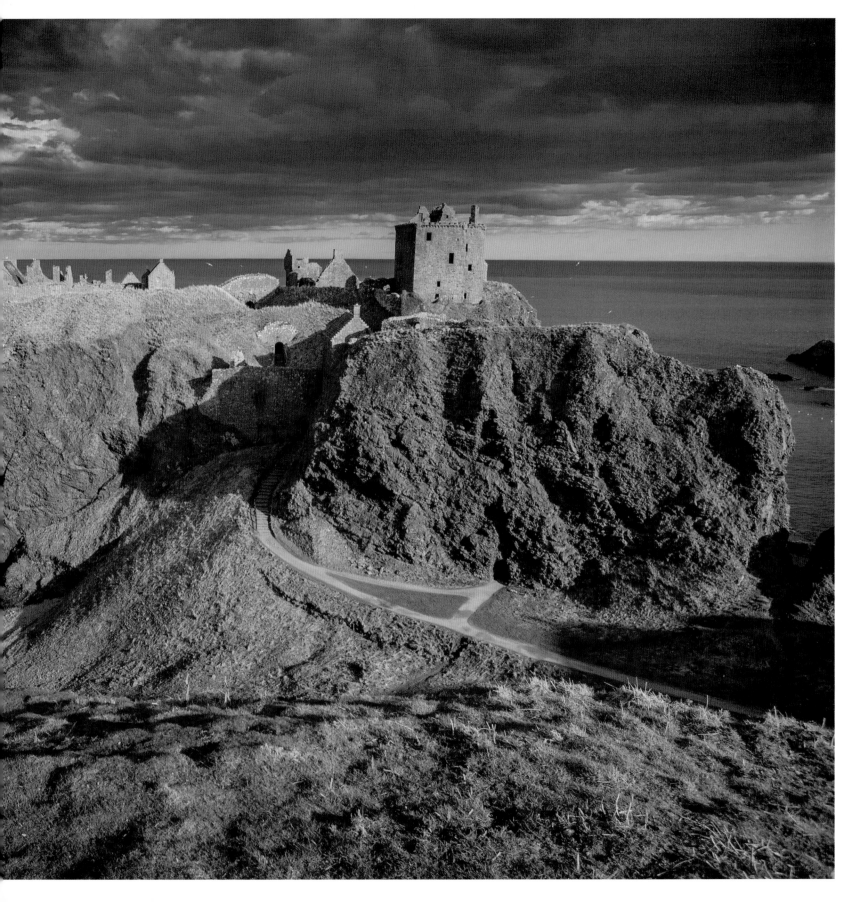

EDINBURGH GRAVEYARDS

For anyone interested in old graveyards, Edinburgh is
an alluring prospect. Old and New Calton, Greyfriars,
and Canongate are all open, accessible and replete
with history, underlining the city's credentials as a World
Heritage site. Graves and monuments are not only a roll
call of well-known historical figures, but also a reminder of
the extraordinary influence and impact Edinburgh had on
the world in the 18th and 19th centuries.

Though Warriston, the cemetery chosen here, may be
less renowned, it is nonetheless remarkable. Certainly it is
less well maintained than others, perhaps partly due to its
location north of the city centre by the Water of Leith, and
although it is A-listed architecturally, it has been poorly
served by the City Council since it took it over in 1994.
Many stones have been toppled for 'health and safety
reasons'.

Nevertheless, this abandonment and the uncontrolled
overgrowing of ivies and other invasive species contribute
to an overpowering atmosphere of romantic melancholy:
that graveyard feeling. There are no tourists here; only
graves, monuments, mausoleums – thousands of them.
Somewhere in this verdant chaos are rare elms and the
grave of James Young Simpson, the father of anaesthesia.
When you leave Warriston it may well take some time to
come round.

PHOTOGRAPH OSCAR VAN HEEK

FIND | WALK | EAT | SLEEP PAGE 215

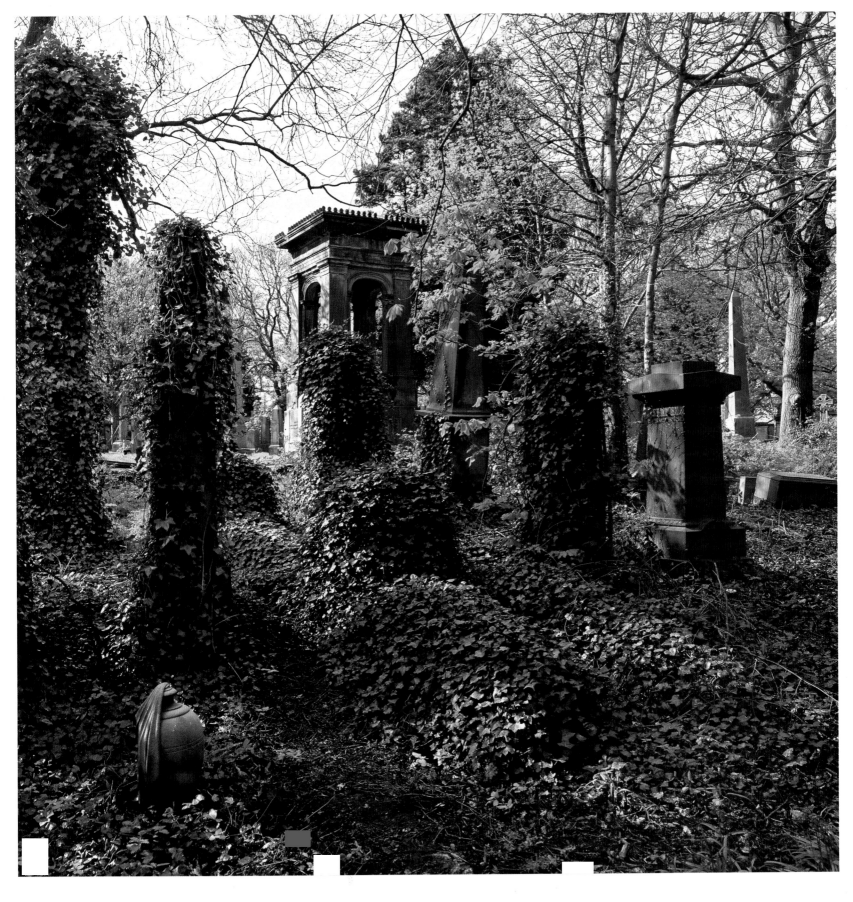

FALKLAND
FIFE

In the 16th century, Falkland Palace, an opulent hunting lodge of the Stewart dynasty (who still live here), was the finest Renaissance building in Britain. Inside it is still dark and redolent of those days of 'dancing and deray at Falkland in the Grene', yet it sits discreetly and sympathetically in an almost bucolic setting, never dominating its demesne or the village that grew up around it.

Quite unlike anywhere else in Fife, Falkland has an intimacy and welcoming ambience of its own. It's a perfect place to while away a day, with country walks that radiate from its charming fountain crossroads, art galleries and a good choice of tearooms and bars. The Palace is managed by NTS, and is open March–October.

PHOTOGRAPH **BRIAN CHAPPLE**

FIND | WALK | EAT | SLEEP **PAGE 215**

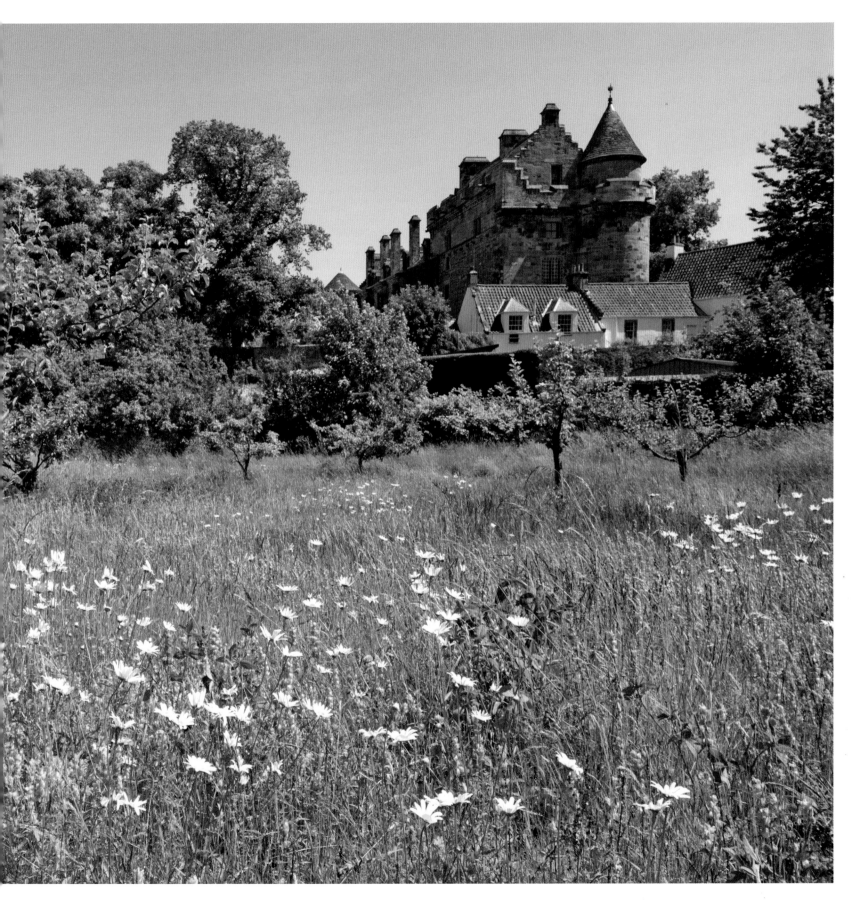

THE FORTH BRIDGE
EDINBURGH

One of the engineering marvels of the world, the Forth Bridge, just outside Edinburgh spanning the Firth of Forth, still enthrals whether on a blue sky summer day, in mist or haar or spectrally lit at night. Its three massive cantilever spans, altogether 1.6 miles long (the bridge has the second largest single span in the world), are *the* Scottish landmark.

Opened in 1890, it took almost five thousand men seven years to build. Though not strictly true, painting the bridge has become a familiar colloquialism for a never-ending job. Apart from its scale, however, the red paint is its other highly identifiable feature, adding to the drama of this massive man-made structure straddling the estuarine landscape. It famously featured in Hitchcock's *The 39 Steps*. There are regular crossings by steam train.

In 2015, the Forth Bridge will have been 125 years *in situ* and in service. The following year there will be another 'Crossing', but nothing will take away from the immense presence of the first.

PHOTOGRAPH **PHOEBE GRIGOR**

FIND | WALK | EAT | SLEEP **PAGE 215**

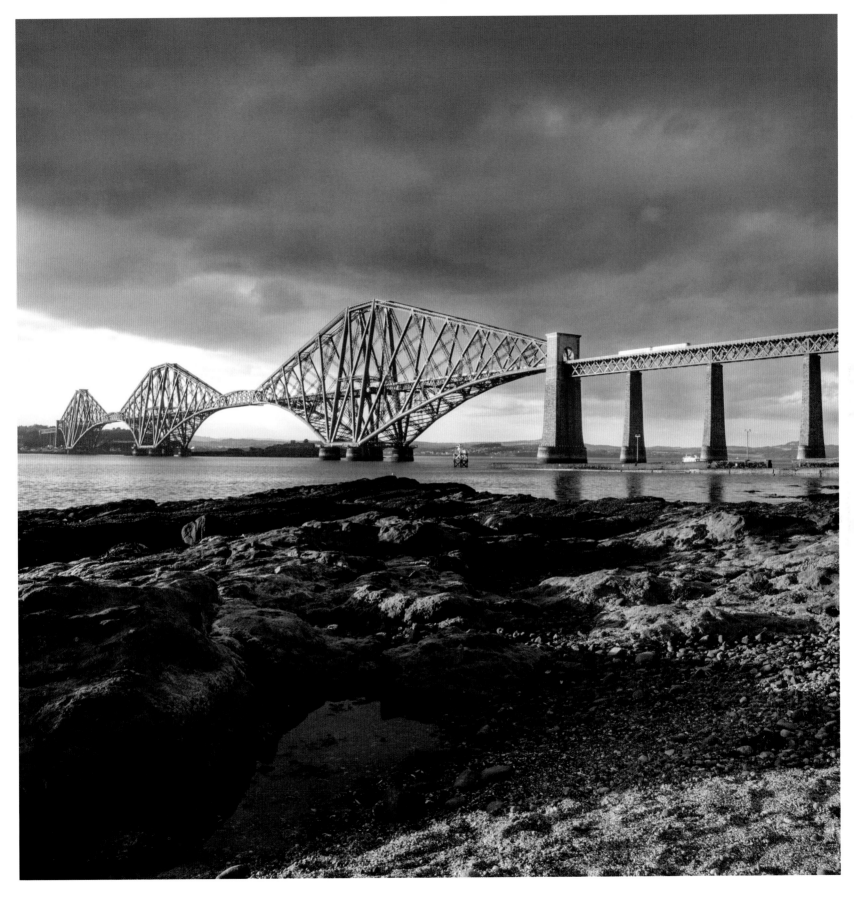

GLENEAGLES
PERTHSHIRE

Gleneagles is a village and a golf course (or four) famously hosting the Ryder Cup in 2014, but principally it is a world-class resort hotel. Opened in 1924 by the Caledonian Railway Company, it still has its own station.

Gleneagles has always moved with the times and has undergone substantial internal renovations, adding wings and lodges, keeping it in the forefront of luxury 21st-century accommodation. The King's, Queen's, PGA Centenary, 'Wee' 9-hole course and the Golf Academy put it firmly in the worldwide must-visit league of golf, but it's not only the greens that make the most of its verdant Perthshire setting; there's a prodigious menu of other outdoor activities. And for the past few years, Andrew Fairlie's eponymous restaurant has been the only Scottish restaurant with two Michelin stars.

A vast but never sprawling or overbearing place, Gleneagles offers just about everything you might want from a hotel in the country and never ennui.

MAIN PHOTOGRAPH **MIKE CALDWELL**
INSET PHOTOGRAPHS **SUSIE LOWE**

FIND | WALK | EAT | SLEEP **PAGE 215**

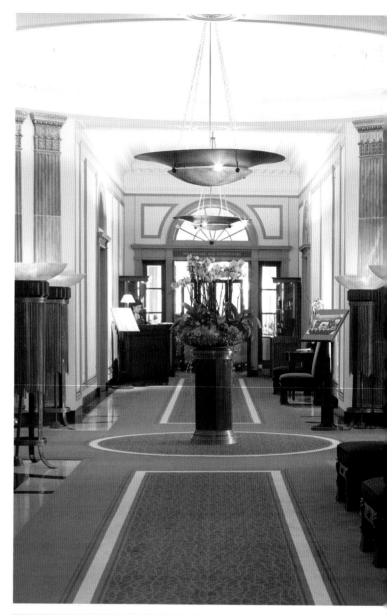

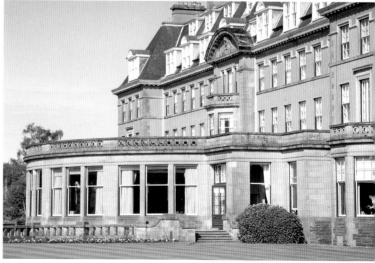

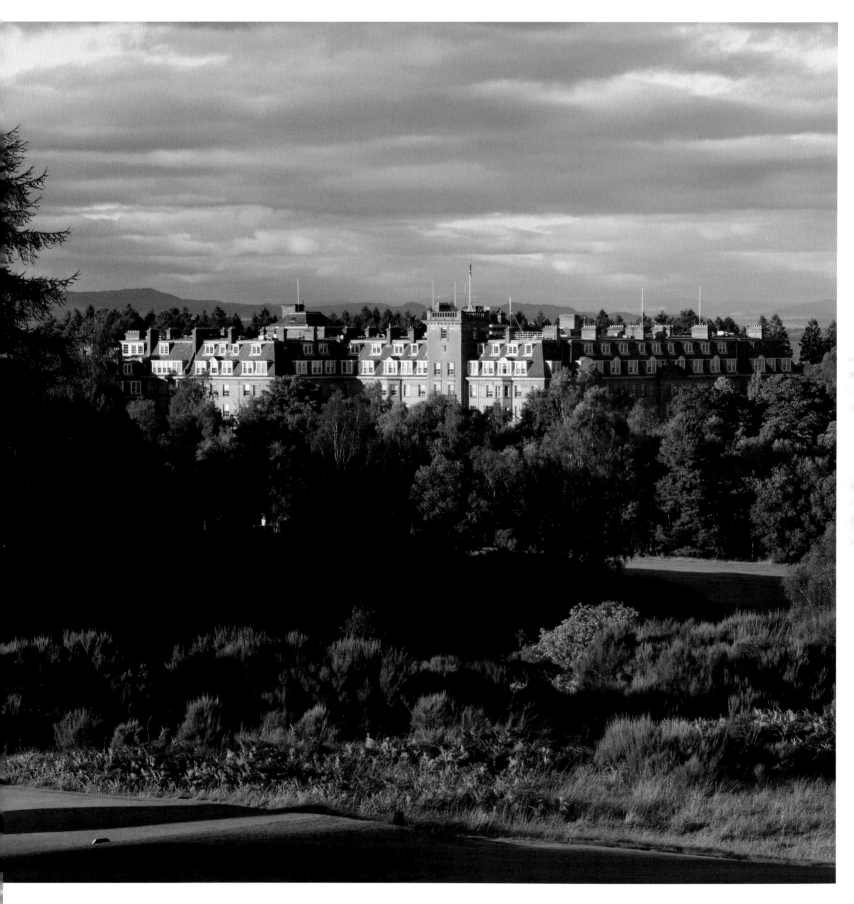

GLEN LYON
PERTHSHIRE

One of Scotland's crucial places, historically, geographically and romantically, Glen Lyon, between Perthshire and the Highlands at the heart of the matter, has long been lauded by walkers, fishers, Munro-baggers and connoisseurs of landscape, including Wordsworth, Tennyson, Gladstone and Baden-Powell.

The Lyon is a classic Highland river tumbling through gorges, ambling through riverine meadows. Several Munros form its watershed, rising gloriously on either side. Eagles soar over the more remote tops at the head of the Glen. The Tearoom in the Post Office halfway up does a roaring trade. A card can be posted from here, but around you are endless subjects for photographs, so more likely you'll post with your phone when you reconnect with the world again.

PHOTOGRAPH MICHAEL STIRLING-AIRD

FIND | WALK | EAT | SLEEP PAGE 215

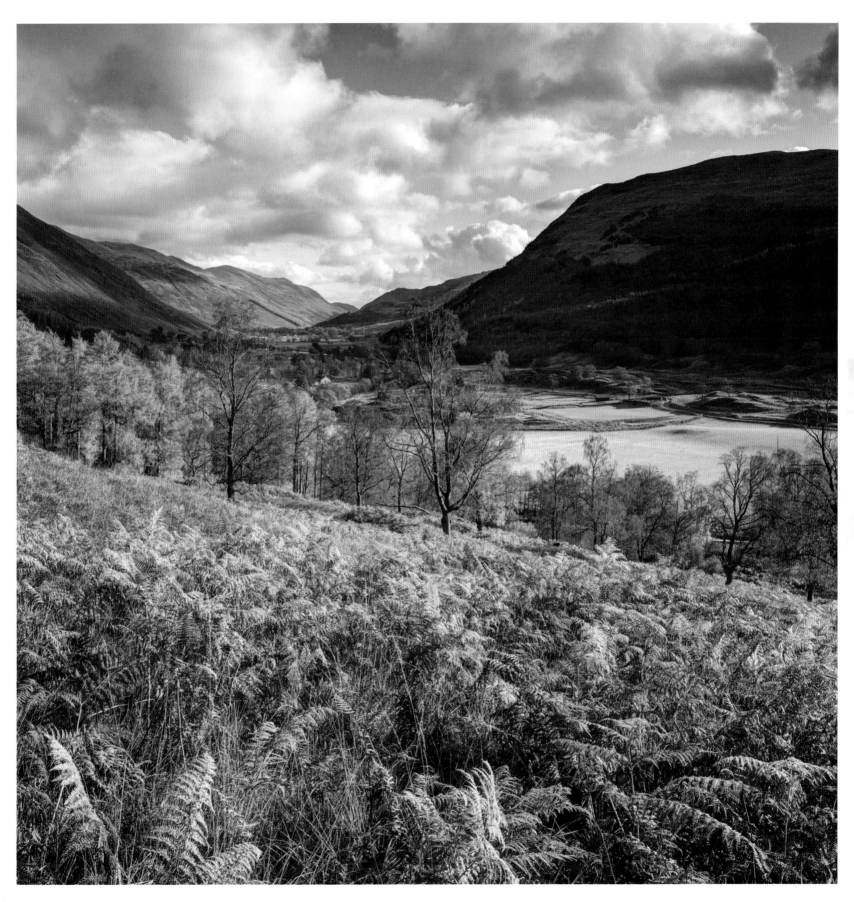

GOSFORD HOUSE
EAST LOTHIAN

Behind a long wall on the East Lothian coast road by Longniddry, discover this hugely impressive house and, inside, its remarkable Marble Hall and art collection, including works by Botticelli, Murillo and Rubens. Alas, it's only open to the public at certain times and for private parties. But the grounds are easily accessible and the house, originally by Robert Adam (late 18th century), with the later wings by William Young (late 19th), is there for us to gaze at in wonder. Along paths through woods and by lakes, you stumble on an imposing mausoleum, a boathouse full of spiders, an icehouse and a rare curling house. Here there are personal moments to savour unlike those of the many manicured and managed House and Gardens experiences of others of this aristocratic ilk.

FIND | WALK | EAT | SLEEP **PAGE 215**

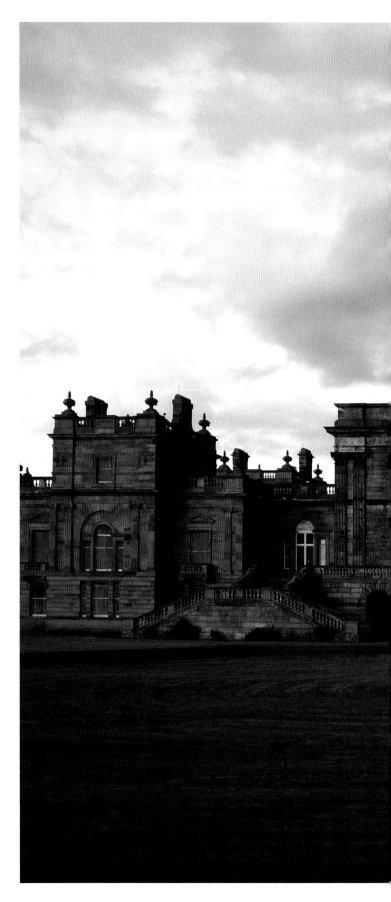

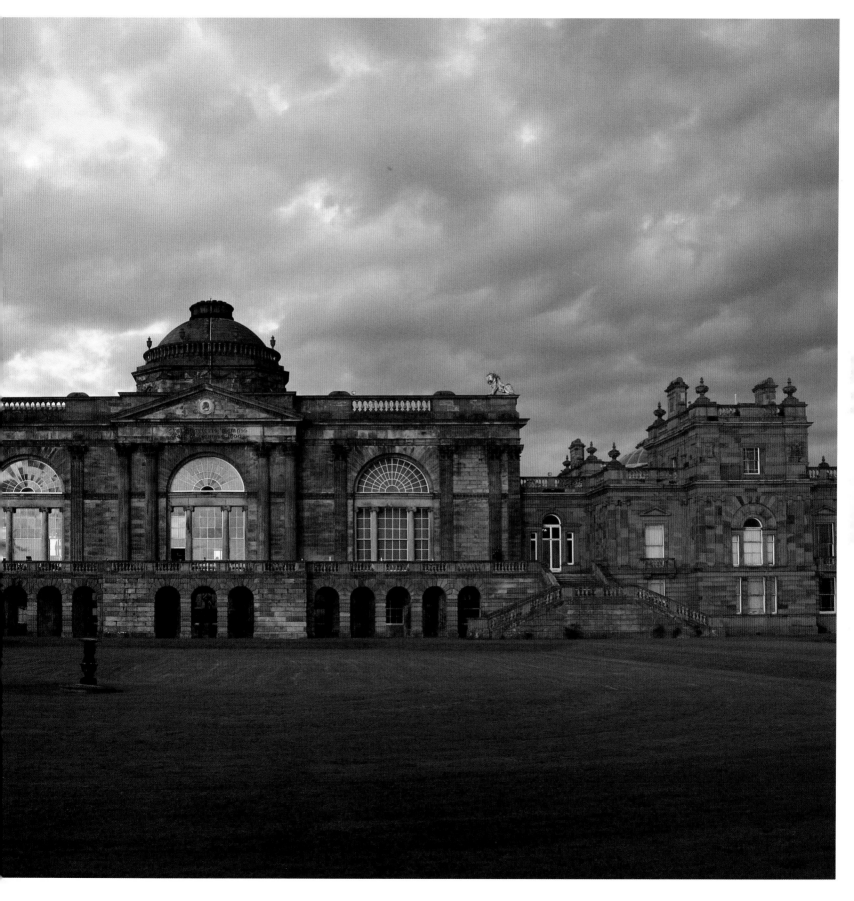

GREYWALLS
EAST LOTHIAN

The walls of this classic Edwardian country manor house near Edinburgh are not grey, rather a warm, dusty red. The whole building was designed in the Arts and Crafts style by Edwin Lutyens and was completed in 1901. Most agreeable both inside and out, to all the senses.

A hotel since 1948, with a notable restaurant, it is a perfect place to repair to for afternoon tea after golf, or a walk on the East Lothian beaches. In this respect there are comfy lounges and a conservatory overlooking the perfectly proportioned four-acre garden.

As Lutyens was the fashionable architect of the day, so was Gertrude Jekyll the horticultural equivalent. Truly this was a winning combination and they created a harmonious, far from ostentatious family holiday home, but now for us, a house that feels both sociable and intimate.

FIND | WALK | EAT | SLEEP **PAGE 216**

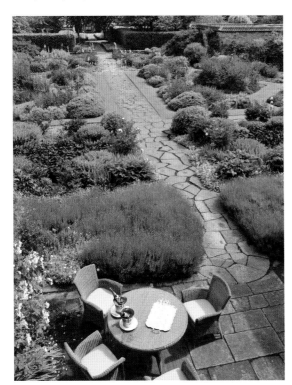

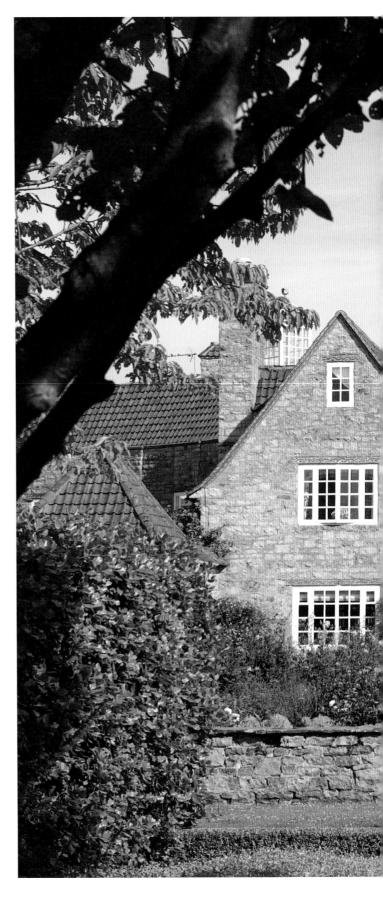

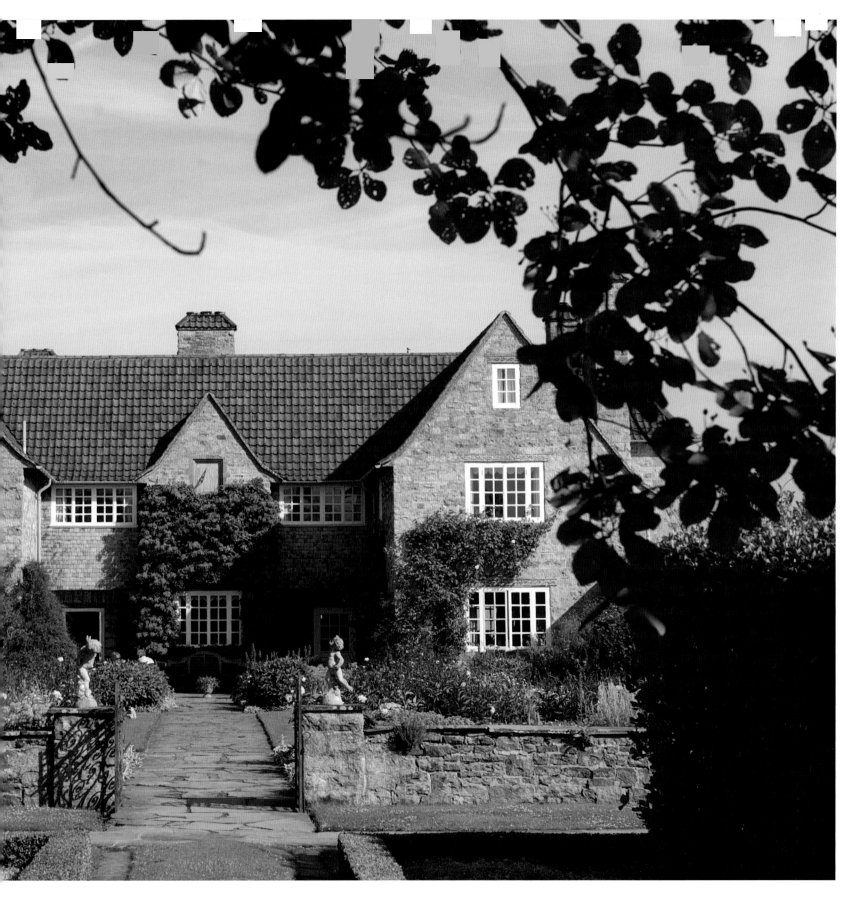

THE INTERNATIONAL BOOK FESTIVAL IN CHARLOTTE SQUARE IN AUGUST
EDINBURGH

Every August, Edinburgh is one of the best places in the world to be. The city is full of Festival, parts of it, whole streets and squares, completely taken over by pop-up theatres, tents, bars, exhibitions and shows. Charlotte Square, temporarily home to the International Book Festival, is likewise transformed: a hive of literary activity, endeavour and entertainment; we swarm through the Garden gates.

Right at the centre of this whirling life of literature, the queues for the pavilions, the café, bars and shops, is a village green. You graze on food and books, sometimes in the sun, talking, watching the world of books go by; quite possibly reading.

FIND | WALK | EAT | SLEEP PAGE 216

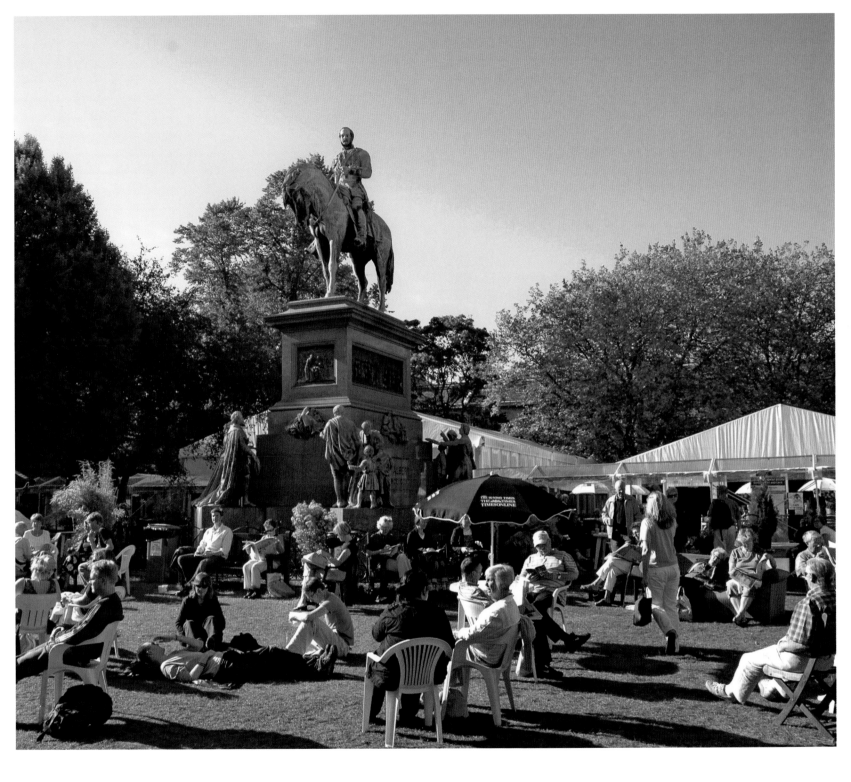

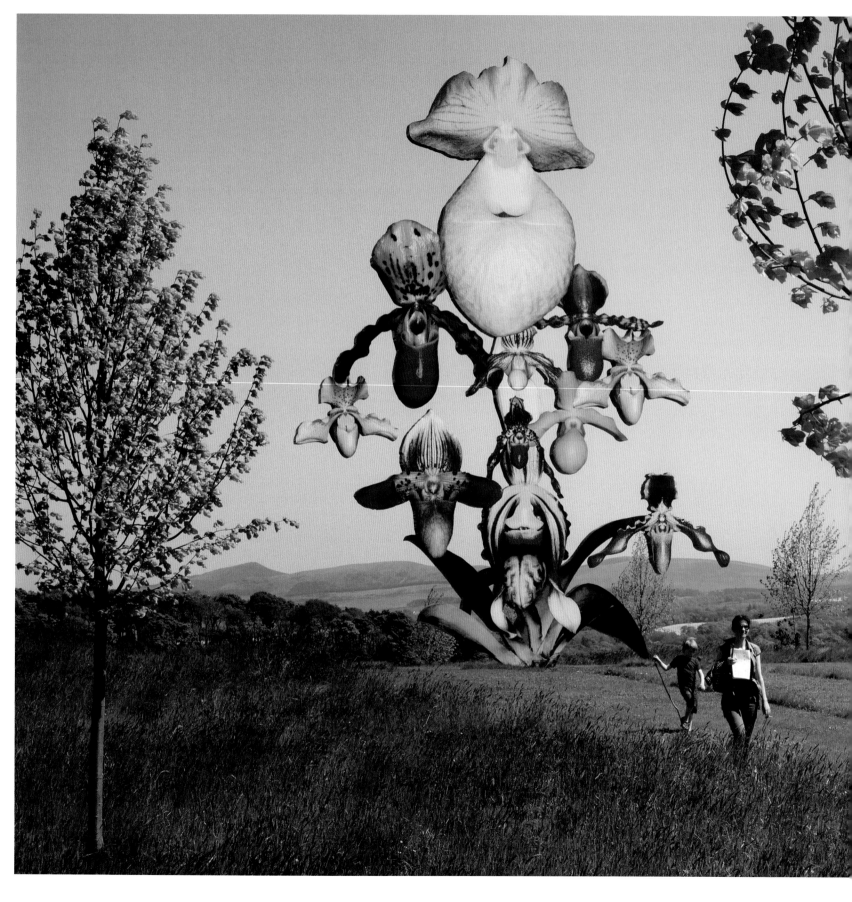

JUPITER ARTLAND
EDINBURGH

It is indeed an artland and simply unique. Bonnington
House is the home of the Wilson family and over the last
few years, in an unfolding story, they have populated by
curation and judicious commission, the groves, gardens and
lawns with a prodigious collection of contemporary art. You
will come upon the diverse and often large-scale work of
many familiar names: Antony Gormley, Anish Kapoor, Andy
Goldsworthy, and here, ostentatiously, Marc Quinn. You
enter by an enormous earthwork by Charles Jencks. Tours,
talks and events go with the seasons. Behind the House
where a marked trail starts, there's a courtyard gallery and
café food served from a vintage silver caravan. This is a
day out of the city like no other: www.jupiterartland.org

PHOTOGRAPH **DOUGLAS CORRANCE**

FIND | WALK | EAT | SLEEP **PAGE 216**

THE KELPIES
FALKIRK

Anyone driving on the M9 will notice, perhaps with astonishment, the extraordinary 100 ft-high horse-head sculptures that now tower above the motorway and the extension of the Forth and Clyde Canal. Made from structural and shimmering stainless steel, these mythical water horses, the product of artisanship and engineering, epitomize the transition of Central Scotland's industrial past to today's investment in recreation and tourism (they are part of a new park, The Helix, incorporating the Canal basin).

But they are more than that. Their creator Andy Scott modelled them on the heavy horses that pulled the ploughs, wagons and barges that forged the Industrial Revolution. He hoped that they might be a new international landmark for Scotland. It was obvious as soon as they lit up in 2014 that they would be. Public sculpture rarely makes this much impact or is as truly transformational as Scotland's already famed and much loved Kelpies.

FIND | WALK | EAT | SLEEP PAGE 216

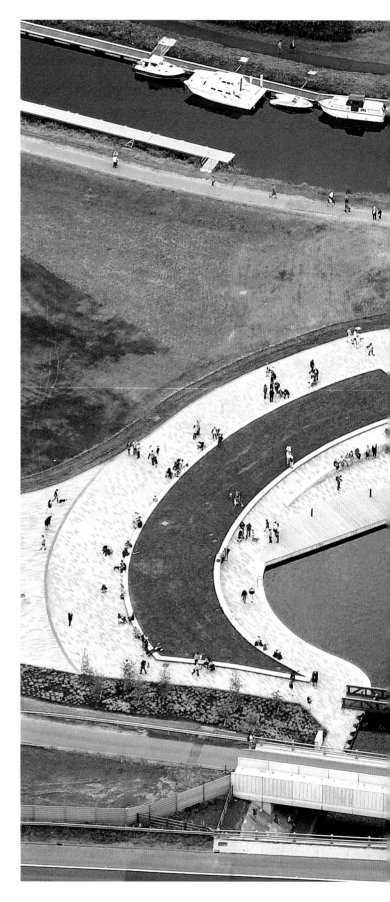

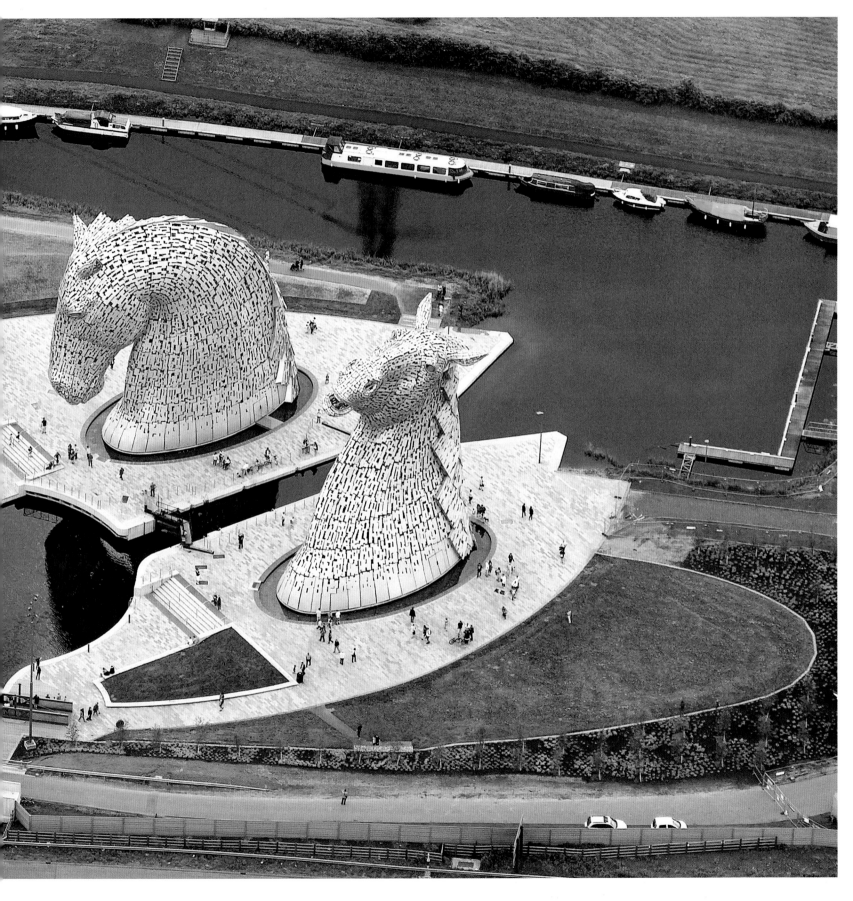

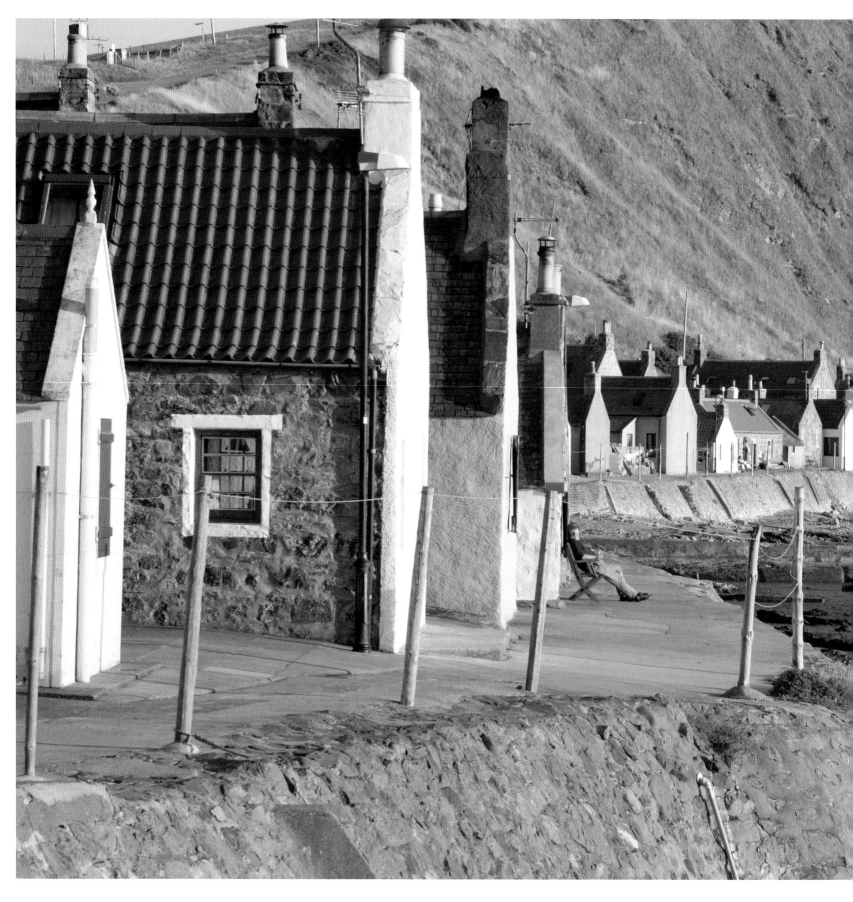

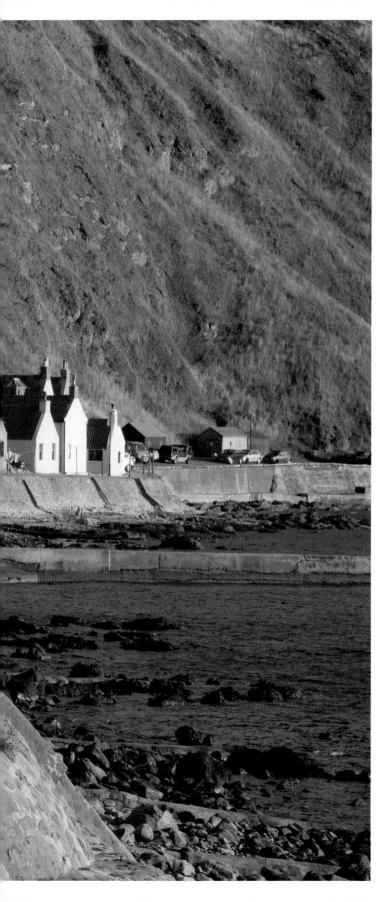

MORAY FIRTH VILLAGES

Off the beaten track, far west of Inverness and north of Aberdeen, there is a stretch of coast with beautiful beaches, airy walks, seabirds, not many folk, and couthy villages, which in places cling to rocky cliffs overhanging the shoreline.

Villages can seem isolated from each other: here is Crovie, near the spectacular sea bird colonies of Troup Head. Nearby are Gardenstown, Rosehearty, and Pennan, which was made famous in the film *Local Hero*. The superb beach of Sunnyside is reached past the dramatic ruins of Findlater Castle. Many good exploration days await on this coast.

PHOTOGRAPH **ALLAN WRIGHT**

FIND | WALK | EAT | SLEEP **PAGE 216**

MURRAYFIELD
EDINBURGH

Murrayfield means rugby. Built in 1925, Scotland's largest stadium holds over 67,000 people, all seated. When they roar and if you love the sport, there's nowhere better to be (most particularly if you're Scottish). This is obvious, but the energy and dynamism of the opposing but good-natured crowds in this place is an experience in itself.

Home to the Scottish Rugby Union, hosting the Six Nations tournament and Edinburgh (league) Rugby, it does lie empty and silent for much of the year, though there are occasional concerts: the Stones, Madonna and last time we looked, One Direction. But such is the power of 'The Game' that on the weekend of a big match, the whole city is transformed, swarming with fans from the visiting team with no atmosphere of animosity – a welcoming Edinburgh doing what it does best.

FIND | WALK | EAT | SLEEP PAGE 216

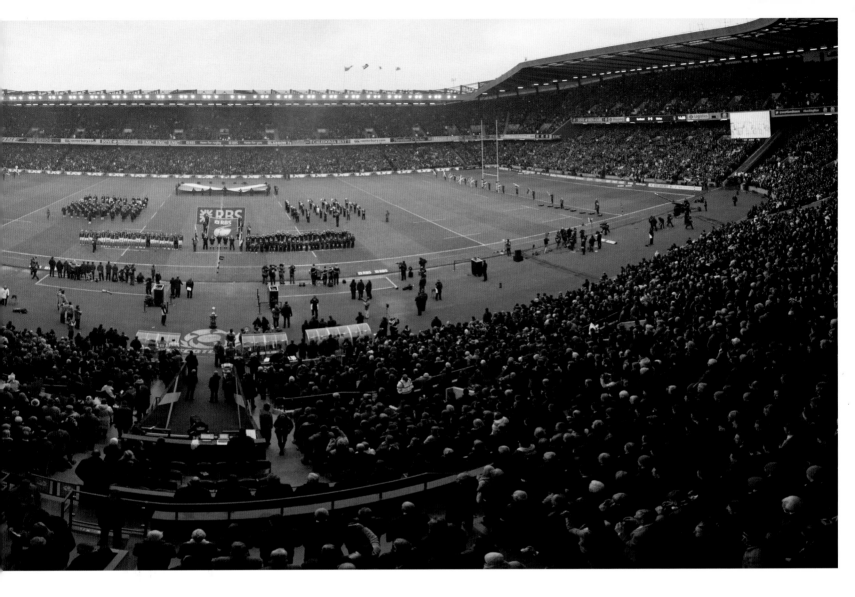

OLD ST PAUL'S
EDINBURGH

Old churches are usually the most engaging. Something about the ancient stone, filtered light through stained glass invites us, as is intended, to feel closer to God. This church in particular, though it is neither that old (the present building since 1883), nor revered in ecclesiastical history or architecture, has, nevertheless, a tangible air of spirituality.

Tucked away on the edge of the Old Town underneath the North Bridge, it is relatively unvisited and so is often quiet, yet it is home to a vibrant community who organize recitals and events, as well as well-attended Episcopalian services. In the chapel built in 1926, which is a memorial to the dead of World War I, the Martyrs' Cross from the old gallows in the city's Grassmarket sits beside a powerful huge painting in white by notable Scottish artist Alison Watt. It's called 'Still': it is what you feel here. www.osp.org.uk

FIND | WALK | EAT | SLEEP PAGE 217

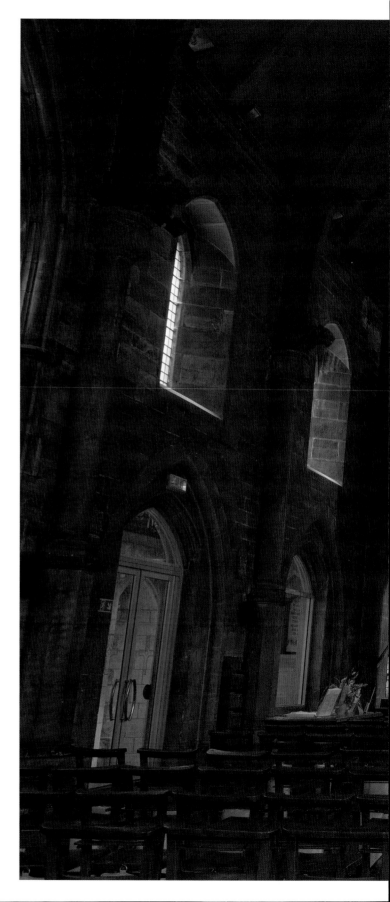

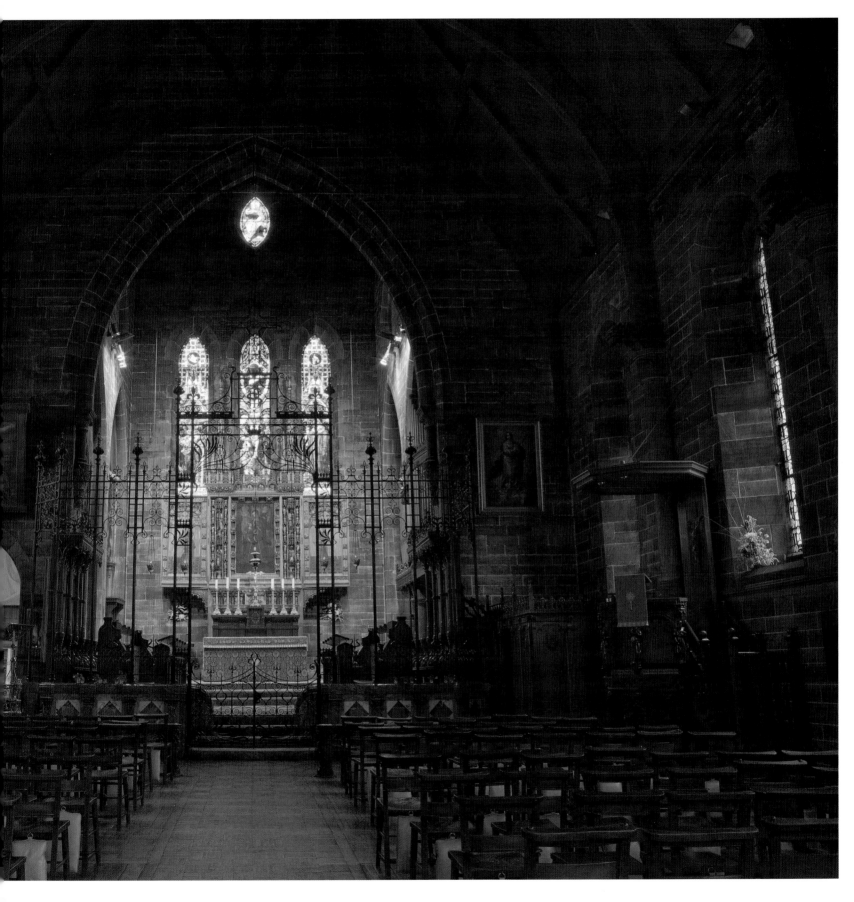

THE PALM COURT
EDINBURGH

The Palm Court of the Balmoral, the flagship hotel of Rocco Forte at 1 Princes Street, has been traditionally, and again after a recent refashioning, *the place* to take tea.

The hotel itself is an Edinburgh landmark, its clock always two minutes fast (except at Hogmanay), so you don't miss your train from Waverley, the station, below. Known as the 'Grand Old Lady of Princes Street', this is the place where ladies have always congregated for a civilized afternoon tea. With the current resurgence of this repast and a new national obsession with home baking, you may wait for a table. Also known as the Bollinger Bar, a glass may be taken with the tier of dainty sandwiches, scones and clotted cream and the other essential components of this revived, reviving pleasure. A harpist plays above.

FIND | WALK | EAT | SLEEP **PAGE 217**

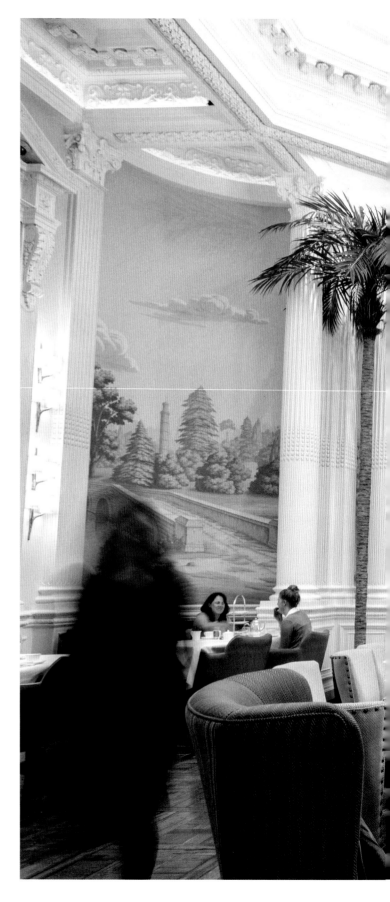

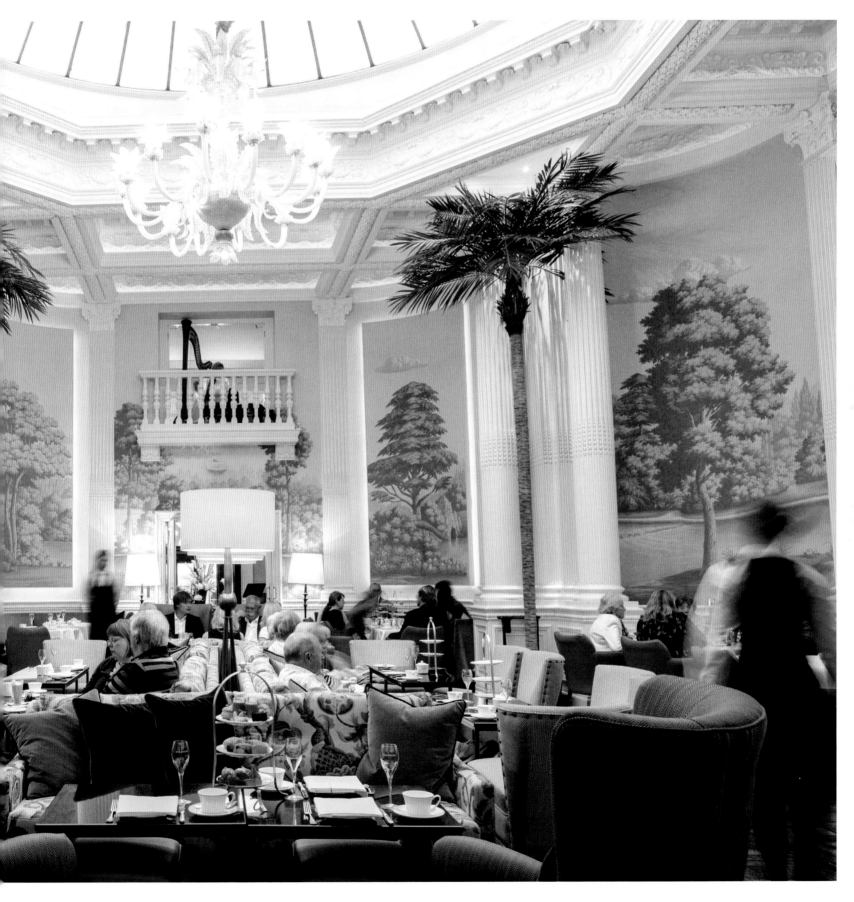

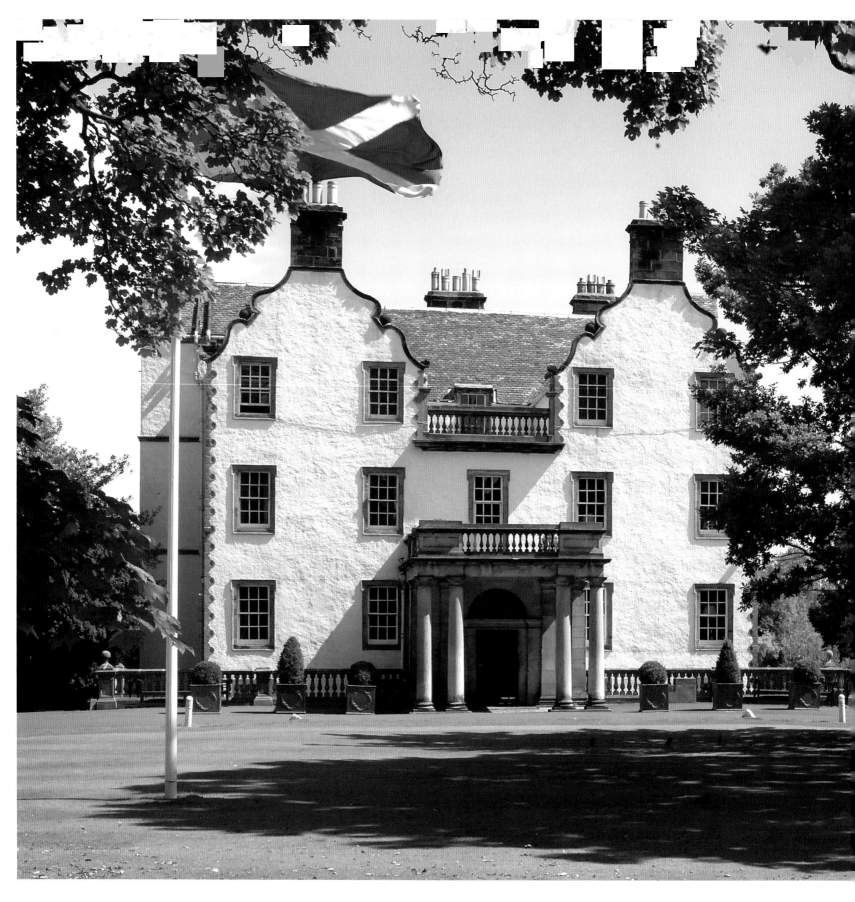

PRESTONFIELD
EDINBURGH

Around the world there are a handful of luxury hotels uniquely at one with their place; they couldn't be anywhere else. Prestonfield, a historic house on the edge of Edinburgh overlooking Duddingston Loch and Arthur's Seat (page 14), as if you were deep in another country, is one such hotel.

You go through gates in a suburb in the south of the city and up a tree-lined drive to an elegant mansion house that goes back to the 17th century. Sympathetically and meticulously restored from faded grandeur to an almost theatrical exuberance, it is imbued with a heady atmosphere of opulence, romance, even decadence. Innumerable accolades are testament to its enduring reputation.

All of Edinburgh society, then and now, come to Prestonfield for high-profile occasions, gala dinners and balls, and some weddings (mainly in an adjacent customized building). As a guest you are part of this society too. Whether here for afternoon tea by the fire or for candle-lit dinner in its signature restaurant Rhubarb, you are part of the consummate Prestonfield experience.

FIND | WALK | EAT | SLEEP PAGE 217

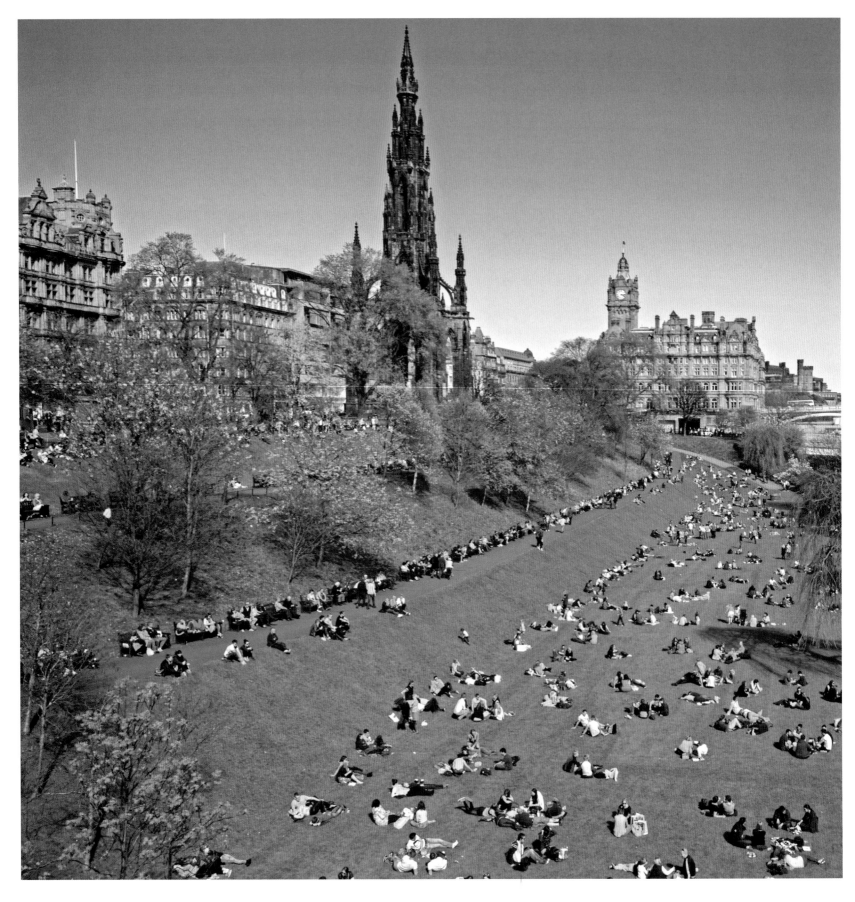

PRINCES STREET GARDENS
EDINBURGH

Due more perhaps to self-interest than foresight or consideration of the common good, the proprietors of Princes Street and the fledgling New Town of Edinburgh managed in the late 18th century to force a court ruling which required the town council in perpetuity to ensure that the land to the south of Princes Street would remain as 'pleasure-grounds'. It wasn't for decades that they became accessible to the public but for now – and presumably forever – Edinburgh's main street will have shops and buildings on only one side, and the view to the Castle and the Old Town will be unimpeded. This and the resulting gardens below make Edinburgh one of the world's most attractive cities.

The gardens (on the site of a pestilent loch which was drained) were created in two stages, in 1770 and 1820. The East Gardens, surmounted by the gothic spire that commemorates Sir Walter Scott, run between the Mound and the National Gallery and Waverley Station. At Christmas, the Gardens are filled with attractions and people; much wine is mulled. In summer they are less frenetic, and packs of tourists, office workers and students with backpacks loll on the grass and the steep embankments, while a floral clock ticks the hours until it's winter again.

PHOTOGRAPH **ALAN WILSON**

FIND | WALK | EAT | SLEEP **PAGE 217**

ROSSLYN CHAPEL
MIDLOTHIAN

Recently restored to its former unique glory, Rosslyn is probably one of the most enigmatic churches in Christendom. Since 1446, though built as a family place of worship, it has attracted the devout, pilgrims, code-breakers and the curious. Numerous speculative theories about its association with Freemasonry and the Knights Templar reached a populist peak with its inclusion in Dan Brown's *The Da Vinci Code.*

Though the Holy Grail remains elusive, the Chapel is still a treasure trove for followers of ecclesiastical architecture and those of us who just like very old and atmospheric churches. You will rarely have it for private contemplation, but Rosslyn never fails to impress. And edify.

PHOTOGRAPH **PAUL TOMKINS**

FIND | WALK | EAT | SLEEP **PAGE 217**

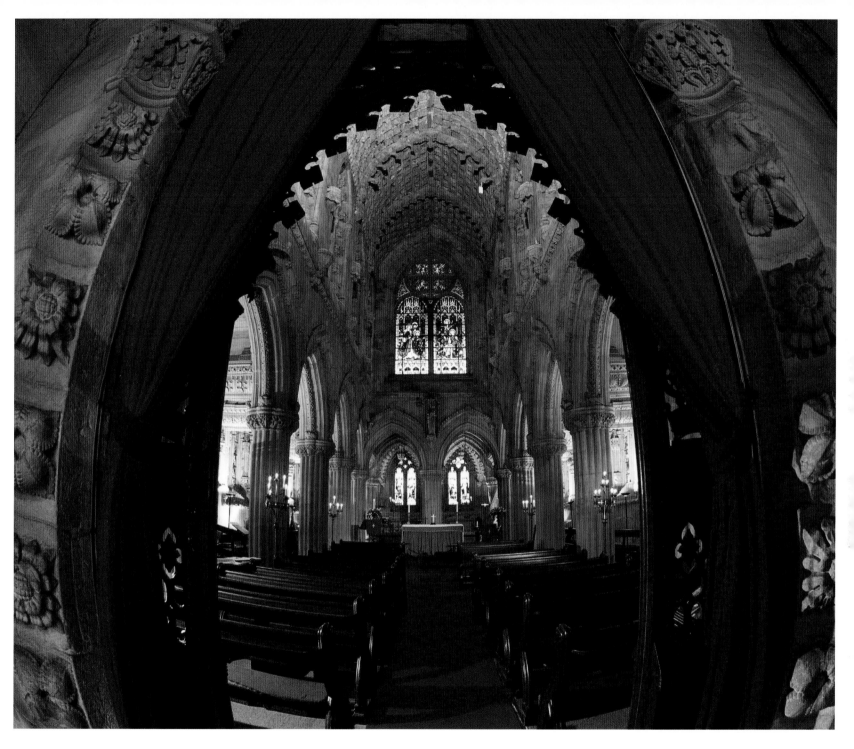

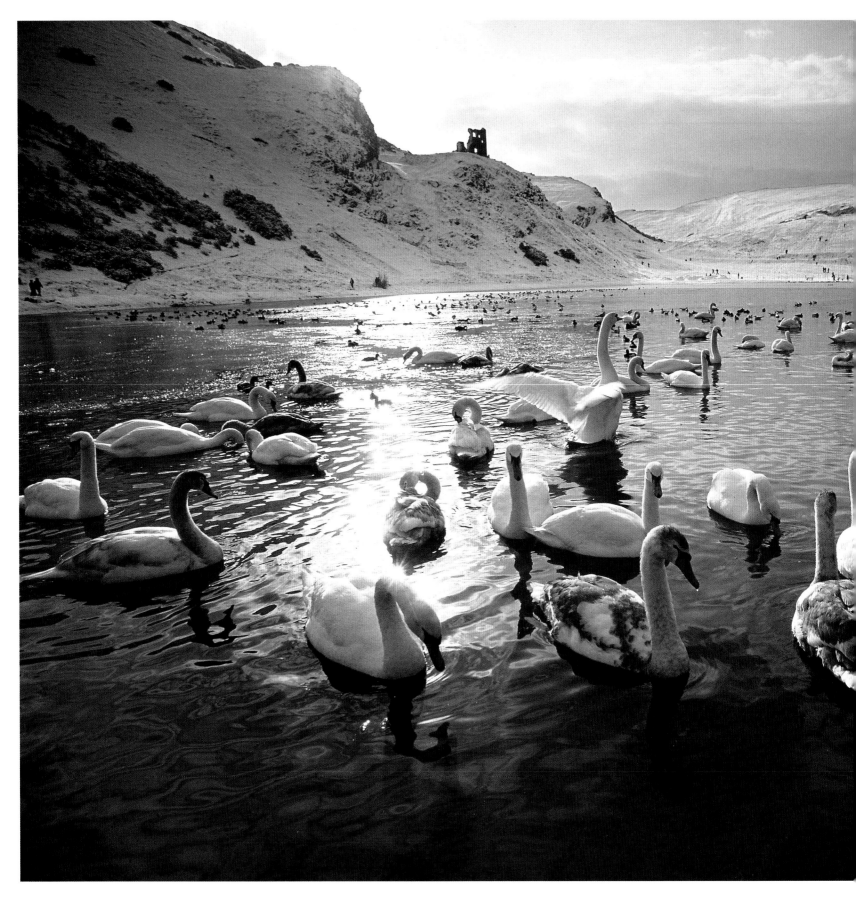

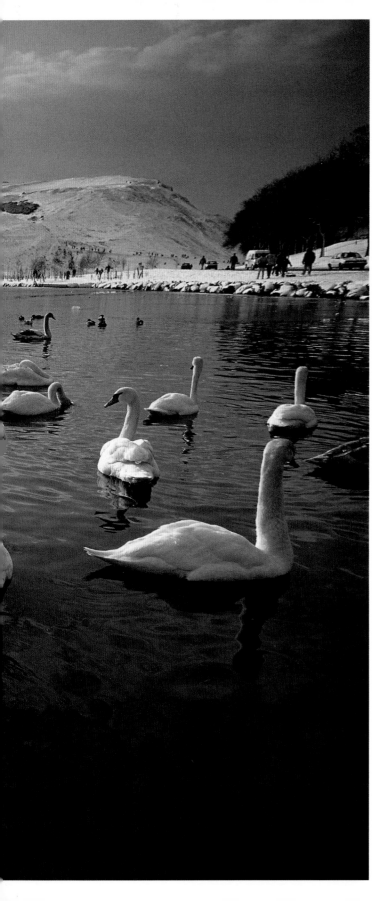

ST MARGARET'S AND THE LOCHS OF HOLYROOD
EDINBURGH

Holyrood Park may easily be taken for granted by citizens, but it is a major asset of Edinburgh. Arthur's Seat overlooks the Parliament, the Palace and this historic parkland of timeless recreation. A sometimes busy road cuts through it, yet St Margaret's Loch sits serenely in the corner, with St Anthony's Chapel above, as if it were in its own quiet country. Always full of ducks and swans it provides a sanctuary for them and, along with Duddingston Loch and Dunsapie Loch around the other side of the hill, for us too.

PHOTOGRAPH **DOUGLAS CORRANCE**

FIND | WALK | EAT | SLEEP **PAGE 217**

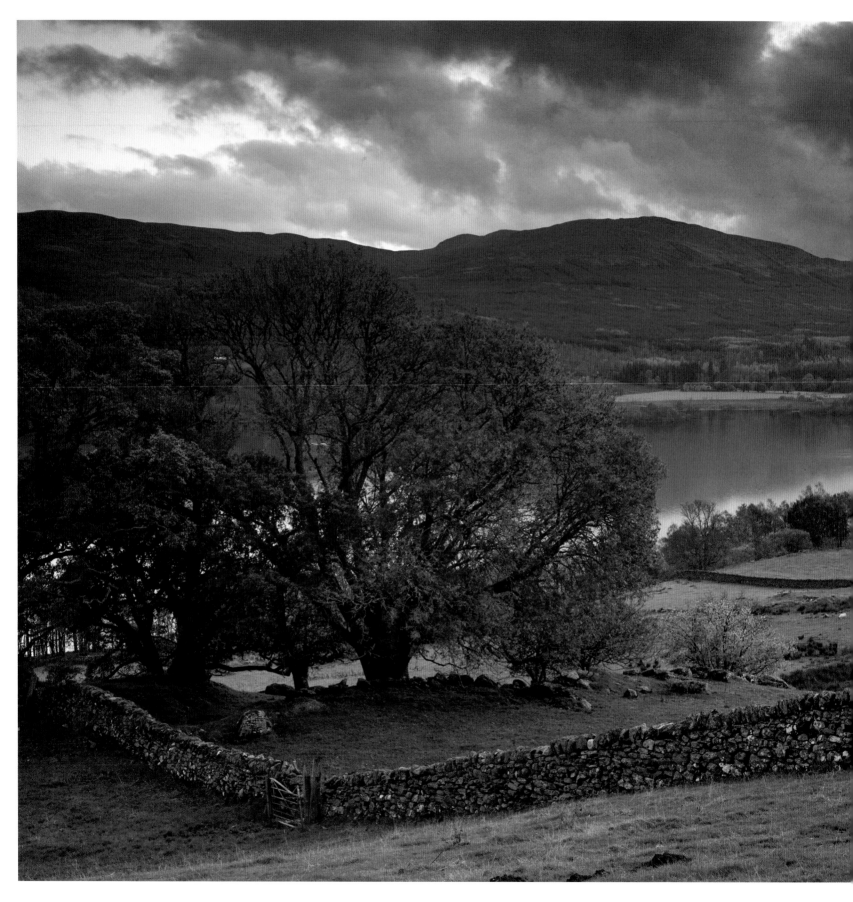

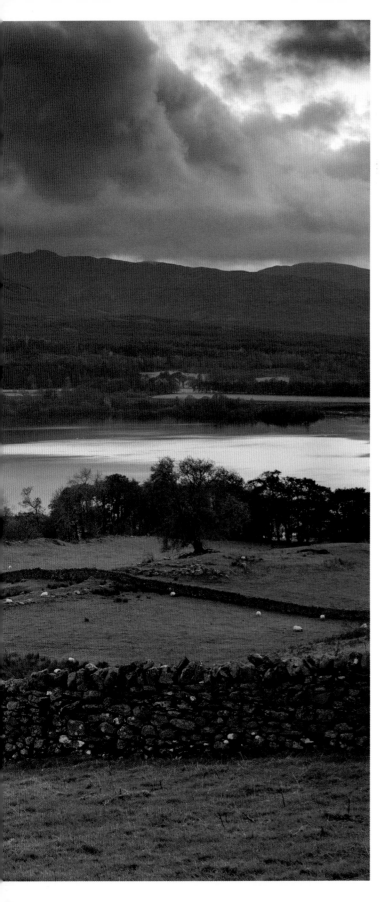

SOUTH LOCH TAY
PERTHSHIRE

Presided over by the Ben Lawers massif to the north, Loch Tay is the long and languid loch of Perthshire that begets a great river that flows through two cities and becomes a Firth. Though rugged, sometimes austere scenery surrounds it, Loch Tay has a pastoral serenity and the best way to experience it is by travelling the unclassified road to the south.

Resolutely single-track with many a twist and turn, this superbly scenic road links the Victorian villages of Kenmore and Killin, with its famous Falls of Dochart (on the river rising far in the west that feeds the Loch). En route is the fascinating Scottish Crannog Centre (www.crannog.co.uk), the lovely gorge and Falls of Acharn and an extraordinary inn, closed at time of publication but hopefully to reopen. Mainly, however, it is the loch we have to enjoy. In certain conditions when the light in the sky is to the north, it takes on a supernatural presence of its own.

PHOTOGRAPH **MICHAEL STIRLING-AIRD**

FIND | WALK | EAT | SLEEP **PAGE 218**

STONEHAVEN POOL
ABERDEENSHIRE

On the northern edge of this proudly self-contained town south of Aberdeen, a much loved and well-maintained open-air pool that echoes seaside days gone by. Olympic-sized, it glitters in the surprisingly frequent sun, inviting you to immerse yourself in nostalgia, as well as its pleasantly heated sea water. A labour of love for the 'Friends of Stonehaven Outdoor Pool', in a world where swimming is mostly confined to soulless centres of relentless 'leisure', an afternoon here is a singular pleasure; it's even open to midnight on Wednesdays in July and August for a thrilling midnight dook. www.stonehavenopenairpool.co.uk 01569 762134.

PHOTOGRAPH **ELMA MCMENEMY**

FIND | WALK | EAT | SLEEP **PAGE 218**

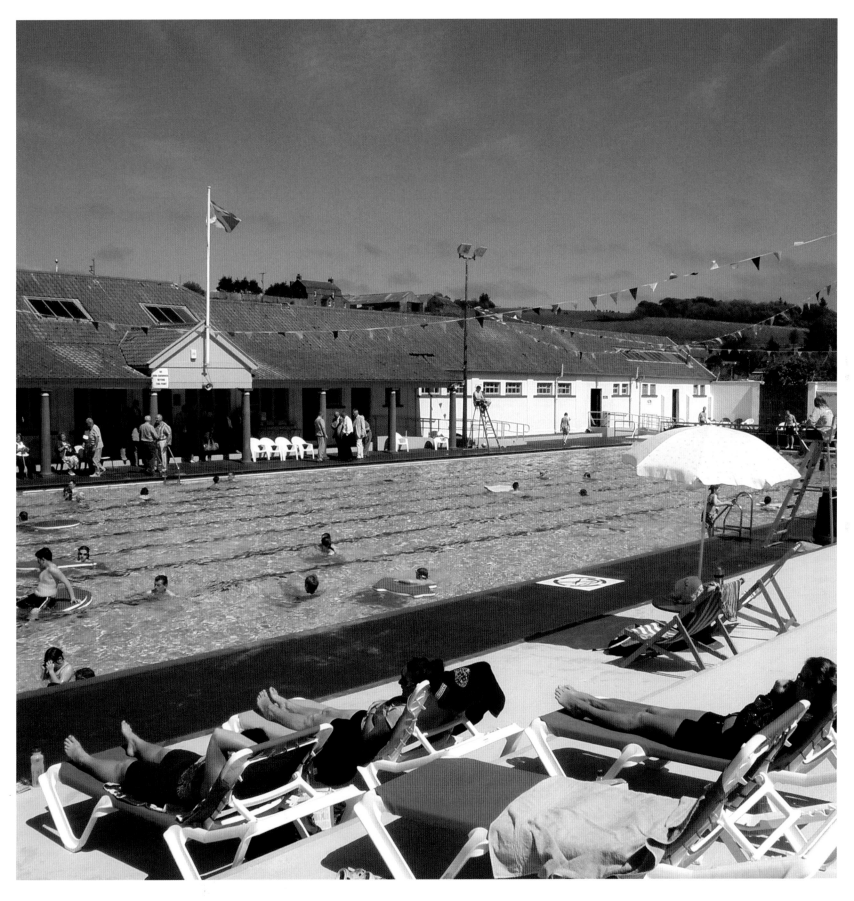

SUMMERHALL
EDINBURGH

Summerhall by the Meadows, on the hitherto untravelled (by culture hunter-gatherers) South Side, has become, since it opened in 2011, Scotland's most eclectic, most exciting arts destination. Their *soi-disant* 'creative hub for the arts with studio and workshop spaces' description doesn't quite convey Summerhall's extraordinary ambition, range or scale.

Until recently it was the Royal (Dick) School of Veterinary Studies. Its 500-plus rooms, including lecture theatres, dissection labs, a mini high-rise block (now filled with IT start-ups) and a large outdoor courtyard, have evolved (rather than by planned transformation) into auditoriums and performance spaces, galleries, a café and the estimable Royal Dick Bar and Restaurant.

During August, it's one of the principal and least predictable Fringe venues (the only one without stand-up comedy) but when the circus moves on, Summerhall, open all year, hosts gigs and clubs of all sorts: the Science Festival, a Festival of Historical Fiction, a Beer Festival and more exhibitions than all the city's major galleries put together. It is probably the biggest multi-arts complex in Europe, yet it is neither proclaimed nor publicly funded. As per the vision of its founder Robert McDowell, Summerhall is for you to discover either as artist or audience.

PHOTOGRAPH **PETER DIBDIN**

FIND | WALK | EAT | SLEEP **PAGE 218**

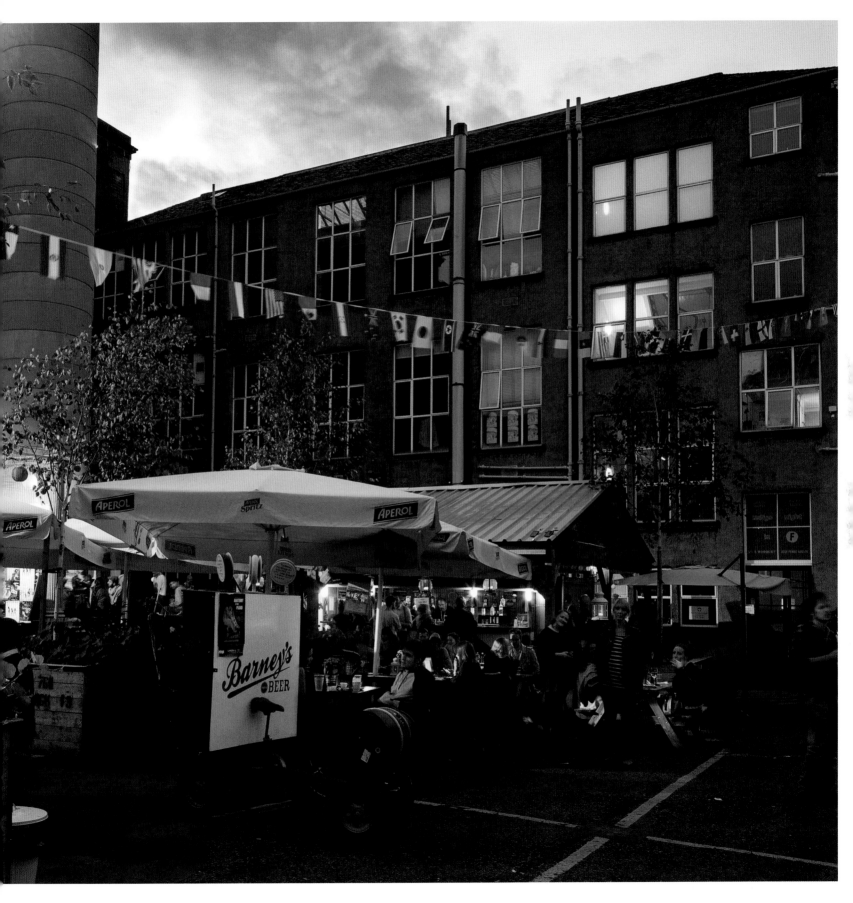

YELLOWCRAIGS
EAST LOTHIAN

The proximity of the East Lothian beaches is one of the best things about living in Edinburgh. Those of us who do may have favourites: Seacliff, Tyninghame, Gullane Bents or Canty Bay but here I have chosen Yellowcraigs, perfect for strolling, picnics and barbies, running the dog. Although you will rarely have it entirely to yourself, it's a long, wide strand and exhilarating from misty dawn to dusk. Sometimes the sea shimmers like liquid gold.

PHOTOGRAPH **PAUL TOMKINS**

FIND | WALK | EAT | SLEEP **PAGE 218**

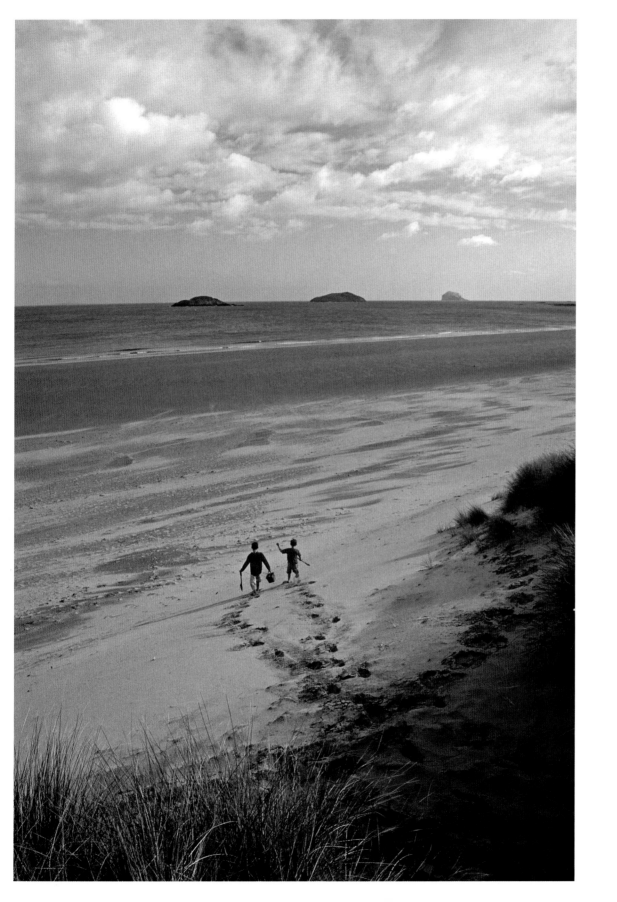

THE BLACKHOUSE VILLAGE
ISLE OF LEWIS

The Gearrannan Blackhouse Village in the northwest of Lewis is just that: a village of squat, thatched cottages, dark inside and out. But it would be hard to find a more atmospheric Hebridean retreat (or on any island). Mainly available for holiday accommodation, the rooms are basic but real-fire warm and cosy. It is almost like you are living in thon times; you wake to the crashing Atlantic foam. Near the Callanish Stones and the earth-floored, just-as-it-was Blackhouse of Arnol (a museum) the village is far from the sodium lights of Stornoway and the rest of the damned world.

PHOTOGRAPH **PAUL TOMKINS**

FIND | WALK | EAT | SLEEP **PAGE 219**

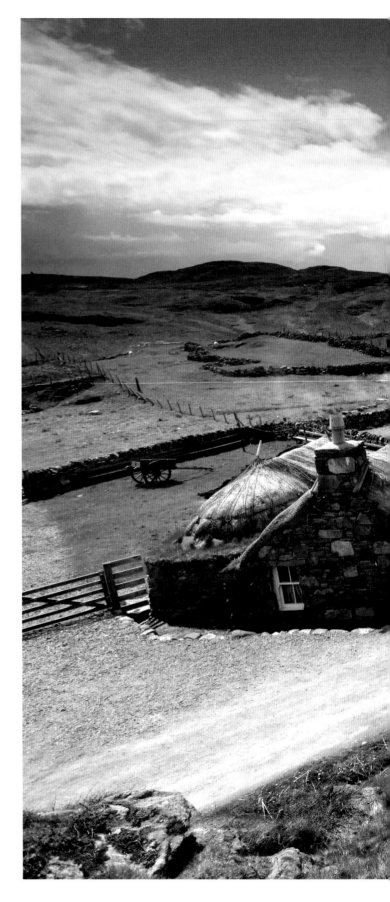

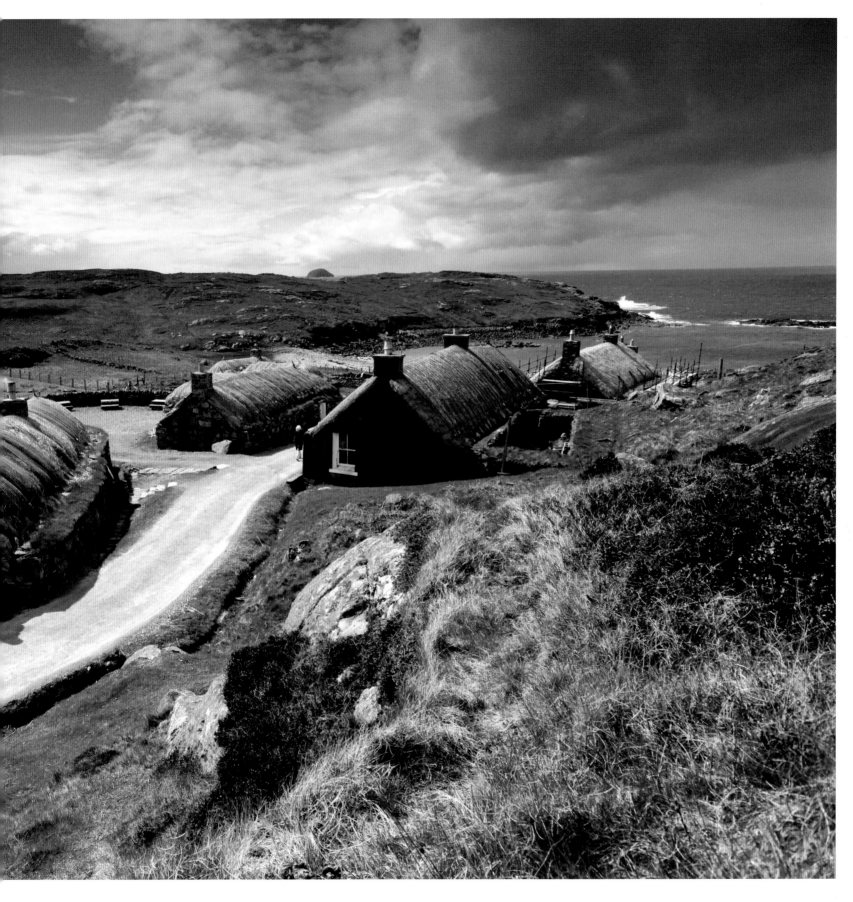

CASTLE TIORAM
WEST HIGHLANDS

On the rocky tidal islet Eilean Tioram (the dry island), in mystical Moidart, the long-abandoned ruin of Castle Tioram (pronounced Cheerum) encapsulates the intoxicating melancholy of this edge-of-the-world seaboard. You don't need to know the sagas of Clanranald which ended in the period before the Jacobite rising of 1745 or the more recent debacles over its conservation or development to sense the history in this place. Though the ruin is closed to visitors, you can cross to it at low tide. The drive here, a short distance from the A861 and the Road to the Isles (the A830 to Mallaig), is one of the most stirringly scenic in the west.

PHOTOGRAPH ROSS GRAHAM

FIND | WALK | EAT | SLEEP **PAGE 219**

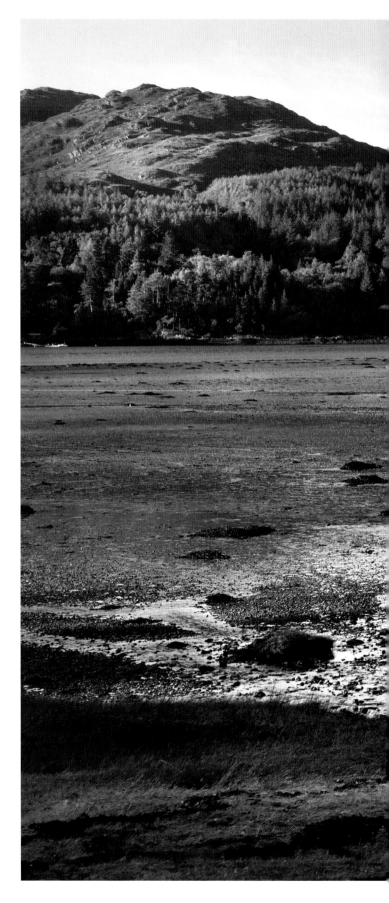

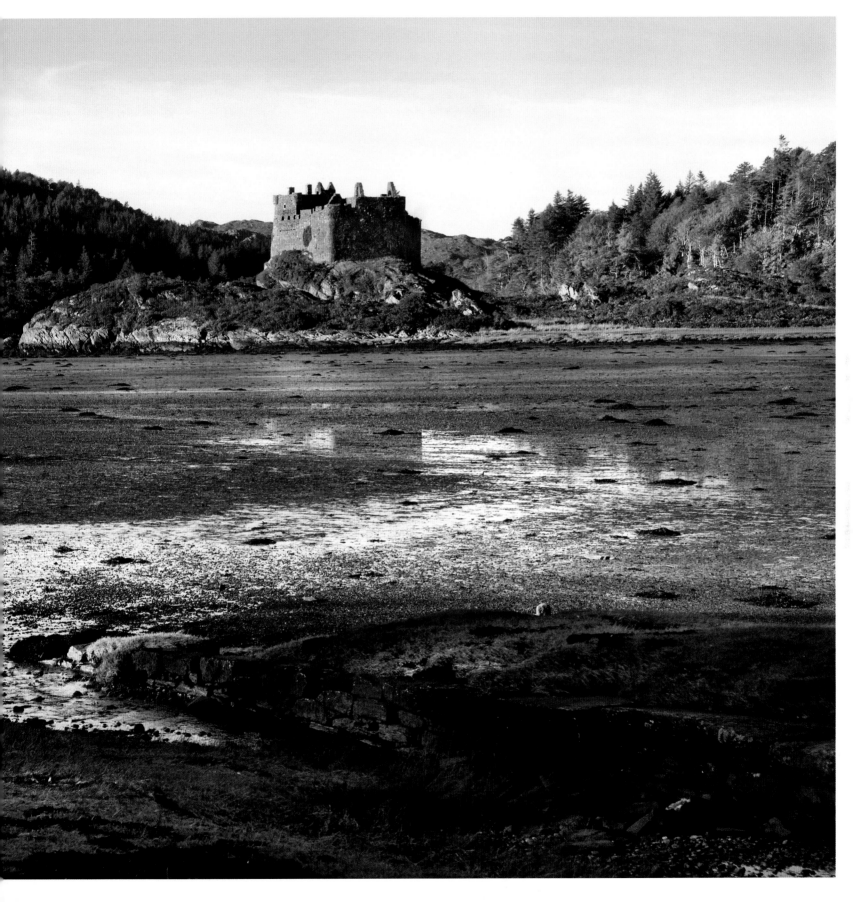

THE CEILIDH PLACE
ULLAPOOL

For over forty years The Ceilidh Place in Ullapool has encapsulated the best of Highland culture and hospitality. Its originality and singular conviviality are as palpable now as when it was first conceived in 1970 in a boatshed as a 'place where not only postcards but life histories would be written'.

This was not merely a fanciful ambition. Under the irrepressible Jean Urquhart, a place for musicians to gather and sing for their supper extended along the street, and became a hotel, a bar and restaurant, performance space, bookshop and then, across the way, a bunkhouse. It is a place for all people: tea on the terrace, a nightcap on the balcony above, the best of live Scottish traditional music, the browsing of Scottish literature. And when posting a photograph like this, a postcard to your world on your phone, you might say with probable conviction: 'wish you were here with me'.

PHOTOGRAPH JANEANNE GILCHRIST

FIND | WALK | EAT | SLEEP **PAGE 219**

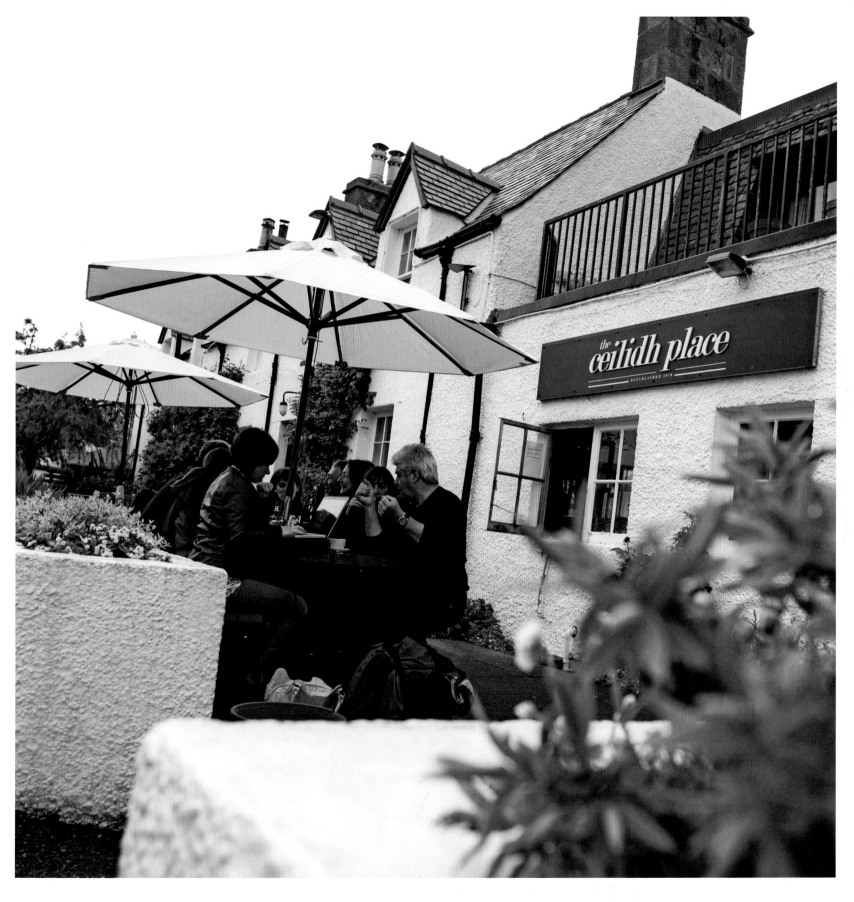

GLEN COE
WEST HIGHLANDS

Probably the most famous glen in the world. To see it for the first time, even from the road that runs through it, restores the awe in awesome.

For mountaineers, climbers and hill walkers and even photographers, Glen Coe is at the heart of a topography that offers a multitude of adventures and challenges. To ascend and walk the Aonach Eagach, the ridge that forms the northern precipitous wall of the Glen, is one of the things you are invited to do before you die; some do. The Lost Valley is easier and Signal Rock a stroll, but there are possibilities at all levels to experience the quietly austere grandeur of the Glen. Unquestionably, this is the Great Outdoors.

PHOTOGRAPH RUSSELL BAIN

FIND | WALK | EAT | SLEEP **PAGE 219**

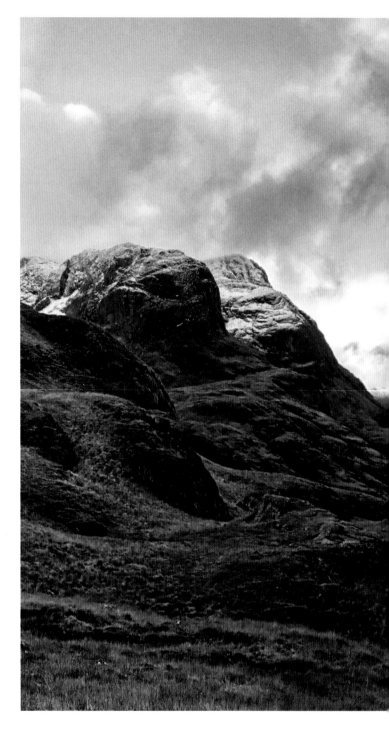

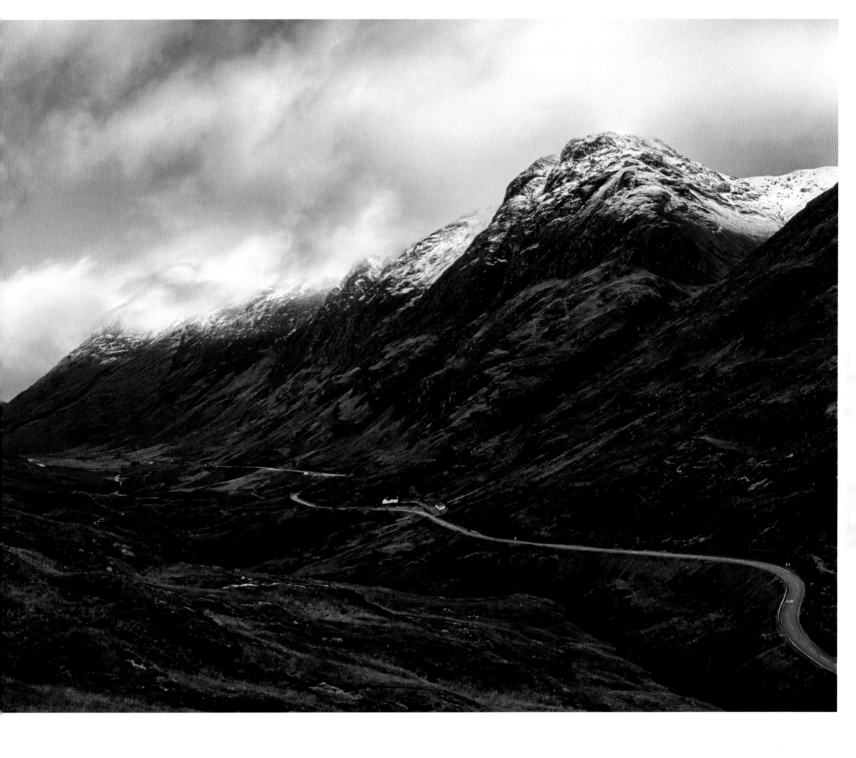

HEBCELT FESTIVAL
STORNOWAY, ISLE OF LEWIS

HebCelt, the annual flagship event of the Outer Hebrides, has been held in July in the grounds of Lewis (Lews) Castle in Stornoway since 1996. Heb is for the Hebrides that stretch from Lewis to Mingulay; Celt for Celtic music, a genre significantly elevated in recent years by the success of Glasgow's Celtic Connections festival in January (see page 140). 'Celtic' does increasingly embrace 'world music', but at its core is the traditional music of the Celtic fringe and the music it inspired in North America. Here on the furthest edge, HebCelt promotes a pure version of it, proclaiming its Gaelic roots (though over the years line-ups have included Van Morrison and The Proclaimers).

Most of the programme is staged in a big marquee which holds 5000 people in the extensive Castle grounds, where it is also good to walk. Within sight of the sea and the ferry by which you probably came, the Festival takes over the town, a uniquely immersive experience in the music of this place and what they call 'the craic'. www.hebceltfest.com

PHOTOGRAPH **ERIC MACKINNON**

FIND | WALK | EAT | SLEEP **PAGE 219**

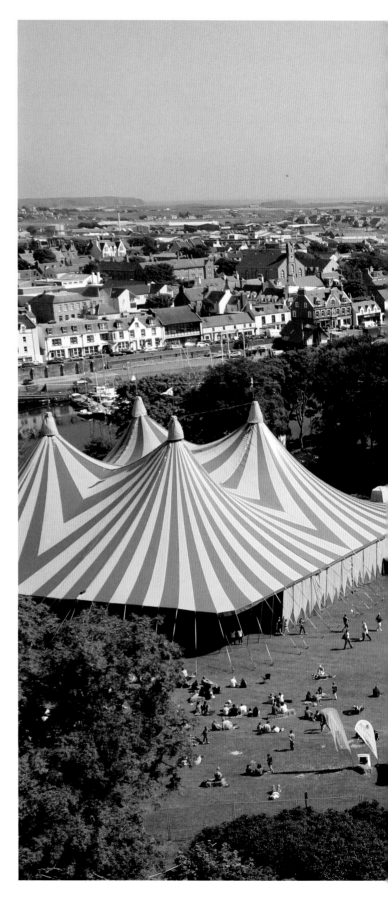

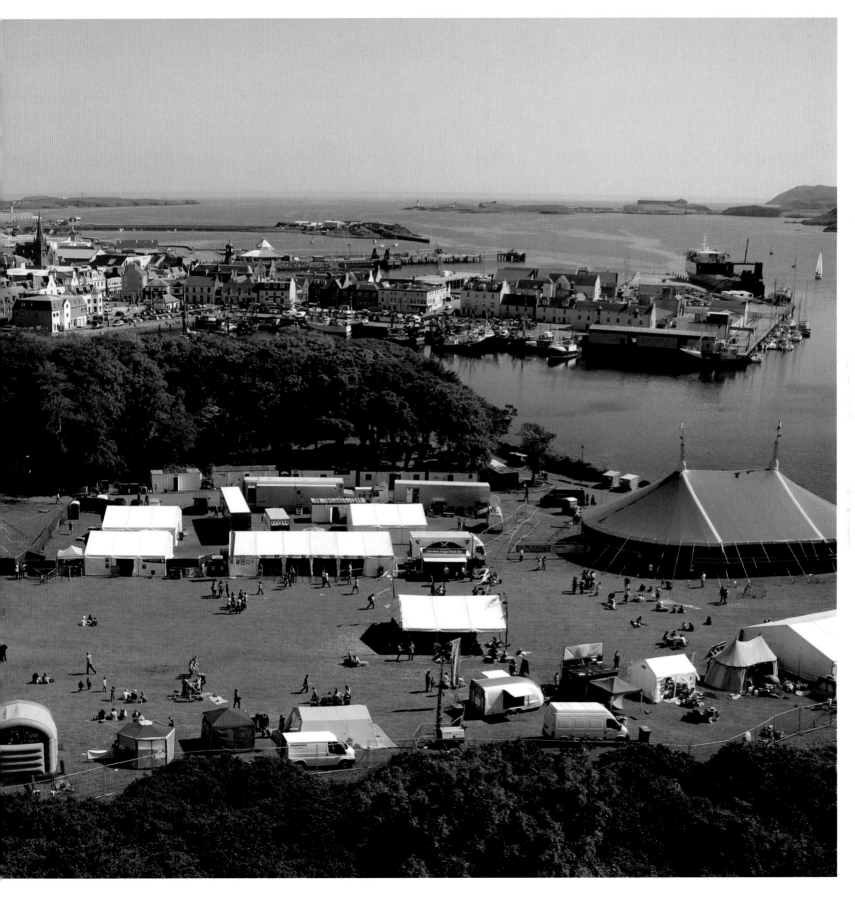

INSHRIACH POTTING SHED
NR AVIEMORE

It is a potting shed in a corner of a garden, but it is quite remarkable. The garden is Inshriach Nursery, a northern garden centre for hardy alpines, rock and border plants since 1938, where gardening still follows the principles of its founder Jack Drake.

But in a flash of entrepreneurial inspiration from the now owners, the Borrowmans, a love of birds and an accomplishment with cakes have combined to propel Inshriach's backyard into the forefront of memorable days in Rothiemurchus. The shed is now a tearoom/cake shop and viewing gallery. Outside, soundless behind the glass, though here we see only a fraction of the fracas, an ever-changing commotion of birds (and red squirrels) materializes from the surrounding woodland to feeders in the trees. It's mesmerizing! RSPB members voted it one of the best places to see wild birds in the UK. These cakes, those birds: exquisite and irresistible.

PHOTOGRAPH JANEANNE GILCHRIST

FIND | WALK | EAT | SLEEP PAGE 220

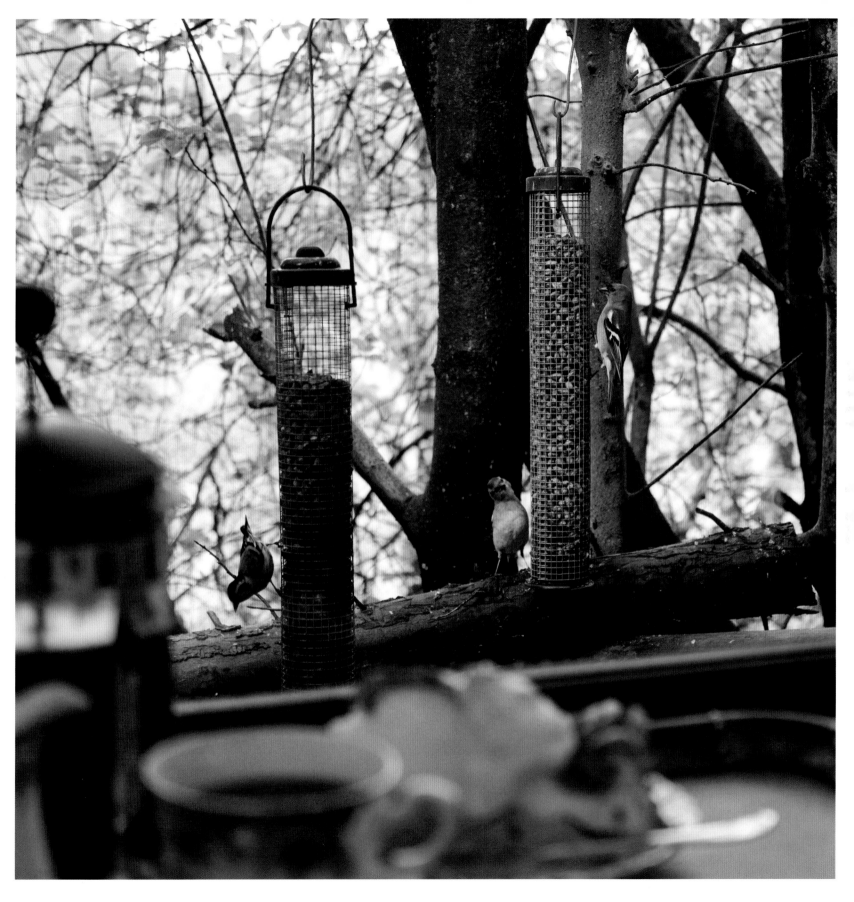

ISLEORNSAY
SKYE

Isleornsay, though a white-cottage village overlooking the tiny island of Ornsay, is more thought of as a cove in a southern corner of Skye, with a hotel that makes the most of its ethereal location. Whether you arrive by boat to the old stone pier or by the short road off the main route through Sleat, you may feel that there is something almost mystic about this shore.

Once a busy herring port and then a stop for steamers from Glasgow, it's a quiet place now, except perhaps in the Praban pub, part of the Eilean Iarmain, the best hotel on Skye for sui generis, not to say generous Highland hospitality. There's a curated art gallery and a classy shop. This is Skye at its most captivating (without the mountains).

PHOTOGRAPH LUCILLA NOBLE

FIND | WALK | EAT | SLEEP **PAGE 220**

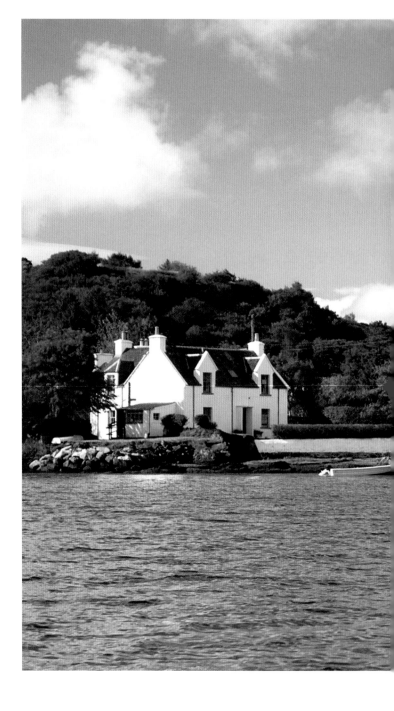

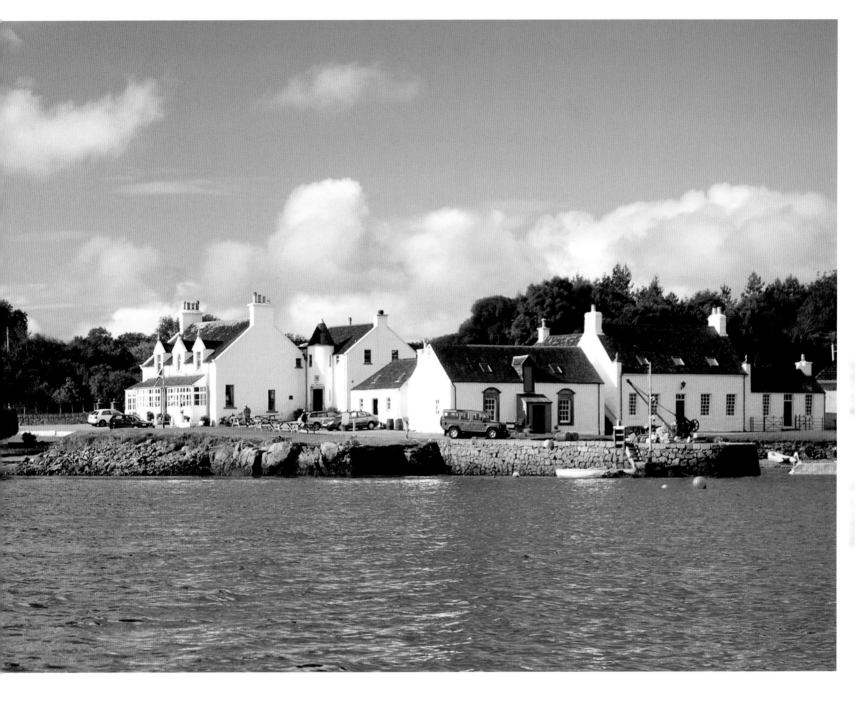

KISIMUL CASTLE AND BARRA
OUTER HEBRIDES

Kisimul sits on a rocky outcrop 200 yards into the bay
guarding Castlebay and Barra, the last of the larger islands
in the Hebridean archipelago. The ancestral home of the
Macneils, you glide past on the ferry and immediately feel
at home here. Built in the 11th century, burned out in the
18th and restored as recently as 1970, it is an essential
pilgrimage for all Macneils and fascinating for all of us
to visit, a forbidding exterior belying an intimate internal
courtyard and rooms betwixt renovation and decay.

Barra and tiny Vatersay, joined by a causeway, are the
perfect size to explore: beaches and bays, a hill to climb
and famed hospitality, not least during Barra Live, a music
festival held at the end of July (though not in 2014).

PHOTOGRAPH **PAUL TOMKINS**

FIND | WALK | EAT | SLEEP **PAGE 220**

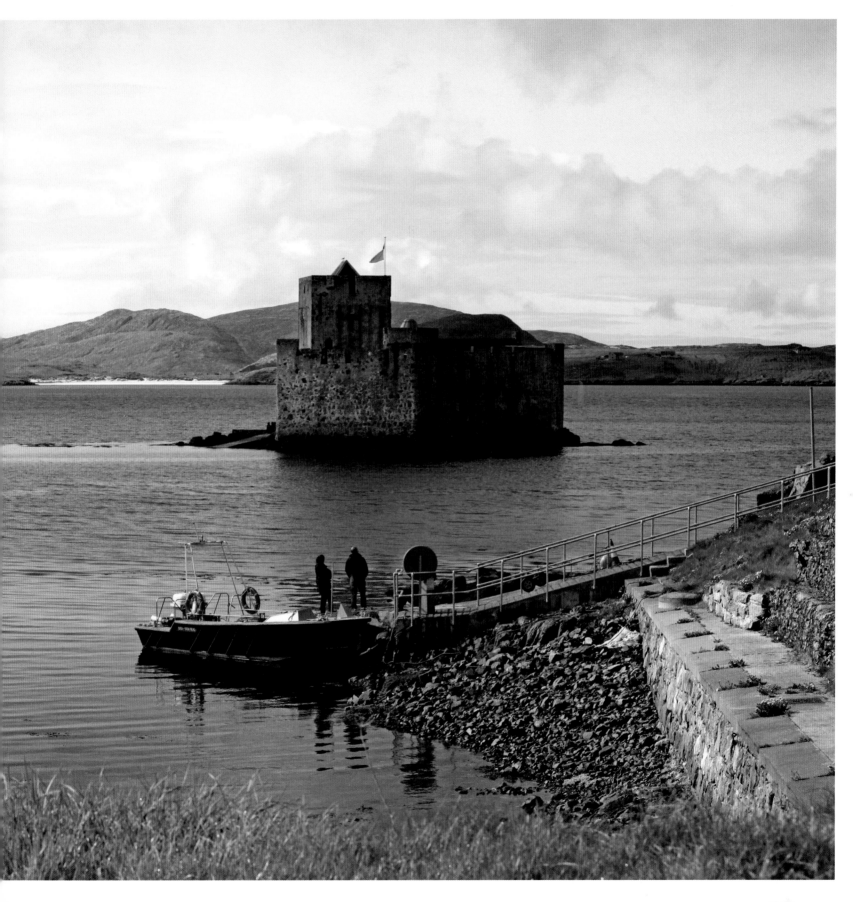

KNOYDART
WEST HIGHLANDS

Knoydart is often said to be Britain's last wilderness. A peninsula over the Sound of Sleat from Skye, between the sea lochs Loch Hourn and Loch Nevis, it's not connected to anywhere by road, so you take the ferry from Mallaig; it can seem like sailing into a painting by Turner. Or you could hike (well prepared) seventeen miles from Kinloch Hourn. Its immensity and remoteness give Knoydart a unique place in Scotland's heart.

The interior, with seven mountains over 2500 ft, attracts walkers and anyone who needs to get away from it all, but the village of Inverie (where you arrive at the new quay from Mallaig) has an inimitable charm and a great pub. It's also the home of the Knoydart Foundation www.knoydart-foundation.com which will tell you everything you need to know and set you on the right paths.

PHOTOGRAPH **MURDO MACLEOD**

FIND | WALK | EAT | SLEEP **PAGE 220**

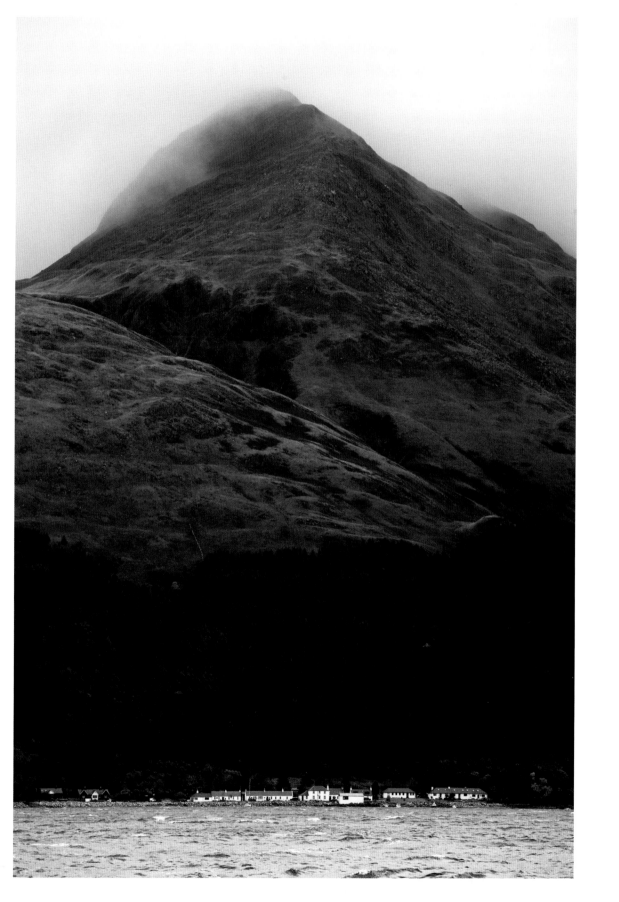

THE MACHAIR
OUTER HEBRIDES

The Machair (or Machar) is not a place but a habitat –
one of the rarest in Europe. A combination of a wet and
windy climate, sand rich in shell fragments, and a gentle
agronomy born of crofting culture nourishes a unique carpet
of grasses and flowers almost only found in certain parts of
northwest Scotland. The Uists, and especially South Uist, are
the best places to experience it.

In summer it is a sea of delicate wild flowers and those from
old crops like black oats and rye. The machair is also home
to the great yellow bumblebee and the elusive corncrake.
If you are lucky enough to hear its distinctive krek krek call
or see the swallows high in a wide blue sky and the sea
shimmering in the distance as you walk through a rippling
field of flowers, and there's nobody around for miles, well,
… you're in a good place.

PHOTOGRAPH LYNNE EVANS

FIND | WALK | EAT | SLEEP PAGE 220

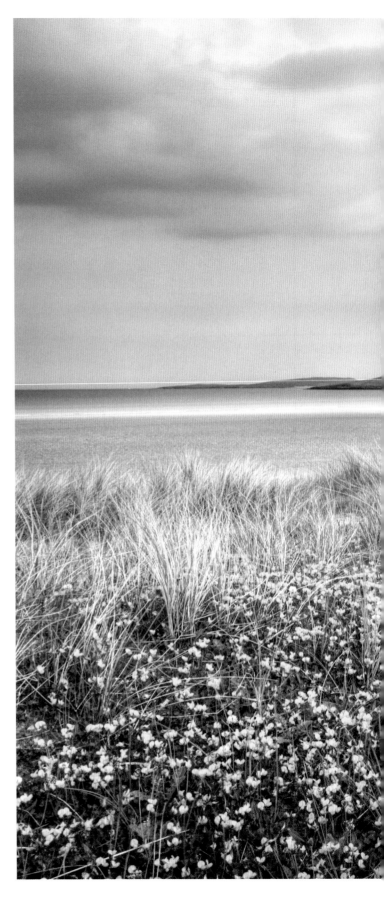

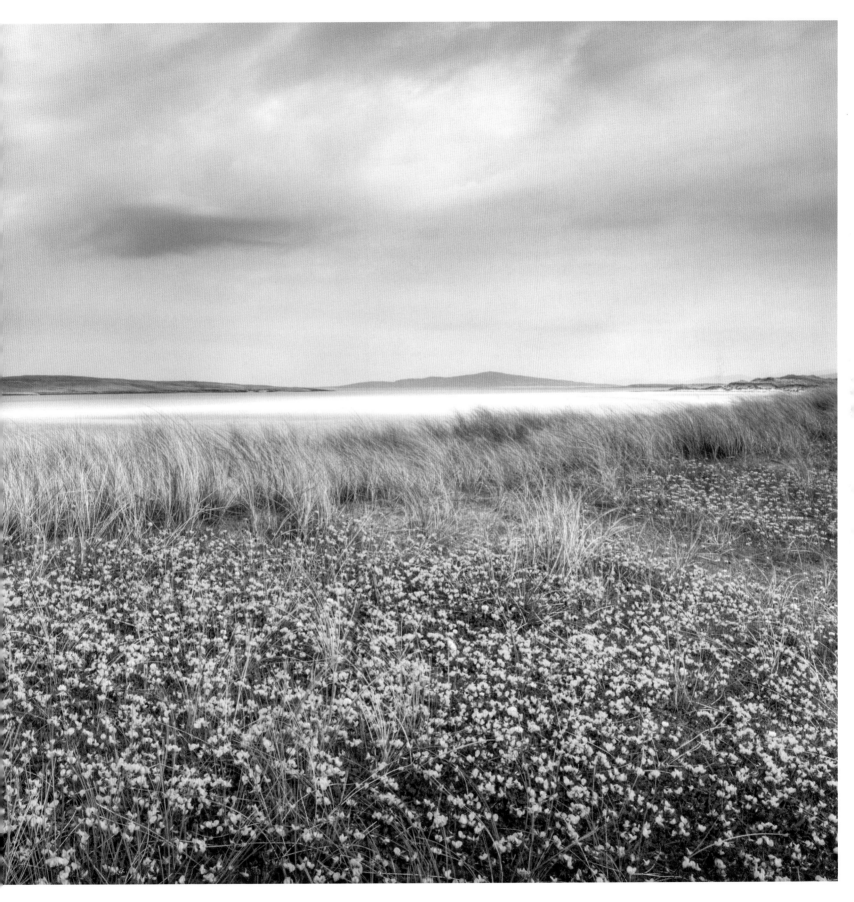

OLD MAN OF STORR
SKYE

This spectacular pillar of basalt, the highest point of the splendid Trotternish Ridge, is eminently visible from the road north of Portree. On an island renowned for inspirational and challenging landscape, this is one of Skye's defining geological wonders. Easily accessible from the car park on the road, it's extraordinary from near or far, and impressive equally on a clear day or through Skye mist and squall: it is a photographer's dream.

PHOTOGRAPH **DAVID EUSTACE**

FIND | WALK | EAT | SLEEP **PAGE 220**

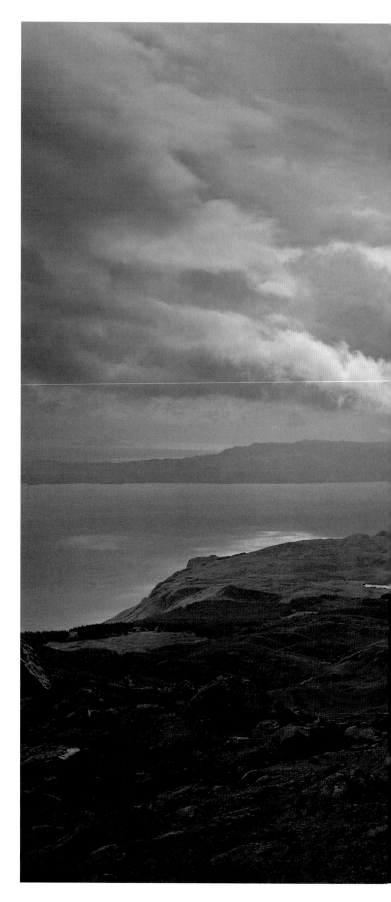

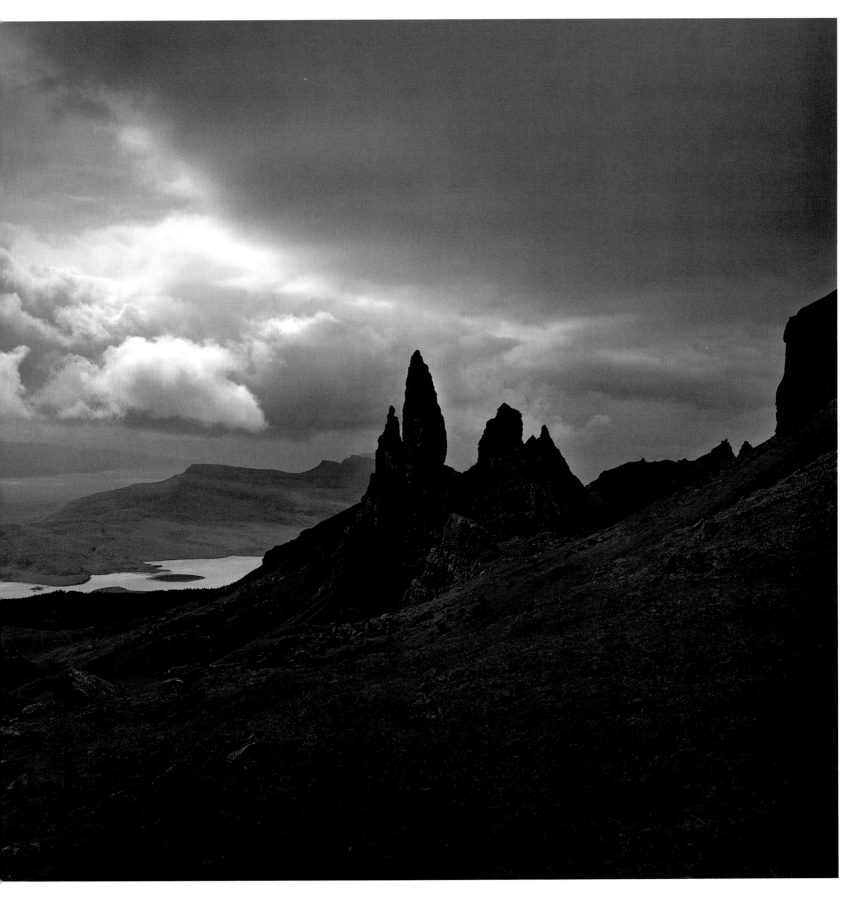

PETE'S BEACH
SUTHERLAND

It's not often you get a chance or have the cheek to name a beach after yourself but when I 'discovered' this one (near Ceannabeinne, an abandoned crofting township) twenty-five years ago, nobody seemed to have a name for it or to see what I saw: the most perfectly proportioned cove with coral-pink rocks and, in summer, turquoise sea. To my mind, this is the finest of all the wonderful, underrated and mostly deserted beaches on the north coast.

PHOTOGRAPH JAMES GRANT

FIND | WALK | EAT | SLEEP PAGE 221

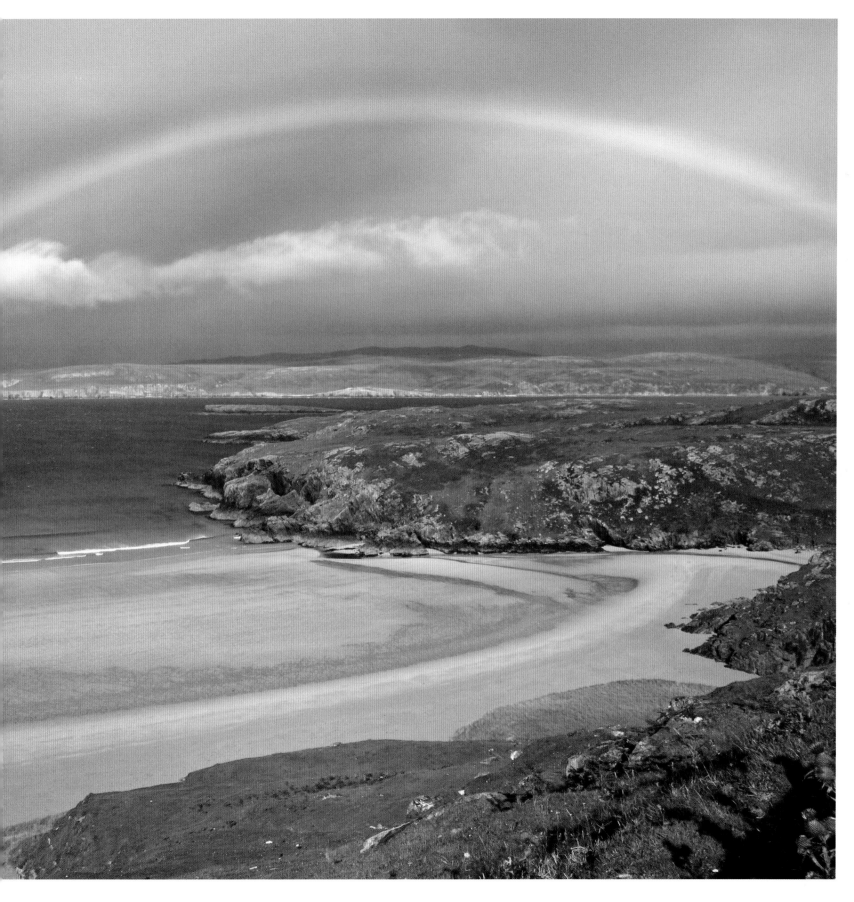

PLODDA FALLS
CENTRAL HIGHLANDS

To the west of Loch Ness through gentle Highland scenery towards mighty Glen Affric (but not quite), your expedition becomes more refined as you reach the quiet conservation village of Tomich and then the last haul into a majestic woodland. Here, deep among the trees, is Scotland's most spectacular sylvan waterfall.

In iced-over winter or wild swimming summer, neither the trails here nor the perspective from the vertiginous viewing platform projecting over the gorge fail to raise the spirits; water spirits especially. The lofty Douglas firs planted on what was Lord Tweedmouth's estate are an echo, like the village, of Victorian patronage and environmental sensibility, long before we knew of climate change. A trunk from this forest was the mast on Captain Scott's *Discovery*.

PHOTOGRAPH **RUSSELL CRAM**

FIND | WALK | EAT | SLEEP **PAGE 221**

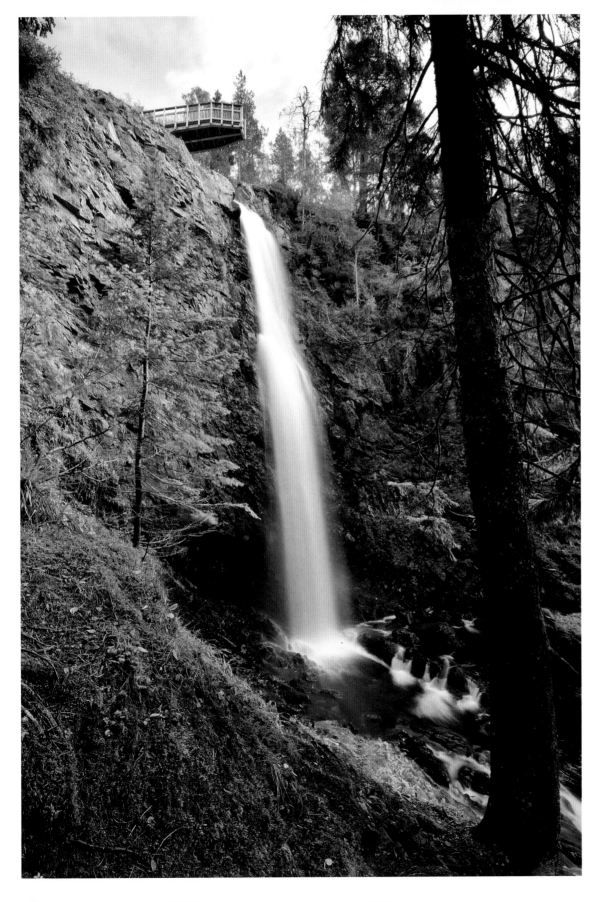

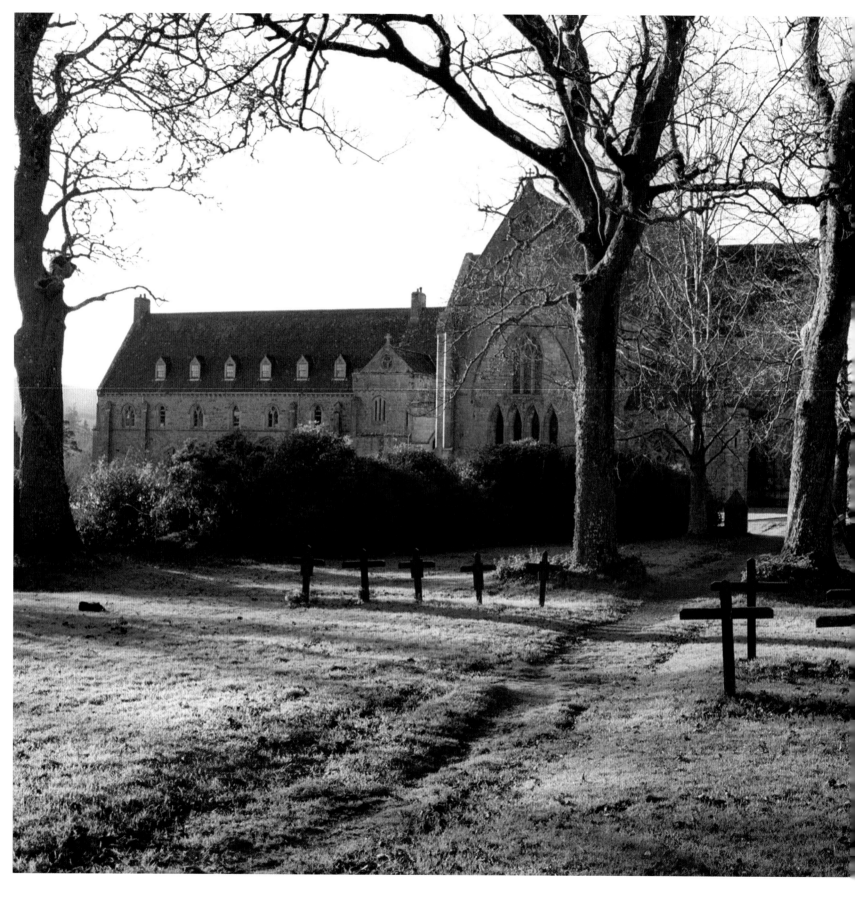

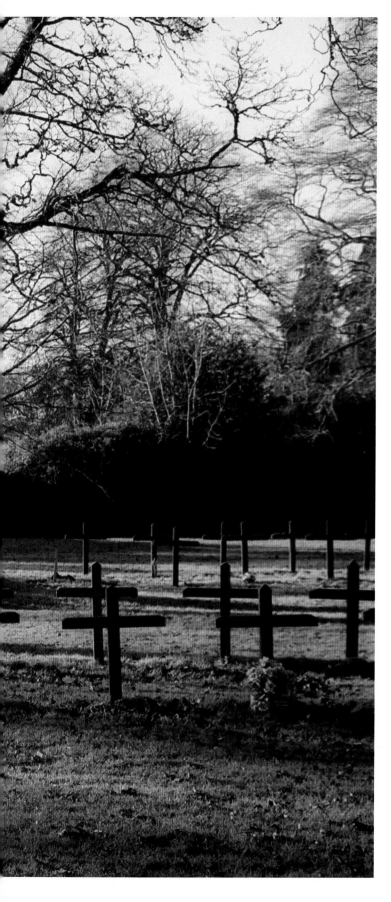

PLUSCARDEN
MORAY

In a sheltered leafy glen, in the Monaughty Forest southwest of Elgin, lies Pluscarden Abbey, a place of pilgrimage from the 13th century, and the only monastery in the UK still inhabited and used for its original purpose. This is a deeply calming place.

The unimposing edifice with honey-coloured walls and splendid stained glass, is home to a working community of Benedictine monks, whose credo is to welcome you. You can properly 'retreat' here for a donation (twelve separate rooms each for men and women) and stay or not, attend the seven services a day that start with Vigils and Lauds at 4.30am and end with Compline at 8pm; their Gregorian chant is mesmeric.

The monks tend walled gardens and bees; there's a simple cemetery under the trees where they are buried, and in this bucolic setting, where the bell rings down the valley summoning you to prayers, you might well ponder your place in the material world.

FIND | WALK | EAT | SLEEP PAGE 221

THE QUIRAING
SKYE

The Quiraing is simply phenomenal. In the far north of Skye, it's easily reached by the A855 from Portree, but the approach on the unclassified road from Uig reveals the full splendour more dramatically. The northern extension of the Trotternish Ridge, these contorted pillars and buttresses of eroded lava are as mysterious as they are astonishing. Gaze from the car park or walk around the 'Pillar', the 'Needle', and the 'Prison'. Fine views also to the island of Staffin and across the bay to Wester Ross.

PHOTOGRAPH **MARCUS MCADAM**

FIND | WALK | EAT | SLEEP **PAGE 221**

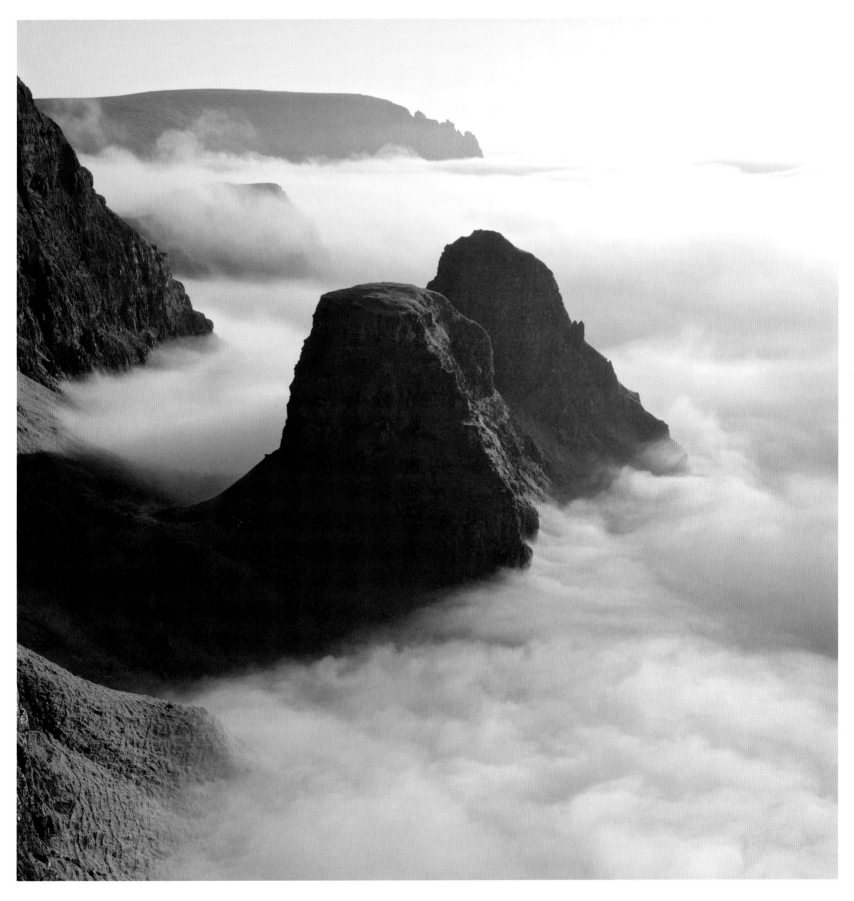

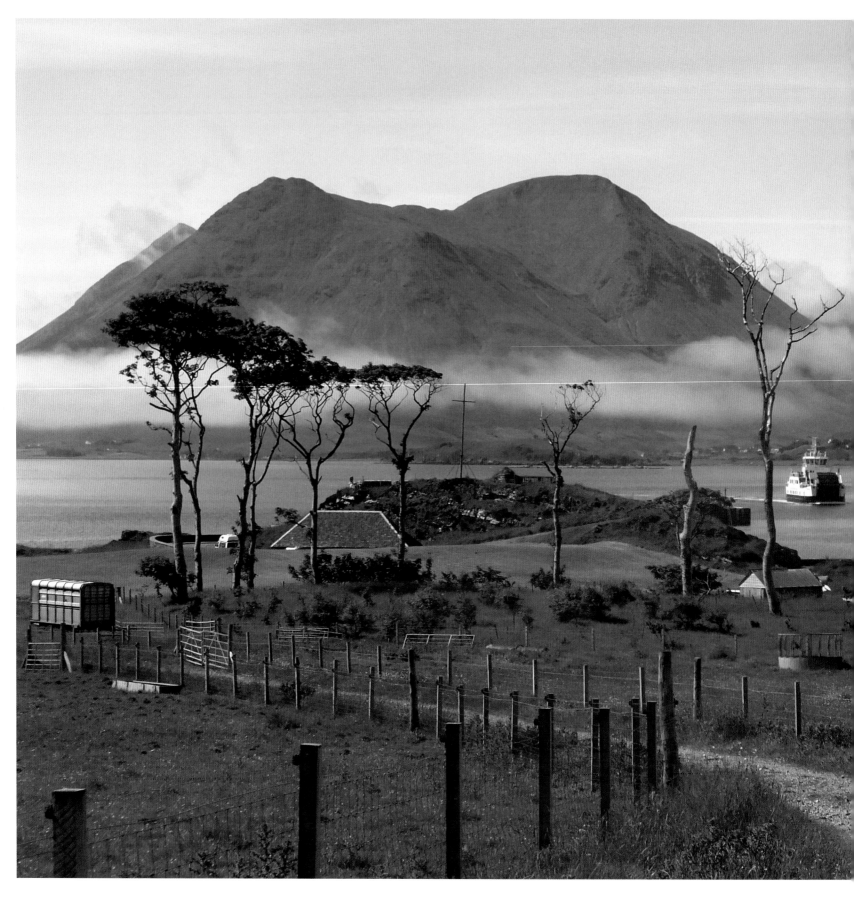

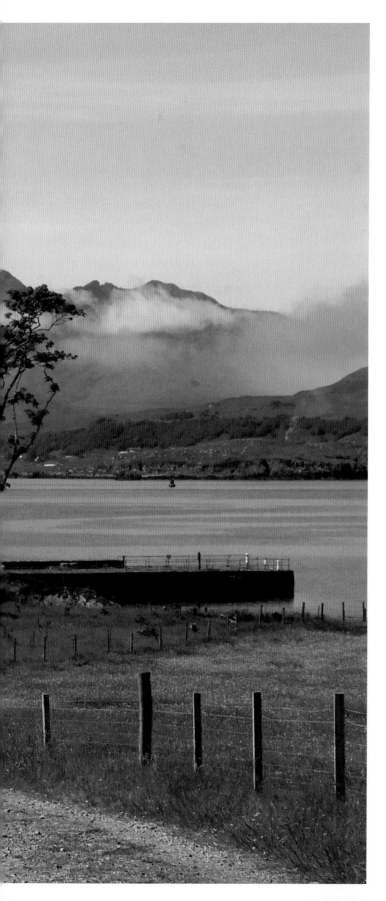

RAASAY
INNER HEBRIDES OFF SKYE

A small ferry transports you from Sconser on the Isle of Skye to this, the best of islands. The distinctive truncated top of Dun Caan presides over a long, narrow island, whose history and natural history is Highland Scotland in microcosm.

Raasay House has been rebuilt after a fire in 2009 and restored as a hotel, hostel, restaurant, bar and, most importantly, an activity centre making the most of its superb location overlooking the Narrows to the Cuillins. This picture is the view beyond the lawn.

If you're staying at the House, or even just visiting for the day, there is much good walking, including, in the north end, Calum's Road between Brochel Castle and Arnish. Two miles long, it was built single-handedly by Calum MacLeod between 1964 and 1974 because Highland Council wouldn't. There's also a village, Inverarish, a lochan with lilies in the woods, and Dun Caan to climb for its sublime views.

PHOTOGRAPH **CAROL ANDERSON**

FIND | WALK | EAT | SLEEP **PAGE 221**

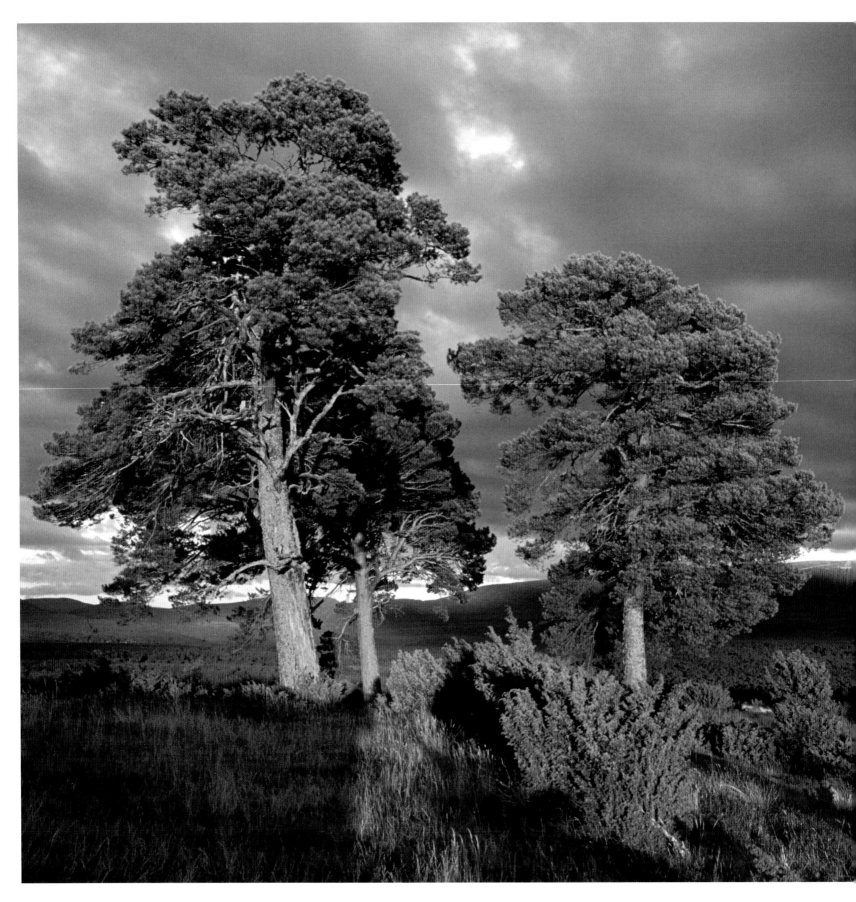

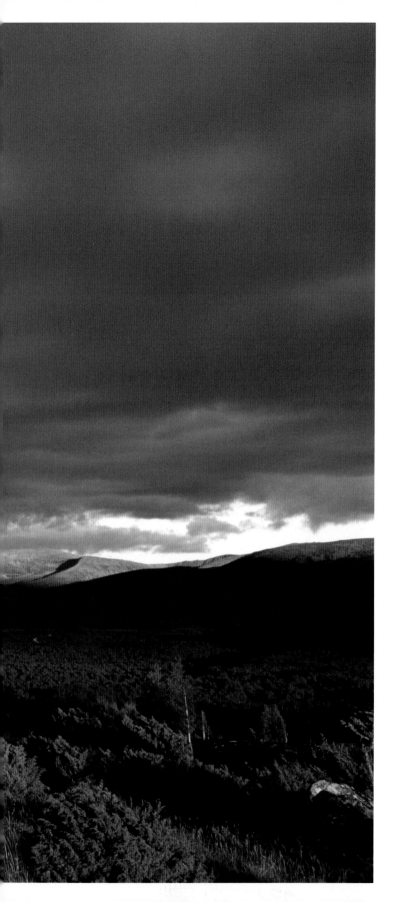

ROTHIEMURCHUS
NR AVIEMORE

Described by Sir David Attenborough as one of the glories of Scotland; a precious place of national importance, Rothiemurchus is at the heart of the Park – the Cairngorm National Park – and is Highland Scotland at its most beguiling. It is a private estate which has been in the same family since the 16th century and is now run and assiduously managed by Johnnie and Philippa Grant. They balance conservation and recreation, caretaking it for future generations, while allowing us, the public, access to some of Scotland's most beautiful land and all the modern-day activities that it now supports.

Conveniently near Aviemore, Rothiemurchus, a remnant of the ancient Caledonian Forest, lies between the River Spey and the Cairngorm Mountains (and its ski resort). Activities radiate from the Rothiemurchus Centre, with over 40 miles of trails, including the walks around Loch an Eilein – widely regarded as Scotland's most scenic loch – and a watersports centre at Loch Morlich. Anyone who loves the outdoors loves Rothiemurchus.

PHOTOGRAPH **RICHARD CROSS**

FIND | WALK | EAT | SLEEP **PAGE 221**

SCARISTA AND THE BEACHES
OF SOUTH HARRIS
OUTER HEBRIDES

Travelling south on the Atlantic coast of South Harris from Tarbert to Leverburgh and Rodel, you pass some of the most breathtaking and pristine beaches in Scotland and possibly the world. Luskentyre is first but it is Scarista that is the most completely aesthetic. The sea scintillates under a wide sky that stretches across the ocean. To wander this far west at sunset is unforgettable; a numinous experience.

PHOTOGRAPH IAN MACRAE YOUNG

FIND | WALK | EAT | SLEEP PAGE 222

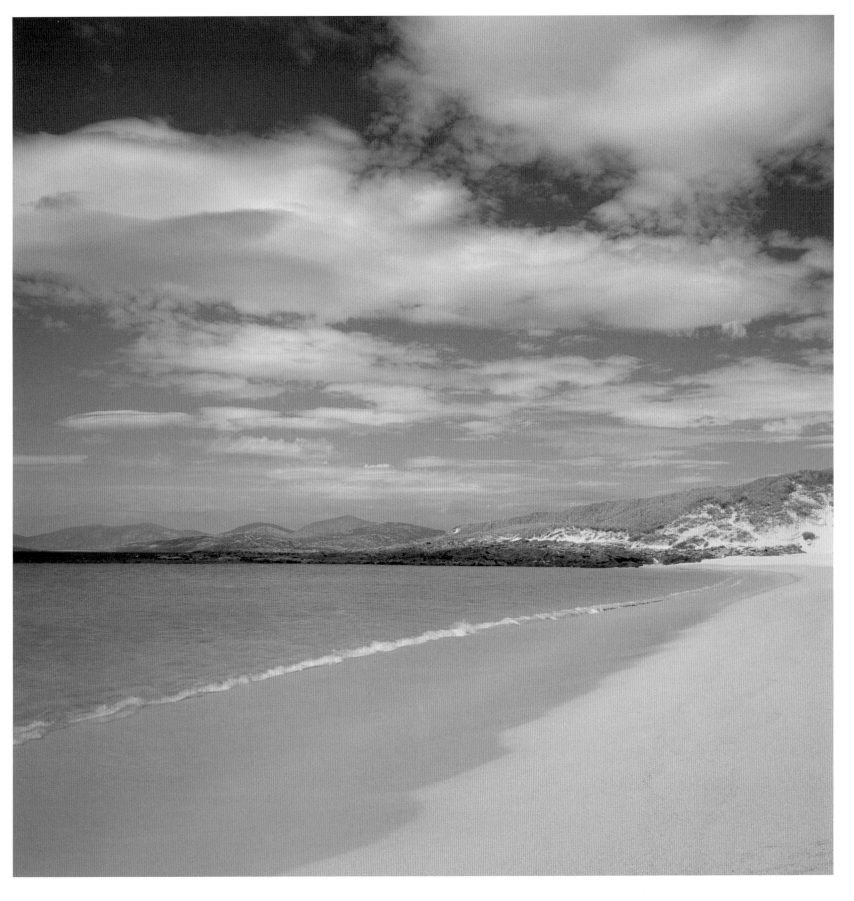

THE SECRET BEACH, THE OLD MAN OF STOER AND THE ROAD TO DRUMBEG
SUTHERLAND

The single-track road north of Lochinver to Kylesku via Drumbeg is one of the most spectacularly scenic in the Highlands. Along the coast, there are many much loved beaches and, with a short detour, this, the venerable Old Man of Stoer. A lesser known spot has no other name, no signposting and often no people: 'The Secret Beach' is just north of Achmelvich (see page 222 for more detailed directions) and a twenty-minute walk from the road following the burn and passing the old grinding wheels of a mill. It's a small, sheltered lagoon with shallow water and the best swimming on this coast.

The Drumbeg road and halfway round the village itself, with its award-winning store and tea garden, is a beautiful drive, cycle or walk in either direction. There are views, especially to Quinag in the north and Suilven going south, round almost every twist and turn.

PHOTOGRAPH **DAVID NOTON**

FIND | WALK | EAT | SLEEP **PAGE 222**

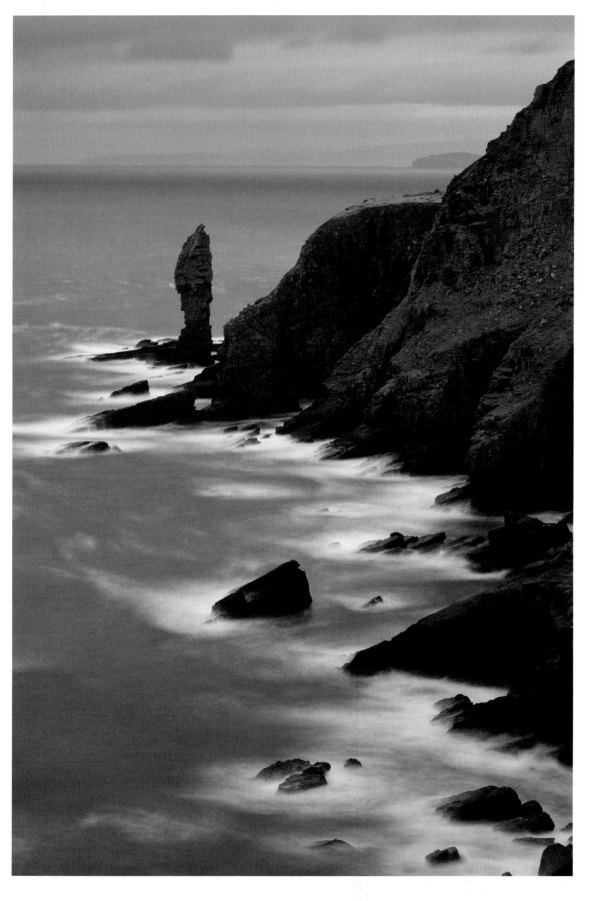

SINGING SANDS, ARDNAMURCHAN
WEST HIGHLANDS

Ardnamurchan offers many natural pleasures and its own quiet splendour. Here in the north of the peninsula around Kentra Bay is the not-quite-singing-but-magical-nonetheless beach of Gortenfern. Whether by wind or walking on it, this sand has been known to sing, though mostly you come to this place at the end of a forest track to beachcomb and contemplate, hopefully swim, possibly sing yourself. It is so remote that it was once an MOD testing ground but these days are long gone in the wind. Now it is quintessentially a quiet place.

PHOTOGRAPH **DEREK FOGG**

FIND | WALK | EAT | SLEEP **PAGE 222**

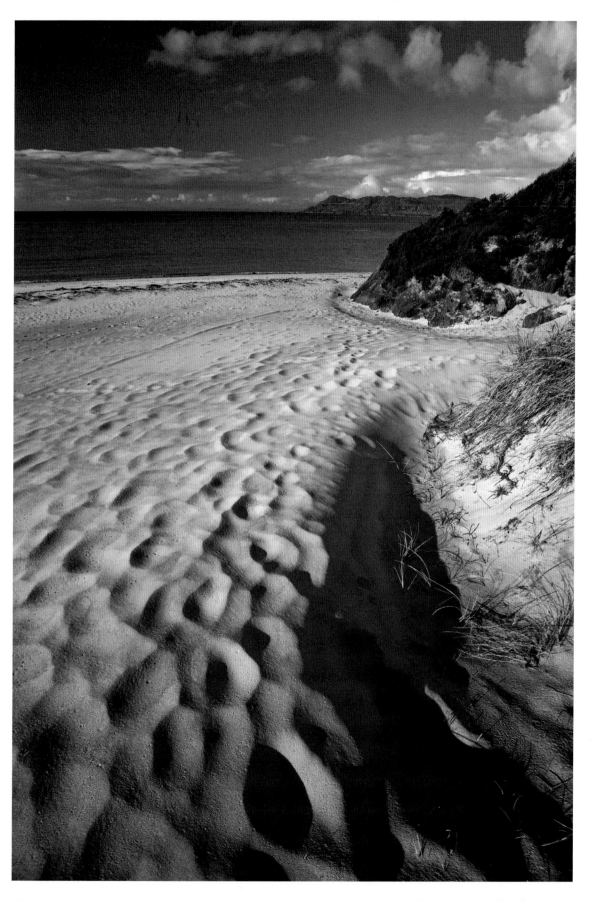

SKARA BRAE
ORKNEY

There is nothing like Skara Brae anywhere else on Orkney
Mainland, or indeed on any mainland. In this remarkable
shoreline site, you look into the subterranean shell of
a compact village that is 5000 years old. First you go
through the excellent visitor centre which presents the story:
six centuries after the village began it was engulfed in a
sandstorm. It lay perfectly preserved until it was discovered
by the laird's dog in 1850.

Now it permits one of the most evocative glimpses of truly
ancient times in western Europe. It is often windy here
and presumably never was one of the most hospitable of
climates or terrains; you can't help thinking how different
and yet how not very different were the fundamentals of life
back then. And how alone and isolated were people for
thousands of years (as you take pics on your phone and
text them to Australia).

PHOTOGRAPH **DOUGLAS CORRANCE**

FIND | WALK | EAT | SLEEP **PAGE 222**

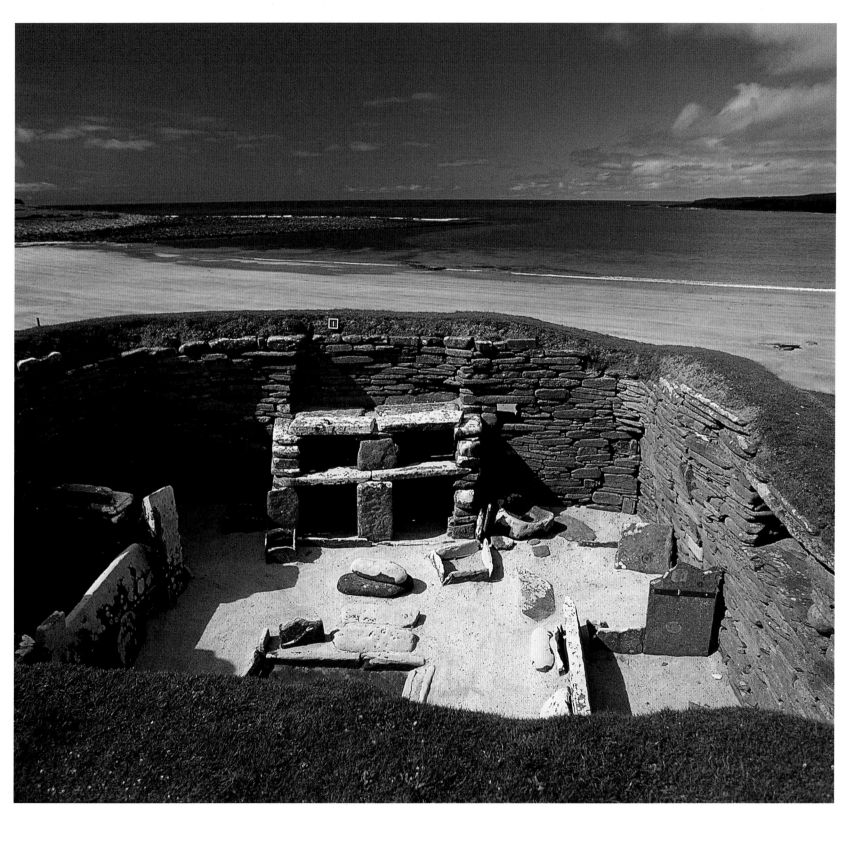

STAC POLLY
HIGHLANDS

Stac Polly or Pollaidh, one of the great Highland landmarks, is variously described as 'preposterous', 'great fun' and just 'perfect'. Its distinctive jagged shape presides over the tantalizing topography of Wester Ross, demanding to be climbed. It's not hard and with easy access from the car park on the road to Achiltibuie, the view of amazing Assynt, revealed as you peep over the rim at the top, is one that will always stay with you.

PHOTOGRAPH RUSSELL BAIN

FIND | WALK | EAT | SLEEP PAGE 222

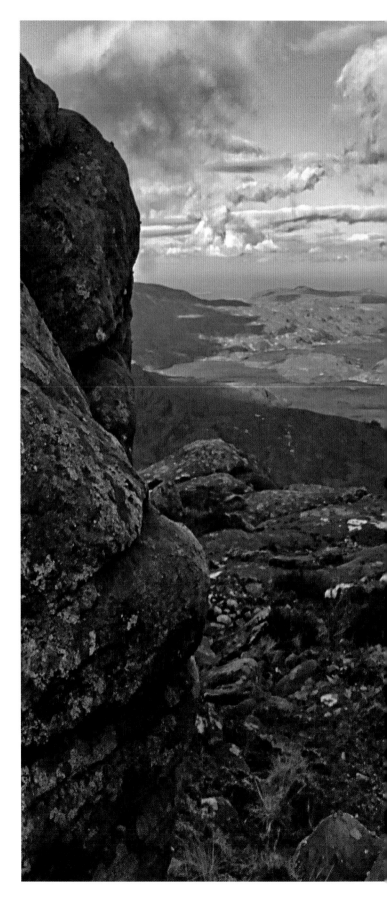

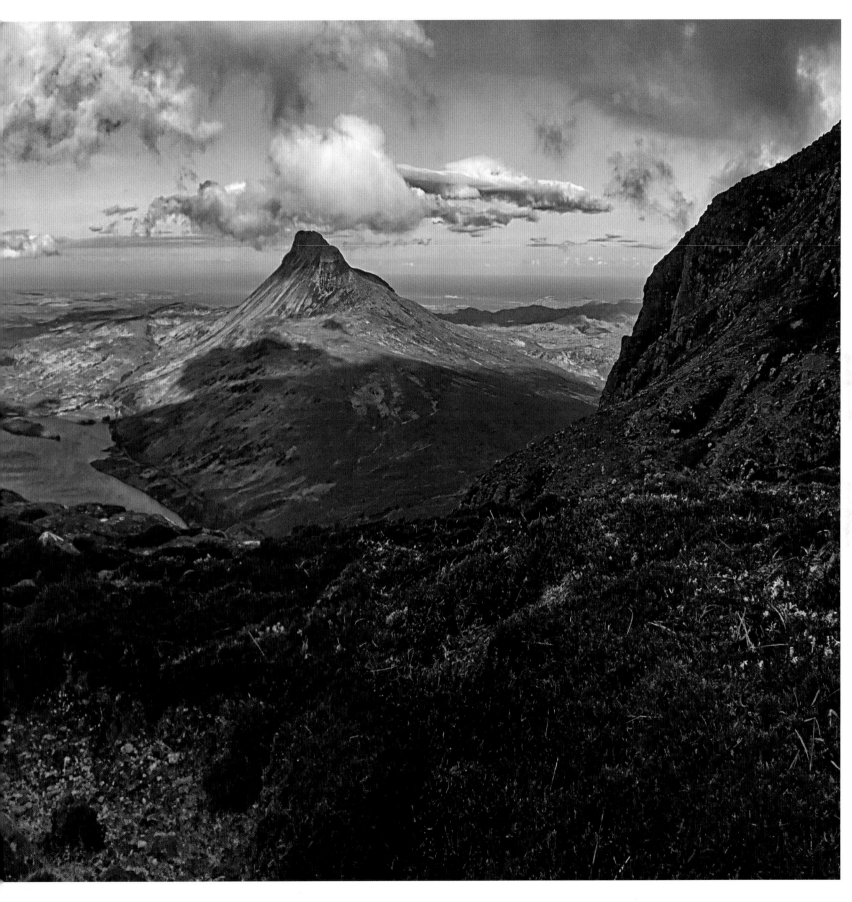

STANDING STONES OF STENNESS
ORKNEY

Orkney Mainland is where to go for the best assemblies of standing stones and prehistoric sites in a landscape that seems hardly touched since yon times. The elegant and enigmatic Standing Stones of Stenness and the nearby Maeshowe, the finest megalithic chambered burial cairn in Britain, are easy to find, a short 500-yard walk from the interpretation centre on the road. Less celebrated perhaps than Callanish on Lewis, there are rarely hordes of folk here to disturb your contemplation.

PHOTOGRAPH **MARK FERGUSON**

FIND | WALK | EAT | SLEEP **PAGE 222**

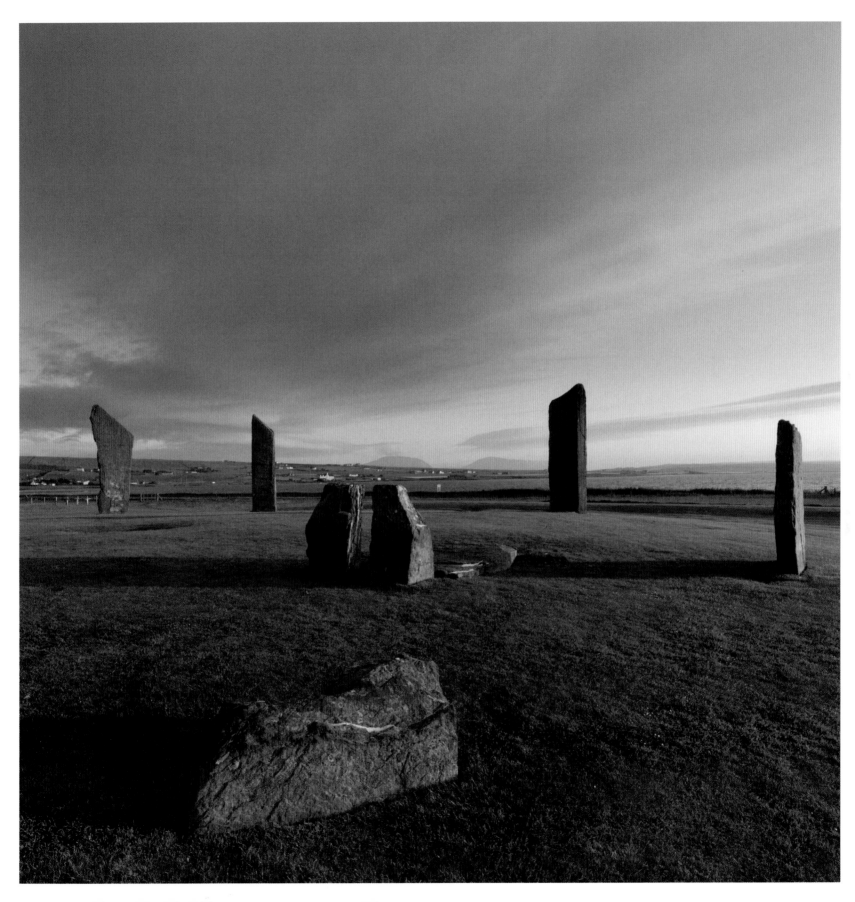

STROMNESS
ORKNEY

Of all the communities on Orkney Mainland, Stromness has the indefinable Orkney 'it'. You are a long way from the real mainland! Though large enough to be in every sense a town, with a harbour and streets and alleys, there is a faraway otherworldliness here that can be enchanting, although at times disconcerting. Of course, that's because you don't live here (only 2000 people do), but Orkney is different and this is a good place to start (the ferry comes here from Scrabster); you also depart for the next large island, Hoy, from here.

Stromness was home to George Mackay Brown, one of Scotland's most lyrical writers; he is buried in the cemetery overlooking Hoy Sound. In this picture, the Pier Arts Centre, one of the most intriguing small galleries in the land, with its notable collection of British contemporary art, fits perfectly into the waterfront. This town is at home with the sea.

PHOTOGRAPH **ALISTAIR PEEBLES**

FIND | WALK | EAT | SLEEP **PAGE 223**

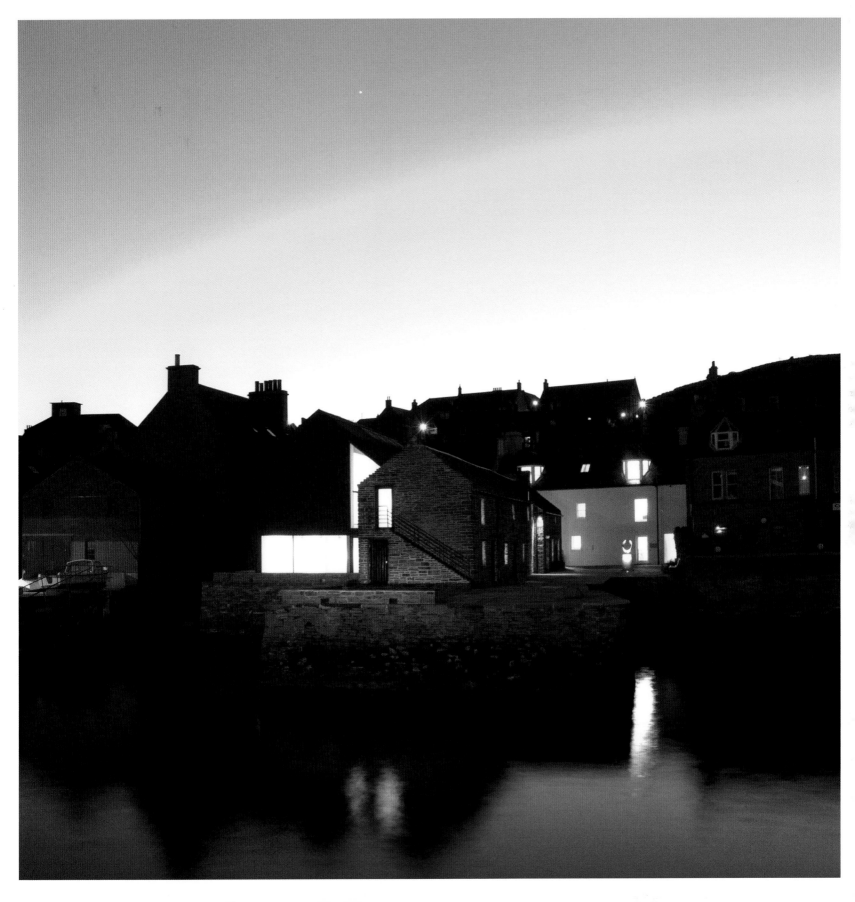

SUILVEN
SUTHERLAND

This most distinctive of mountains, rising so solidly alone from the ragged, watery Assynt landscape, is mesmerizingly magnificent; it has immense presence. Climbing it is no stroll though not difficult (just long), but mostly we admire from afar. The view from north of Lochinver, with the best perspective of its sugarloaf shape, is especially fine. At (only) 2398 ft, it's not a Munro but many think old Suilven is the finest mountain in Scotland.

PHOTOGRAPH MICHAEL STIRLING-AIRD

FIND | WALK | EAT | SLEEP **PAGE 223**

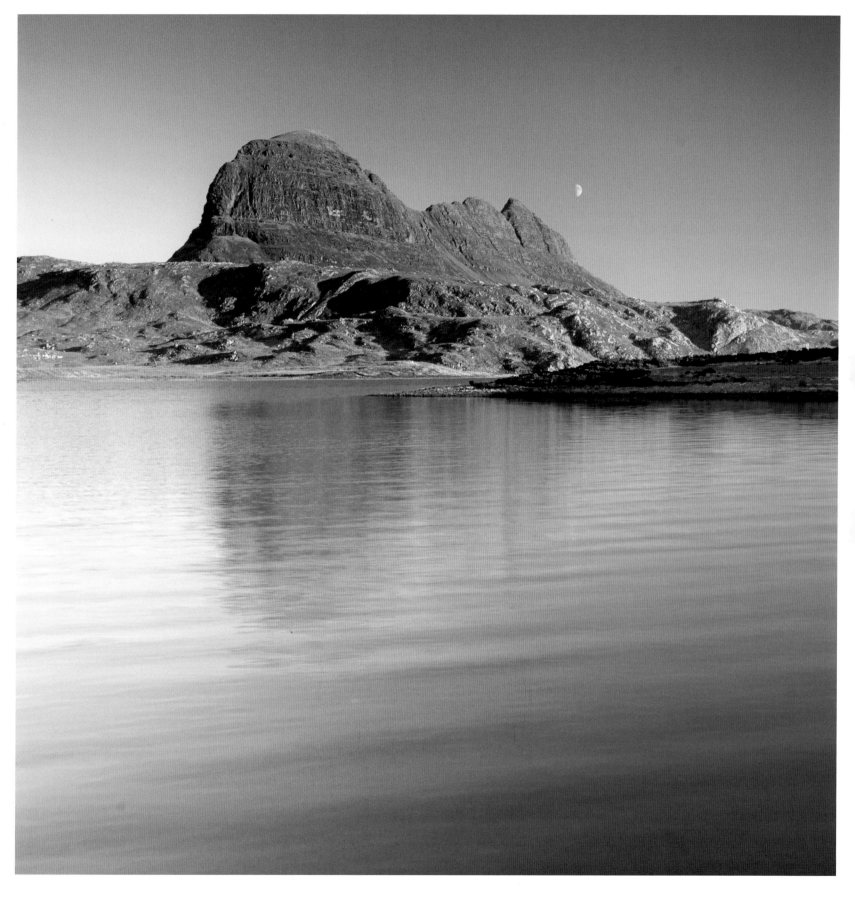

THE SUMMER ISLES
ROSS AND CROMARTY

An archipelago of tiny low-lying islands, the Summer Isles seem almost to be a chimera; a wistful fiction, somewhere we yearn for but cannot go. We can, of course: there are boat trips from Ullapool and Achiltibuie, from where they lie just offshore, but there's only one, Tanera Mòr, the largest, where boats land. It's privately owned (for sale in 2014), and has a café and a post office (and even its own stamps).

But perhaps the Summer Isles are best looked upon rather than landed upon, to remain enigmatic and unattainable in an often glittering sea. They are famously photogenic, especially at sunset. While there are great views all along the Achiltibuie Strand, one of the most memorable (this one) is further along, beyond Altandhu (see Directory). Or arise and go now, take a small boat and a tent (there are eighteen isles to choose from), and find your own 'Innisfree'.

PHOTOGRAPH **DUNCAN ANDISON**

FIND | WALK | EAT | SLEEP **PAGE 223**

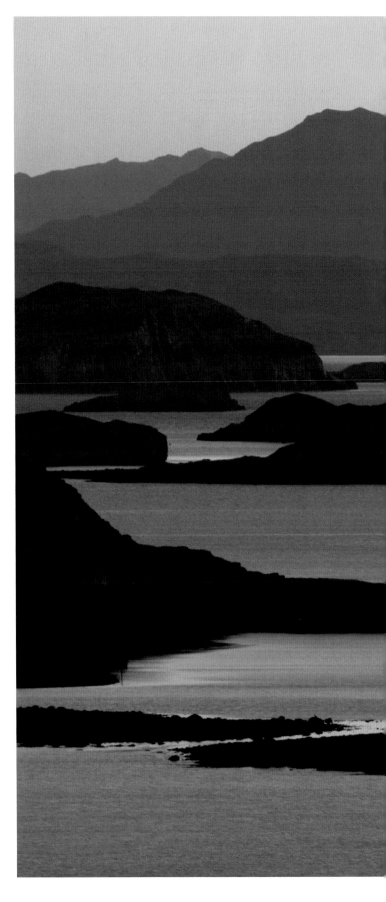

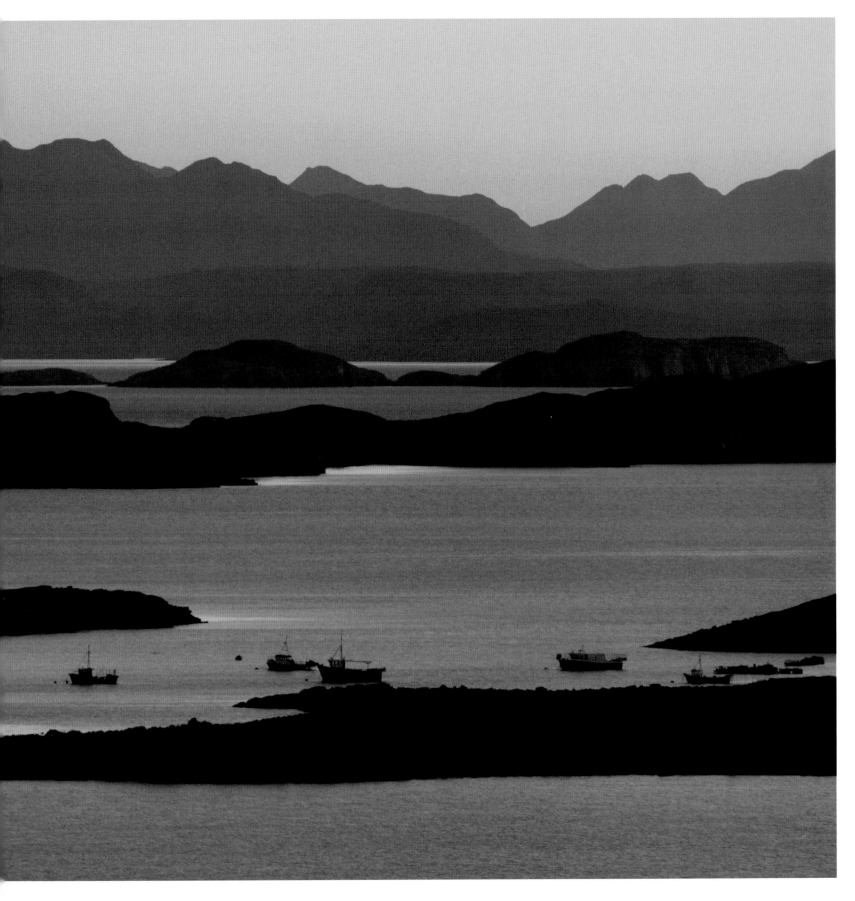

THE TORRIDON MOUNTAINS
WESTER ROSS

The Torridon Mountains in Wester Ross are the most dramatic and ancient mountains in Britain, whether from above, below or far away. Carved from the oldest rocks in the world, Torridon sandstone on Lewisian gneiss, they stand between Loch Maree and Little Loch Broom south of Ullapool.

Individual and complex, Beinn Alligin, Beinn Dearg, Beinn Eighe and, paramount, Liathach (3461 ft), all rising to the north of Glen Torridon (and the A896 road running through it), are the Torridon peaks per se, though Slioch, overlooking the fabled and much photographed Loch Maree, and the highest and mightiest of the lot, An Teallach, further north, have the same grandeur and Torridon aspect: broken summits, spurs and terraces, and steep gullies. They are mountain castles in the air.

PHOTOGRAPH **MICHAEL STIRLING-AIRD**

FIND | WALK | EAT | SLEEP **PAGE 223**

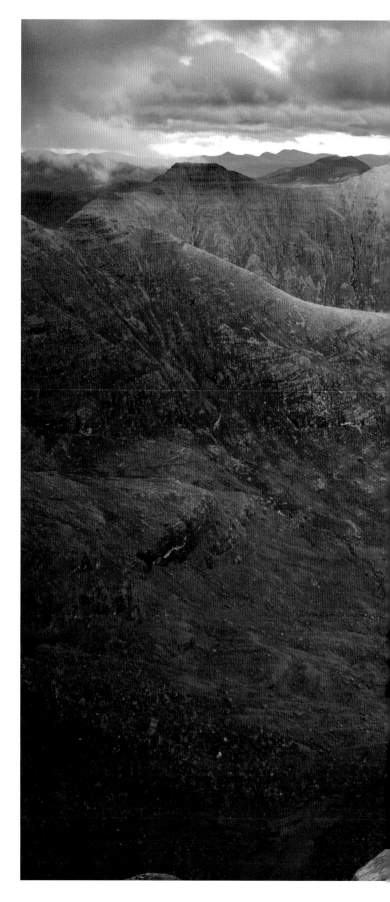

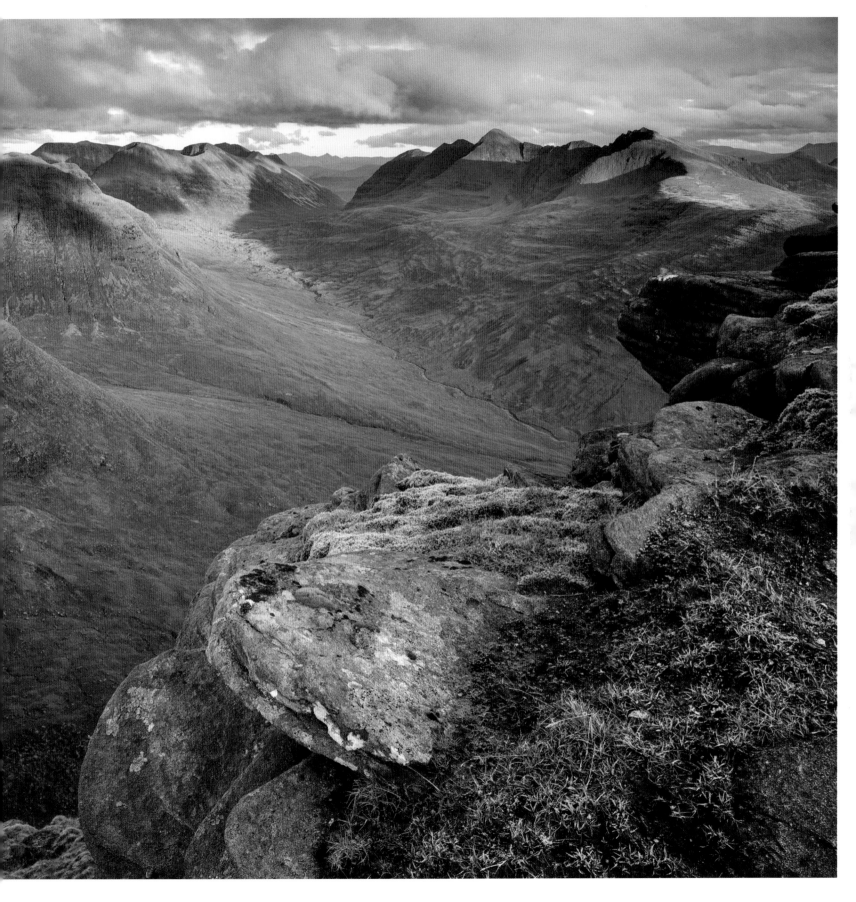

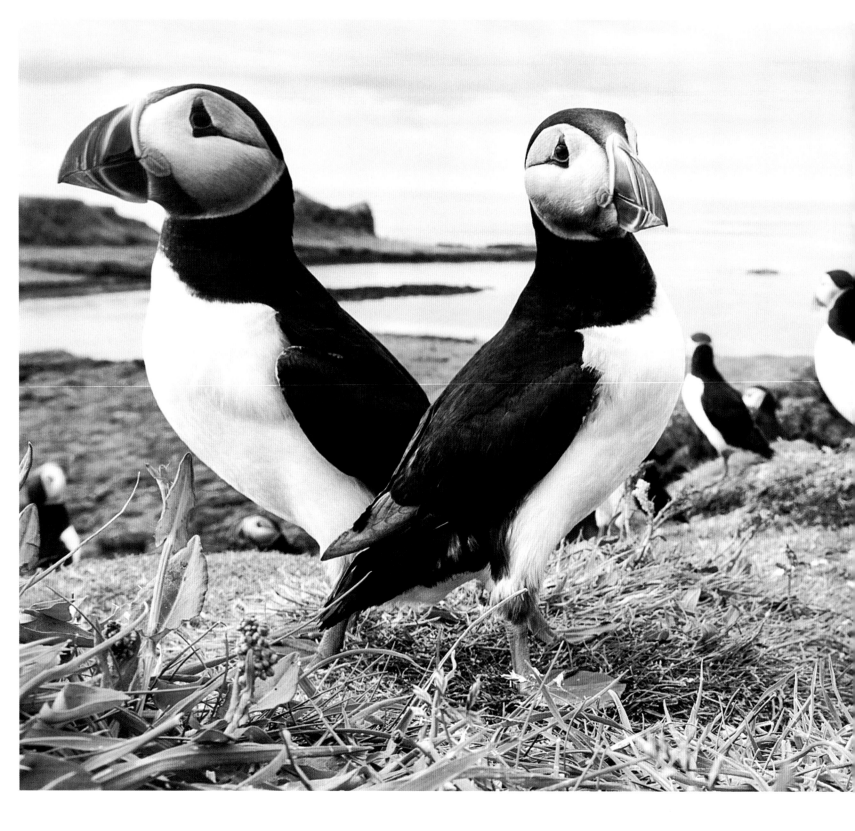

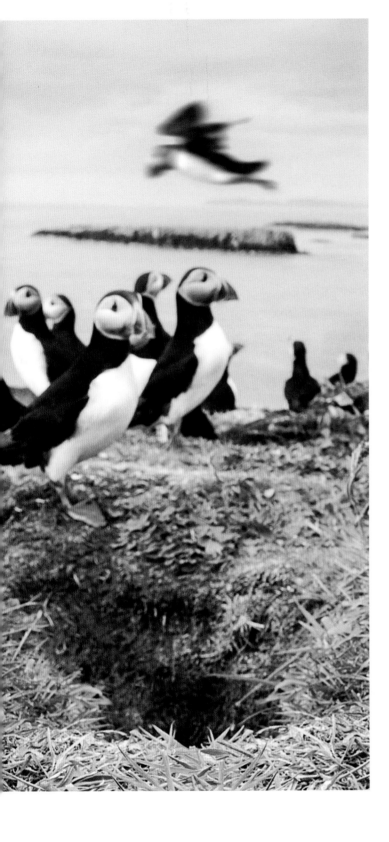

THE TRESHNISH ISLANDS
WITH THE PUFFINS
INNER HEBRIDES OFF MULL

To hang out with the puffins, especially here on Lunga, one of the Treshnish Islands to the west of Mull, is one of the great joys of early summer. Lunga, the largest of this small archipelago, is home to thousands of seabirds: guillemots, razorbills, skuas, but it is the Atlantic puffins, thriving here (though declining in some other places), that are so loved by everyone who lies among them in their clifftop colonies as they go about their waddling ways. The most striking and comical of seabirds, they are apparently oblivious to our presence. It's a kind of therapy. Puffins are only here from mid-April to August; they soon disappear back to the ocean. The single chick, hatched in its burrow, leaves in the night after six weeks, paddling out to sea, and doesn't return to land for years. They are in every way amazing!

PHOTOGRAPH **NICK GARBUTT**

FIND | WALK | EAT | SLEEP **PAGE 223**

UP HELLY AA
SHETLAND

Unique to Shetland, Up Helly Aa is a spectacular party where up to a thousand 'guizers' process through the streets of Lerwick with giant burning torches and then throw them into a replica of a Viking galley bonfire. They've been doing this since 1881 and even with the advent of more recent health and safety regulations, which have put paid to many other traditional celebrations, Up Helly Aa goes from strength to strength.

For the 'Procession', the main event of a day which starts before dawn with the 'Proclamation' and goes on at ticketed parties and throughout the town well into the night, all the street lights are extinguished. For Shetlanders, whose winter nights are as long as their summer days, Up Helly Aa is a defining moment: their Norse past and the confident assertion of a living culture are different to and independent of anything on a distant Scottish mainland.

PHOTOGRAPH ANDY BUCHANAN

FIND | WALK | EAT | SLEEP PAGE 223

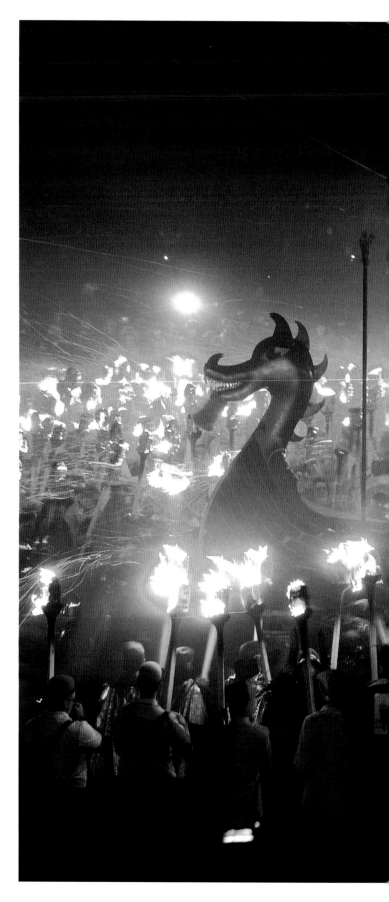

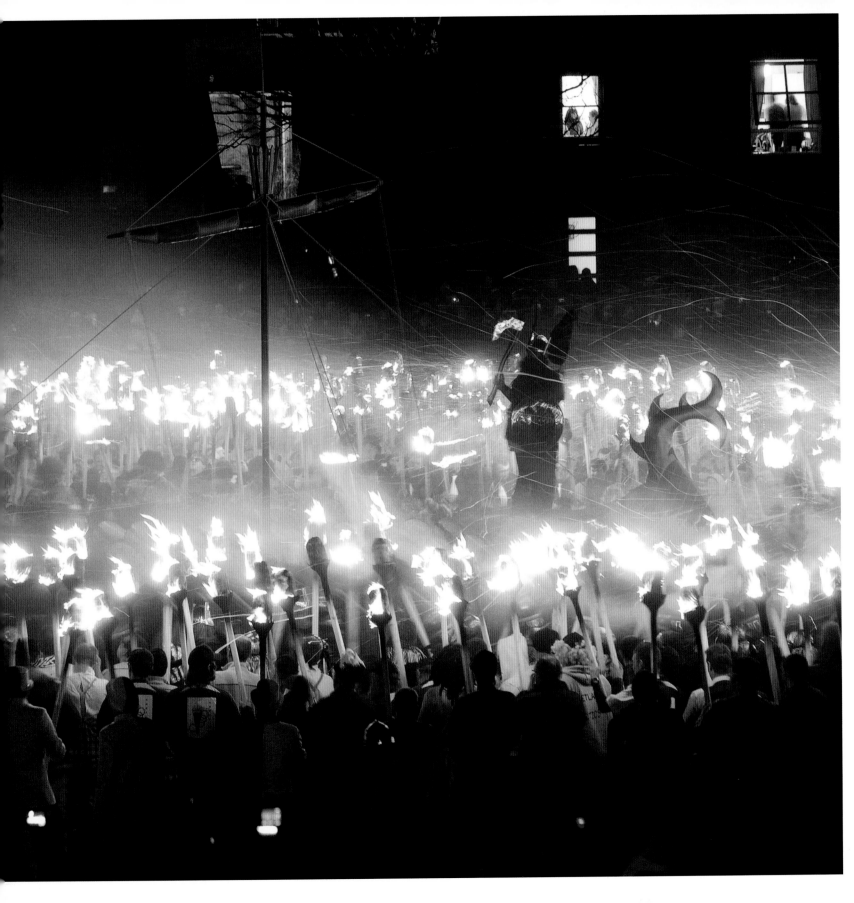

ANGUS'S GARDEN NR TAYNUILT
ARGYLL

This poignant, semi wild garden is off the beaten track
and off many of the garden guides to Argyll; it's all the
better for going unnoticed. It was coaxed and reconfigured
from a gentle hillside overlooking a loch with views to
Ben Cruachan and Glen Etive by the parents of Angus
Macdonald, a journalist killed reporting the war in Cyprus;
the garden was made in his memory.

You are free to wander among a joyously informal mix of
shrubs and trees, especially rhododendrons and azaleas;
the loch brimful of lilies, ducks and swans. Usually there's
no one else around; it's hard to conceive of a more fitting
remembrance.

PHOTOGRAPH PHILIP LOVEL

FIND | WALK | EAT | SLEEP **PAGE 224**

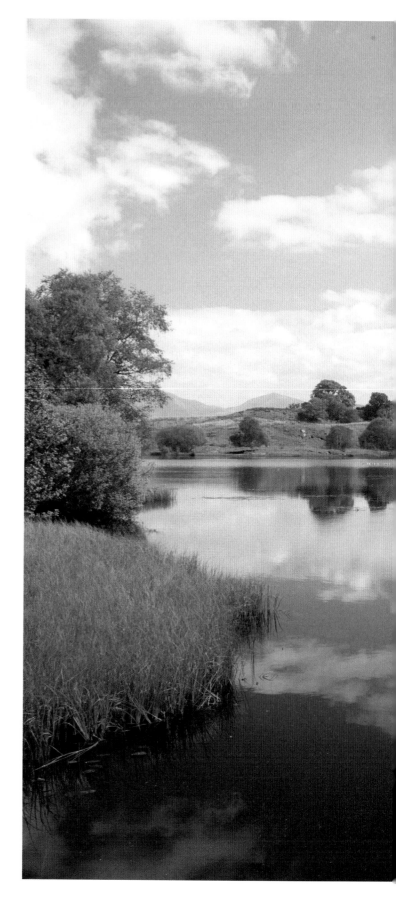

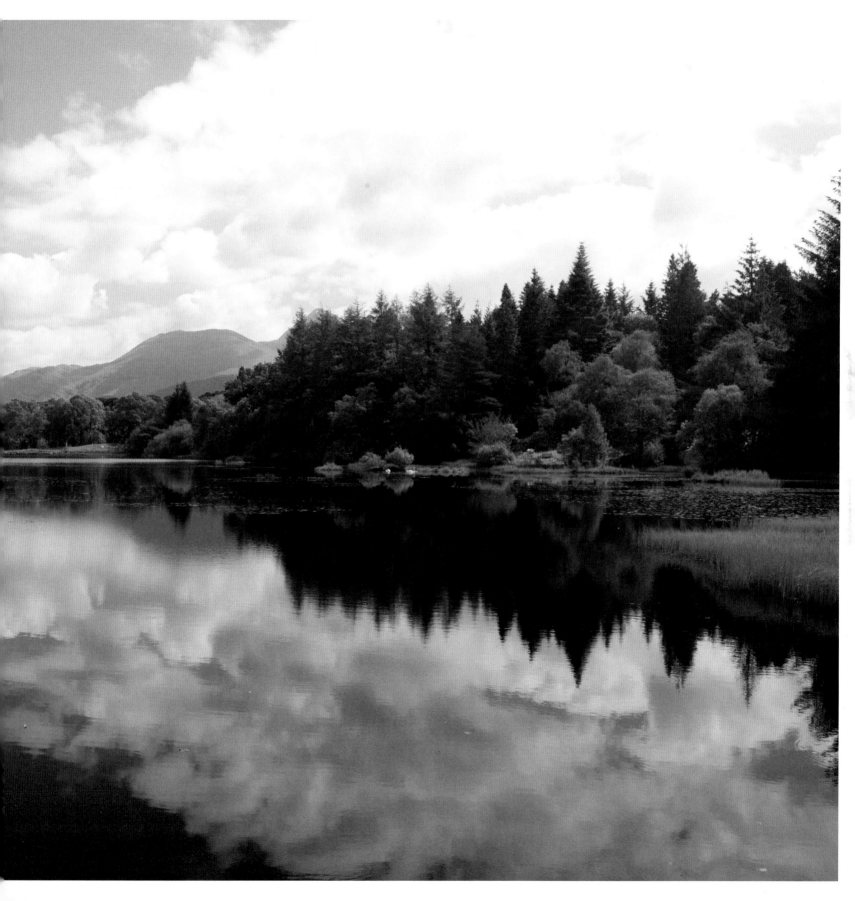

BARROWLANDS
GLASGOW

Once it really was a ballroom, above Glasgow's famous indoor and outdoor market – the Barras – in the city's East End. Rebuilt after a fire in 1958, it became notorious in the late sixties as the stalking ground of a serial killer dubbed 'Bible John' who picked up girls on the dance floor and murdered them on the way home. No one was ever charged but the dangerous reputation meant its dancing days were over and it remained closed until this writer (yes, me) reopened it in 1983 with Glasgow's favourite sons, Simple Minds, who were looking for a venue to record a live video for what became one of their greatest hits, *Waterfront*.

The rest is rock 'n' roll history and The Barrowlands became and remains what many bands consider to be one of the best gigs in the world; a combination of the acoustic (designed for an unamplified dance orchestra), the raucously receptive Glasgow audience and the unique dynamic of the sprung dance floor. For UK bands at least, this is where you go to cut it live.

PHOTOGRAPH **MARTIN GRAY**

FIND | WALK | EAT | SLEEP **PAGE 224**

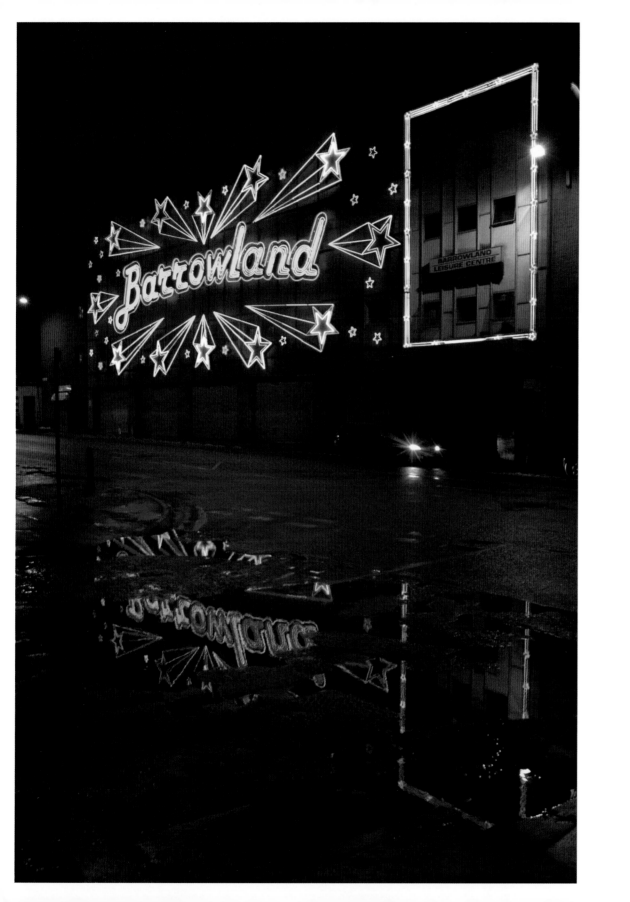

CELTIC CONNECTIONS
GLASGOW

Created in 1994 to fill the January programme gap of Glasgow's Royal Concert Hall post Christmas, Celtic Connections has become the pre-eminent celebration of Celtic music and the city's standout festival. While the more traditional music of the 'Celtic Fringe', those Celtic language regions on the edge of northwest Europe, including Ireland, Wales and Brittany, is at its core, increasingly the programme embraces not only North American Celtic derived forms, but ethnic and roots music from across the world.

But it's the congeniality of the city and its venues (the Concert Hall, the Old Fruitmarket, the City Halls), the late night 'Club' and the camaraderie between international musicians and anyone in Scotland who has ever picked up a fiddle, accordion, bagpipe, etc, all hosted with Glasgow's legendary goodwill, that make the over 300 performances and sessions of Celtic Connections so engaging. Even if folk ain't your thing.

FIND | WALK | EAT | SLEEP PAGE 224

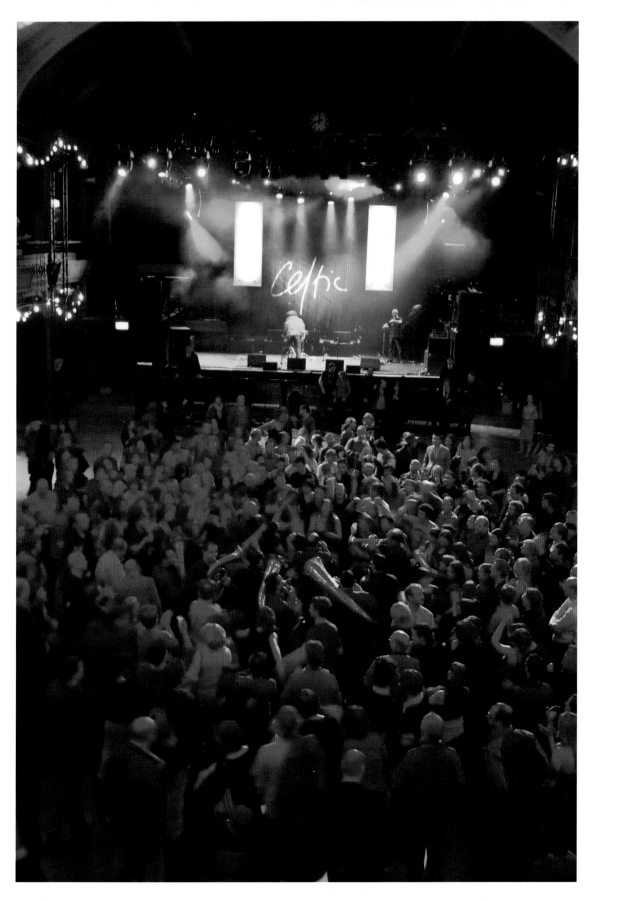

CITIZENS THEATRE
GLASGOW

Certain actors are described as 'national treasures', less frequently are the theatres – especially outside of London – where they first trod the boards. Glasgow's Citizens Theatre is one of them: simply loved.

Established in 1878 and with some Victorian features still intact, including the oldest continuously working understage machinery in Britain, the Citz has long helped to define theatre in Scotland. Its company (since 1945) growing up in the Gorbals, once one of the worst slums in Europe, has produced transformative and often provocative work, but has always lived up to its founding mandate to provide accessible theatre for all.

While the period from 1969 to 2003 – under the creative triumvirate of Giles Havergal, Philip Prowse and Robert David MacDonald – may have been glory days, the Citz, currently undergoing a huge refurbishment, will provide for decades to come a unique night out at a theatre in which the building plays a leading role.

PHOTOGRAPH **TOMMY GA-KEN**

FIND | WALK | EAT | SLEEP **PAGE 224**

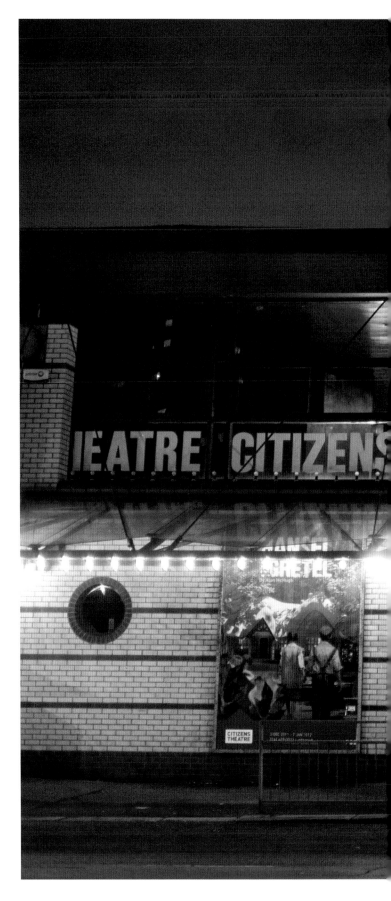

CRARAE GARDEN
ARGYLL

The truly gorgeous of the famed gardens of Argyll, profuse and vibrant in any season. Close to the shore of Loch Fyne and arranged around the cascading Crarae Burn, the naturalistic planting of Himalayan trees and shrubs make this one of Britain's most exotic gardens to clamber over. Rhododendrons are celebrated rather than denigrated here, as are azaleas, magnolias and camellias: a riot of flowers in spring and vivid foliage in autumn. Crarae is near the always impressive Inverary and its famously hospitable George Hotel.

FIND | WALK | EAT | SLEEP **PAGE 224**

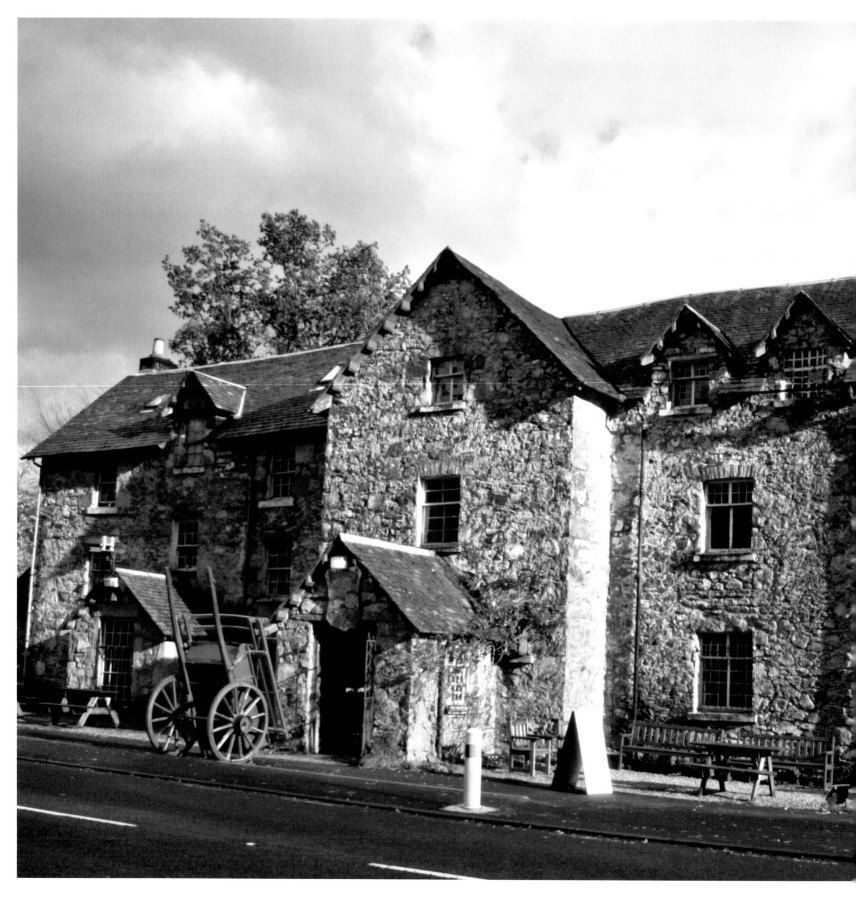

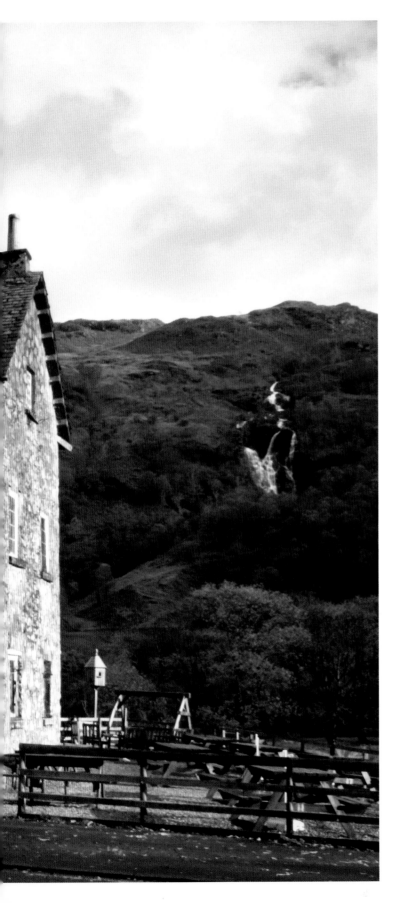

THE DROVERS INN
NR LOCH LOMOND

The Drovers is the epitome of a historic, walkers' and Highland Inn. Once it was for the Highland drovers driving their cattle south; now walkers, Munro-baggers and travellers descend on it in *their* droves. But it never loses its sense of place or purpose. With its low ceilings, bare floors, kilty barmen, open fires, heavy drinking and an interesting range of stuffed local animals, it is in every sense inimitable, though many boho Scottish chic makeovers have tried. It was pub of the year in 1705 and its appeal and 'authentic atmosphere' have hardly changed or diminished.

PHOTOGRAPH **JOHN MCKENNA**

FIND | WALK | EAT | SLEEP **PAGE 225**

DUNADD, THE HILL OF THE KINGS
ARGYLL

Overlooking Kilmartin Glen and its prehistoric sites and stones, this is not just a big, old hill, more a much loved lump with its own place in history. This is where the Kings of Dalriada were crowned for half a millennium – for a long time, a long time ago.

Rocky staircases lead to a soft, grassy top. Stand here when the Atlantic rain is sheeting in and, well, you get wet much as the kings did, but when the light is good you look far over the glen to Knapdale and over the sea to Jura.

PHOTOGRAPH **BJ STEWART**

FIND | WALK | EAT | SLEEP **PAGE 225**

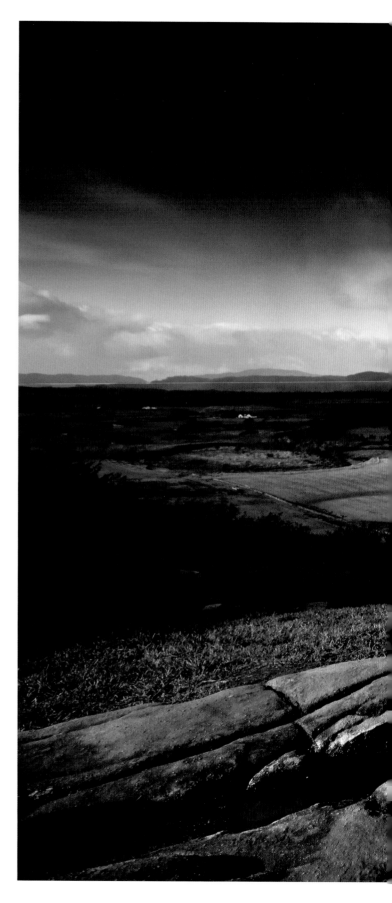

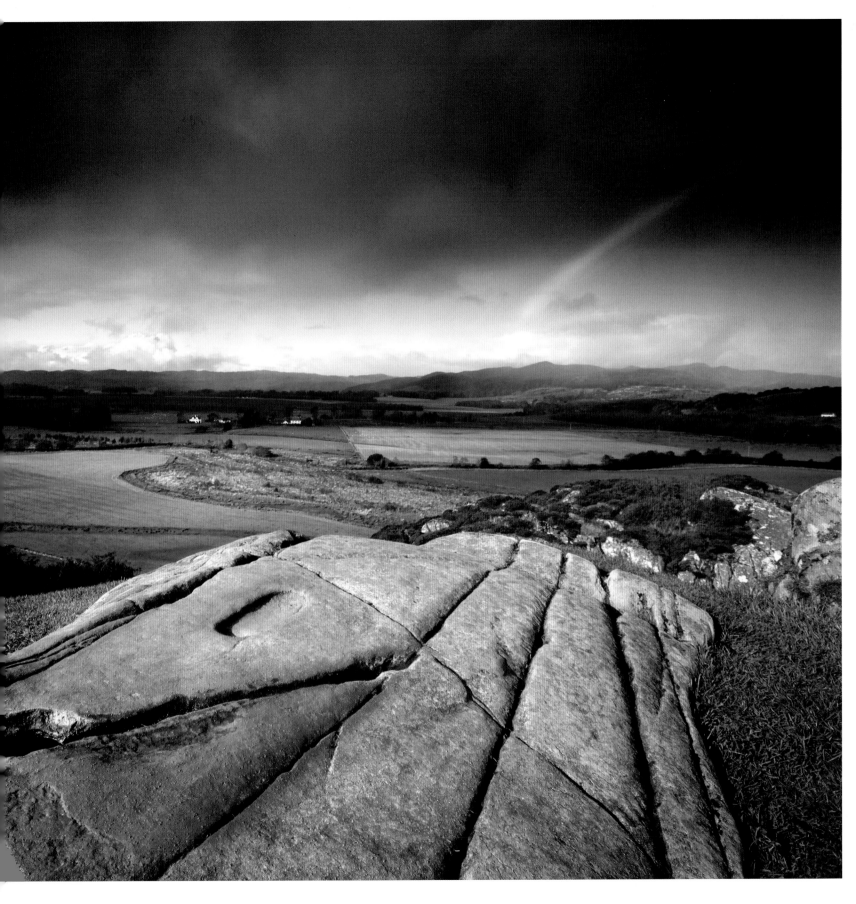

GEORGE SQUARE
GLASGOW

George Square may not have seen the impassioned furores of recent times in the squares of North Africa and Eastern Europe, but it is both the civic heart and the iron soul of a great city, where Glaswegians have always focused their celebrations, commemoration and their protest.

Contemporaneous with Edinburgh's New Town, its design and construction in the late 18th century reflected the influence of the 'Scottish Enlightenment' at a time of rising ambition. At first a private garden, those unruly Glaswegians soon tore down the railings and claimed it as their own.

The impressive building on the east side houses the City Council Chambers, a glorious place to visit. On the south side, the old General Post Office is now, among other things, a Jamie Oliver! Queen Street Station (and trains to the east) is in the northwest corner; George Square is where the Edinburghers arrive.

Glasgow is rightly proud of its square and its statuary (Robert Burns, James Watt, and in the centre the 80-ft Doric column to Sir Walter Scott that predates the monument in Edinburgh). It's an open space to make of what you will. Plans to change it have oft gone awry, perhaps because to sit there with the pigeons and watch Glasgow pass around you is, in itself, such a timeless pleasure.

PHOTOGRAPH **PETER MCDONALD**

FIND | WALK | EAT | SLEEP **PAGE 225**

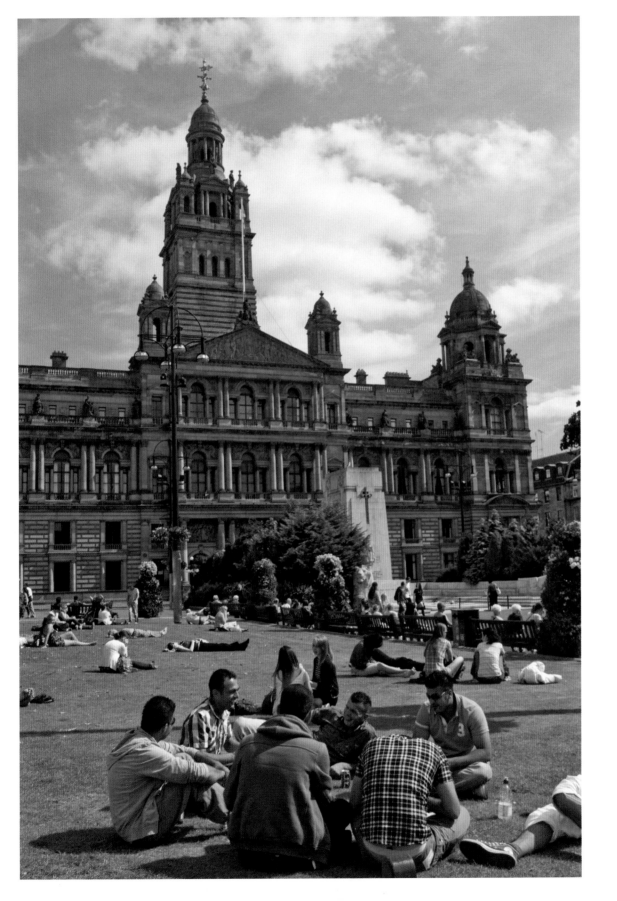

GLASGOW SCHOOL OF ART

The historic Glasgow School of Art, rising from the ashes of a fearful fire which gutted its famous library in 2014 – an event which demonstrated the universal esteem and love in which it is held – remains one of the most important working buildings in Europe. In the main photograph we see students on the summer night of their degree show. Designed by Charles Rennie Mackintosh and widely held to be a masterpiece, it was completed in 1909. It presents a complete architectural vision where every detail both on the façade and in the dark interior contribute to a modernist and individual statement that remains unsurpassed.

Its story (its notable alumni and the part it has played in the city which in many ways it represents) is told in a fascinating exhibition in the striking new Reid building opposite, which was designed by American architect Steven Holl (2014). There are also temporary exhibitions and guided tours. It is a joy to look at and to visit. The Library will return.

PHOTOGRAPHS **ALAN MCATEER**

FIND | WALK | EAT | SLEEP **PAGE 225**

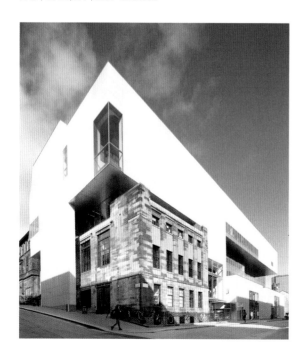

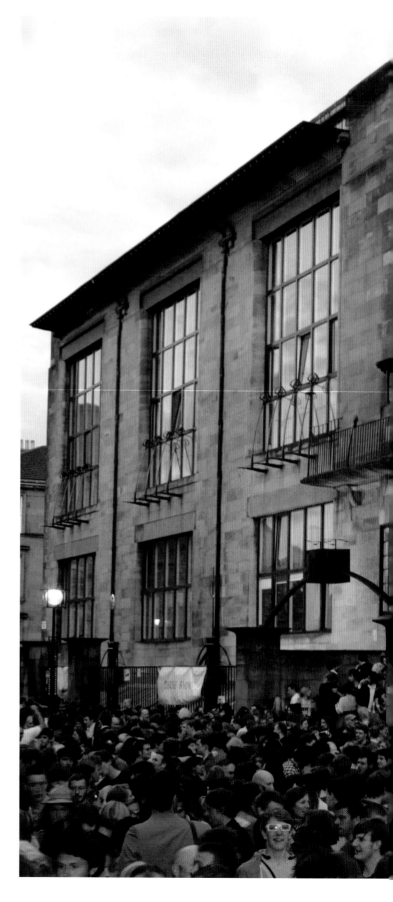

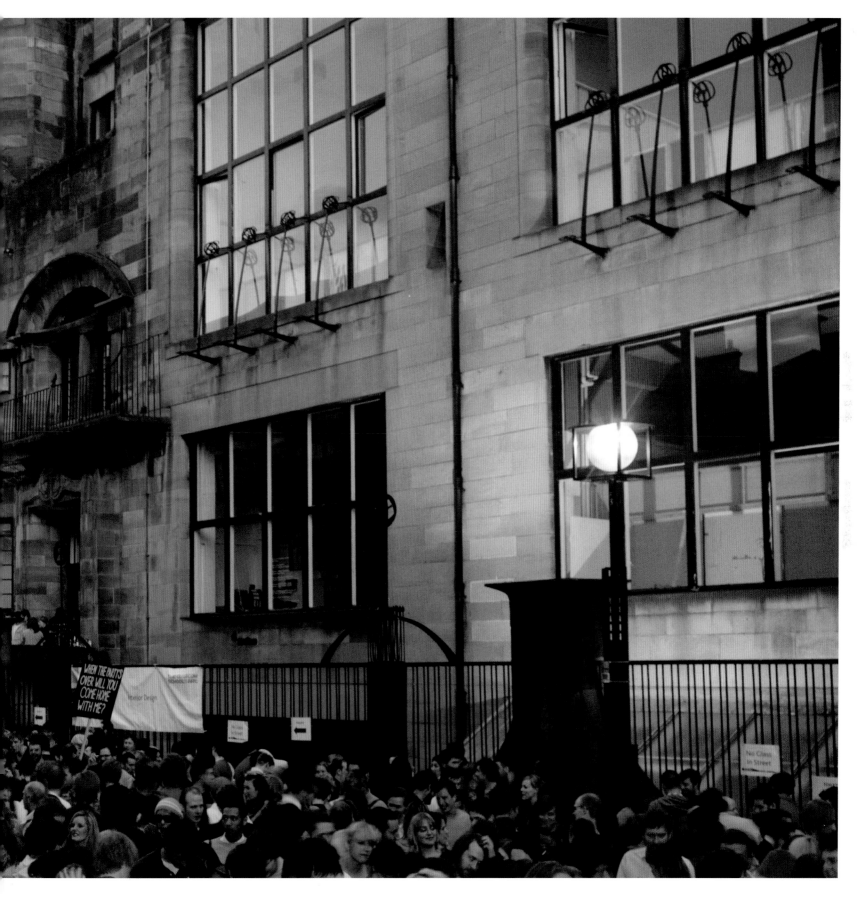

GLEN ETIVE
WEST HIGHLANDS

Glen Coe may be more renowned but many a lover of these Highlands would say that Glen Etive, reached by the same road (the A85 from Crianlarich to Fort William), is *the* Glen of Glens. The single-track road follows the river the twelve miles to the head of Loch Etive, deep in mountains; these also enthral on the boat trip from Taynuilt.

Buachaille Etive Mor, an epic and easily distinguishable peak and one of Scotland's most revered Munros, presides over the entrance to the Glen. It's one of many mountains which have been climbed here in the Glen Coe area for generations. Glen Etive is where those climbers and walkers might camp, braving the midges and swimming in the Etive's many pristine pools. This is God's country; leave not a trace.

PHOTOGRAPH **KEITH FERGUS**

FIND | WALK | EAT | SLEEP **PAGE 225**

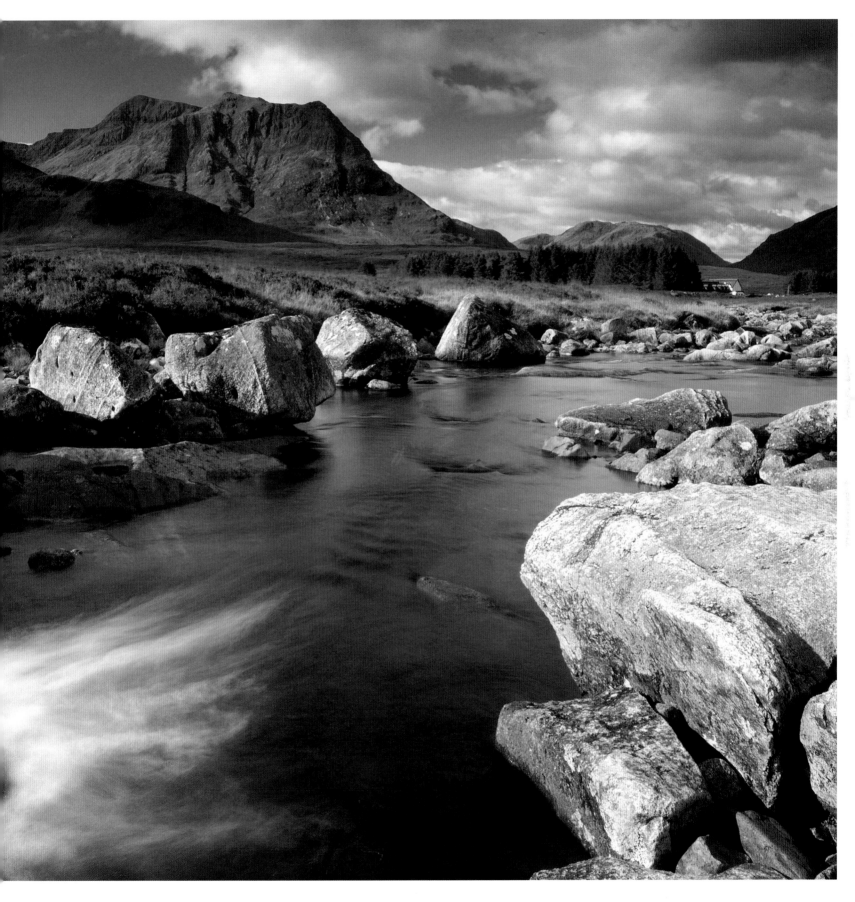

GOUROCK POOL
RENFREWSHIRE

Find the nostalgia of 'Doon the Watter' days here, in a rare open-air swimming pool overlooking the Clyde. It can go like a fair though sometimes it's just you and the gulls and the timeless pleasure of swimming outdoors. Gourock is an easy distance from Glasgow and is where the ferry leaves for Dunoon. The pool is heated, open May until September, and on Wednesdays a midnight swim session is way more life-enhancing than clubbing up in Glasgow or just going to sleep.

PHOTOGRAPH **ANGIE FREEMAN**

FIND | WALK | EAT | SLEEP **PAGE 225**

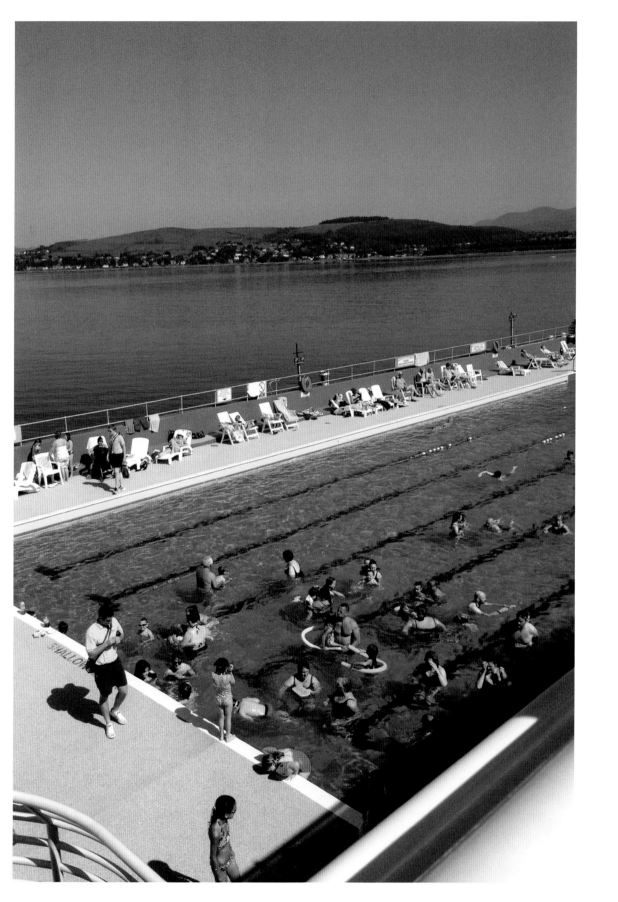

IONA
INNER HEBRIDES OFF MULL

Iona, the enchanted island, a place of pilgrimage for centuries, and where an exiled Irish monk, St Columba, set up a community in AD 563 that became one of the most influential in western Europe. Iona Abbey and the Iona Community remain ever active today and confer a spiritualism to the place, tangible to all who come here. But it is perhaps a greater feeling of peace, a tranquillity that must always have been here, that makes Iona so compelling. Even the weather seems kinder than on Mull from whence you've come; and it has a light that inspired the Scottish Colourists. People (around 150,000 a year) mostly come for the day, but it is magical to stay, climb the hill and wander as you will.

PHOTOGRAPH DAVID LOMAX

FIND | WALK | EAT | SLEEP PAGE 226

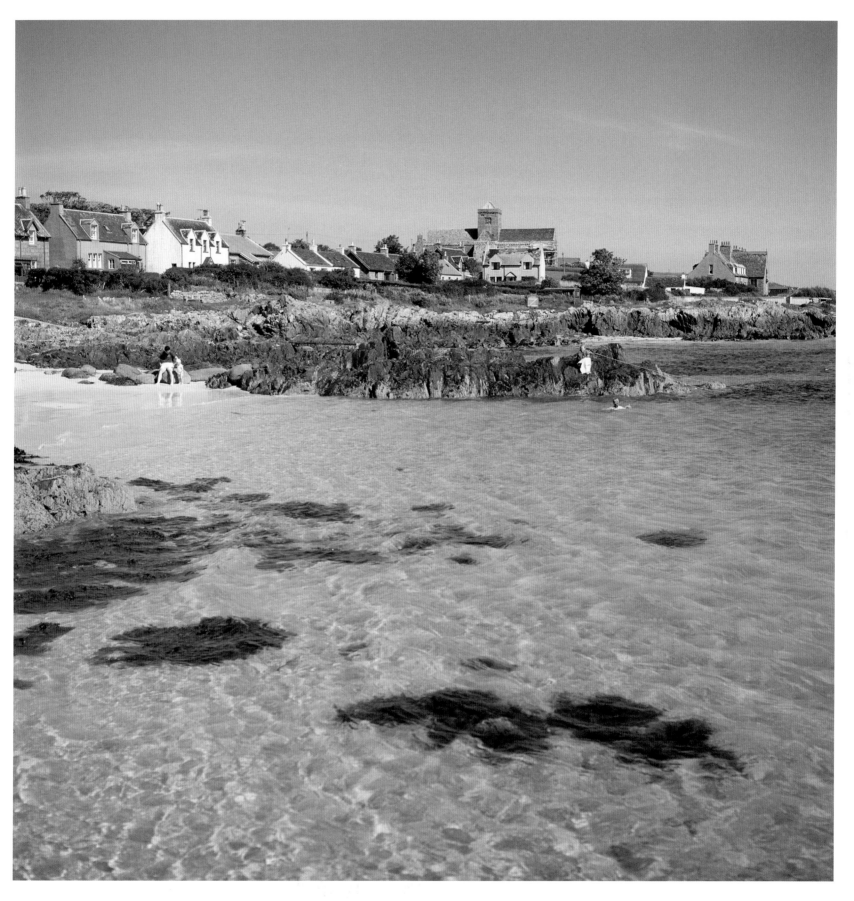

JURA
INNER HEBRIDES

For many of those who come again to cross the narrow Sound, Jura is in the blood. Dominated by the Paps we see from afar, we love it because of its wild emptiness and its self-contained island life. It gives solace.

A single-track road connects most of its thirty-five miles. Craighouse township has a great wee hotel – the social hub – with camping and a bar. There's a café, a shop and the Distillery: the internationally revered Jura Malt. Every May, one of Scotland's most gruelling outdoor challenges – the Isle of Jura Fell Race – leaves the Distillery and climbs the three Paps and four other tops, the winners back in just over three hours.

But we can take our time discovering Jura, a land that's always been uncompromisingly and powerfully itself.

PHOTOGRAPH **EUAN MYLES**

FIND | WALK | EAT | SLEEP **PAGE 226**

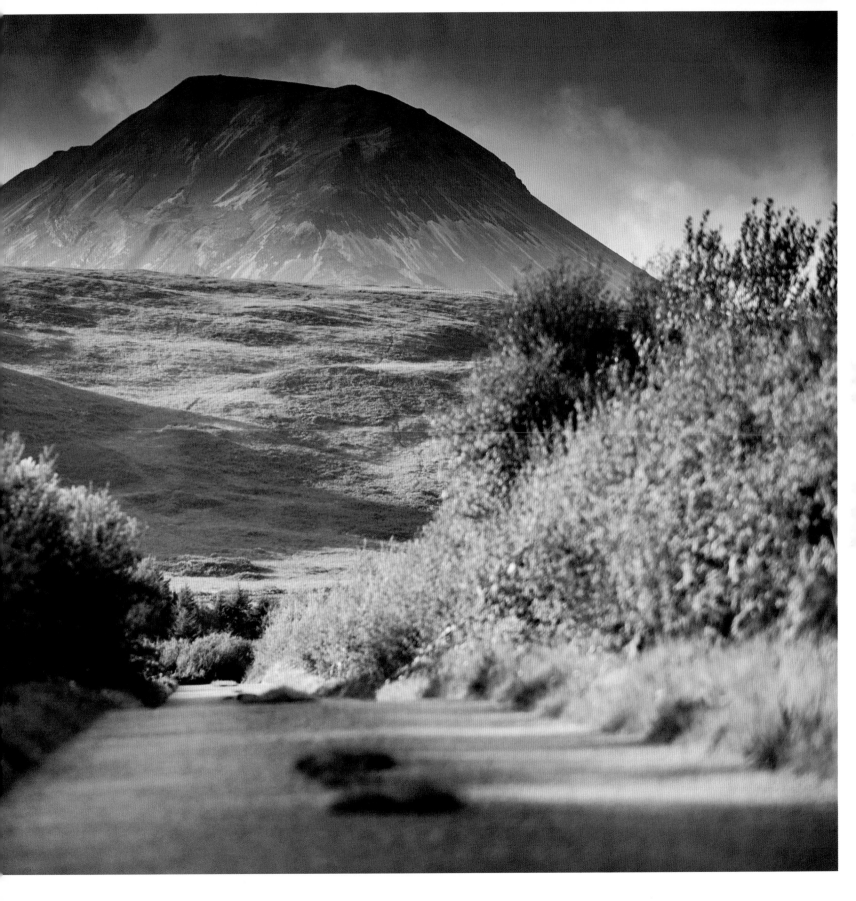

KELVINGROVE
GLASGOW

Since its reopening after a major refurbishment in 2006, Glasgow's landmark Kelvingrove Art Gallery and Museum has been Britain's most visited attraction outside of London. A distinctive warm red sandstone edifice on the banks of the Kelvin river between Kelvingrove Park and the campus of Glasgow University, a cerebral and civilized side of the city, it houses one of Europe's greatest civic collections. From the proceeds of the 1888 International Exhibition, it opened in 1901 as the Palace of Fine Arts and has been Glasgow's pride and joy ever since.

Along with the Burrell Collection to the south of the city, the People's Palace in the east and the new Museum of Transport in Zaha Hadid's statement building on the Clyde, Kelvingrove proclaims Glasgow's energy, ambition and cultural credentials in a characteristically human way.

PHOTOGRAPH **DOUGLAS CORRANCE**

FIND | WALK | EAT | SLEEP **PAGE 226**

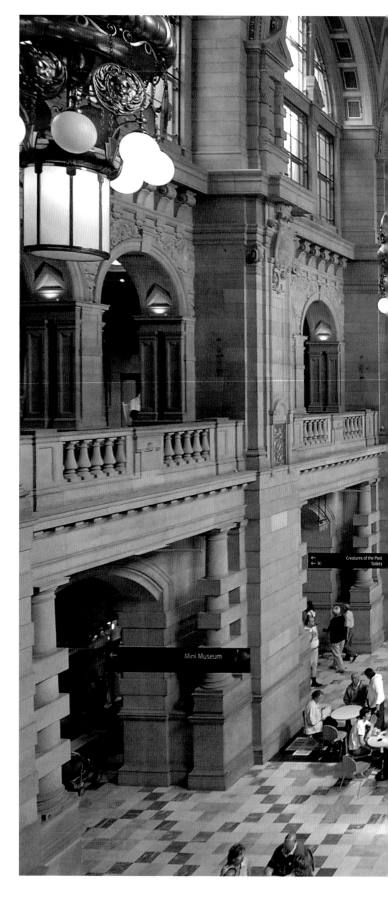

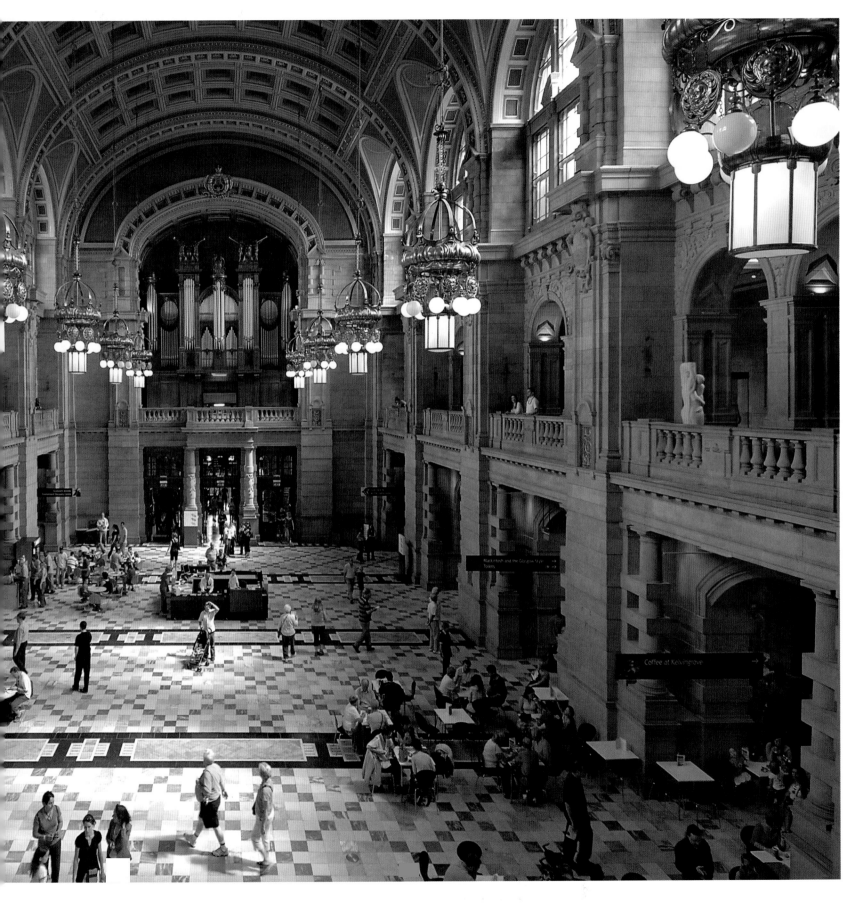

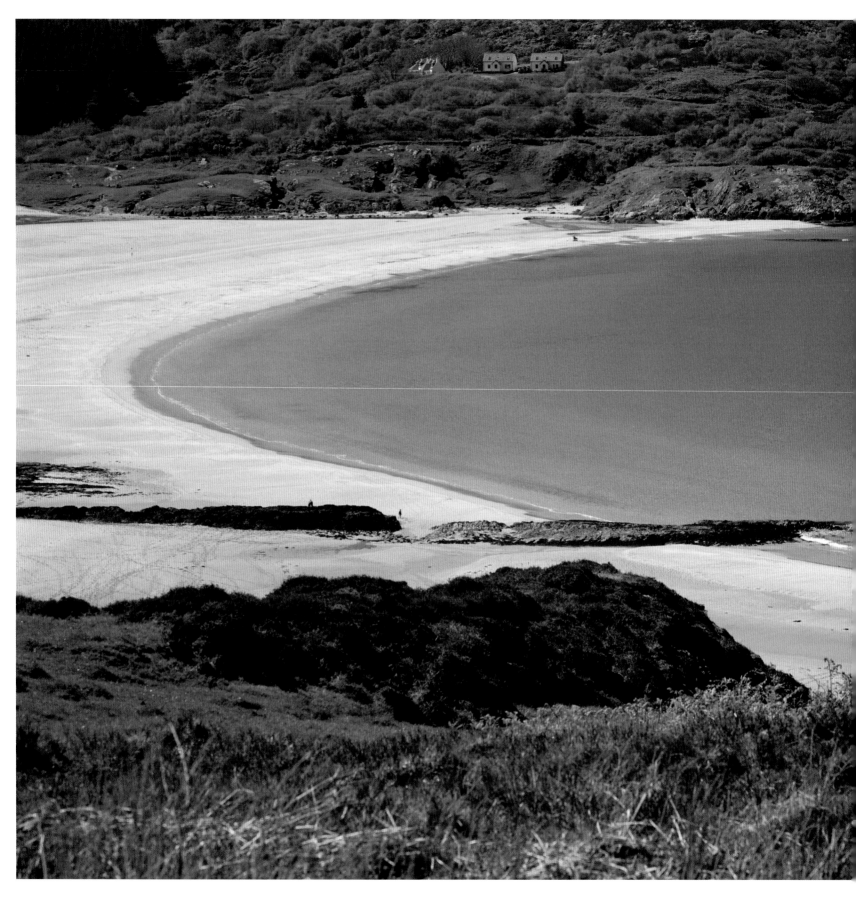

KILORAN BEACH
COLONSAY, INNER HEBRIDES

Colonsay, a haven of all small things Hebridean, has many charms and many beaches but Kiloran is its gem, the one that folk talk about with a wistful glint in the eye; it's often described as the finest in the islands. Low, craggy cliffs on one side and negotiable rocks and tiers of grassy dunes on the other. Colonsay – the whole island – was once bought as a picnic spot. Kiloran was probably the reason why!

But there is more to this perfectly proportioned island only ten miles by two. Colonsay House has surprising botanical gardens brimming with rhododendrons, there's a very civilized hotel and pub, and a golf course that's over two hundred years old. With birds atwitter in an often blue sky, the machair spread with flowers in spring and splendid sunsets because you're way out west, it's not surprising that people come back here all their lives.

PHOTOGRAPH MATTHEW HART

FIND | WALK | EAT | SLEEP PAGE 226

LOCH AWE
ARGYLL

Lochs Lomond, Ness and Tay are the big ones of our imagination and in fact. Though Loch Awe may be less loved, it often lives up to its name. It slices through the heart of Argyll and is the longest freshwater loch in Scotland, with forests and ruined castles on its islands and shores – it doesn't care what you think: this is a loch with enigma.

Loch Awe is briefly encountered on the road to Oban but the two best ways to approach it are either from Inverary through Glen Aray and the ancient Caledonian Forest of oak and birch, with the loch glittering and Ben Cruachan above, or from the north at Taynuilt through Glen Nant to Kilchrenan. A single-track road goes round the loch, which is surrounded by woods that are enveloping and old. Kilchurn Castle, close to the main road, one of the most photographed ruins in Scotland, and St Conan's Kirk (see page 180), invite pause for reflection, the loch a perfect setting for their dark, mysterious stones.

PHOTOGRAPH **KATHY COLLINS**

FIND | WALK | EAT | SLEEP **PAGE 226**

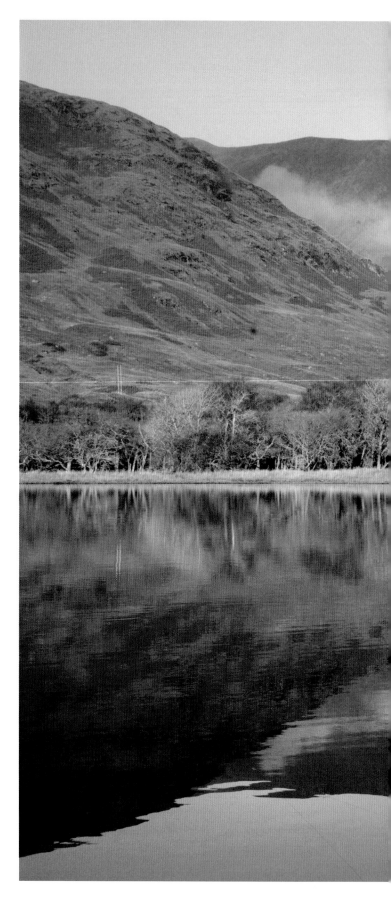

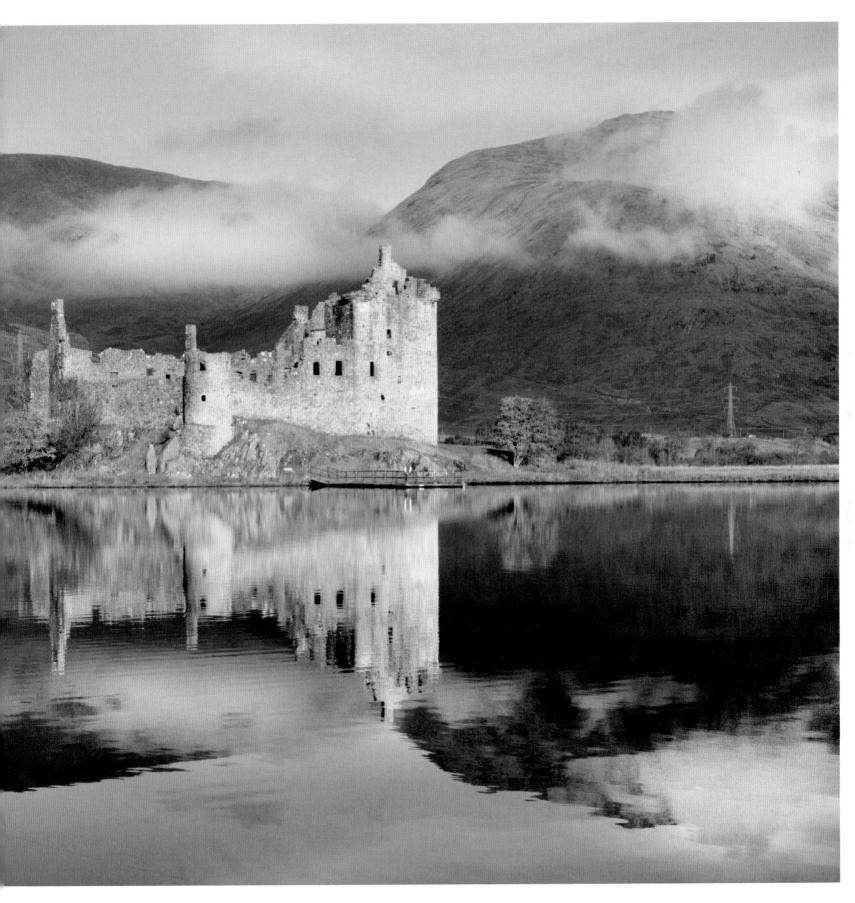

MHOR 84
STIRLINGSHIRE

Mhor 84 is (proudly) a motel though not in any neon-lit nostalgia, Route 66 sense. It was a run-down roadhouse hotel just off the A84 that was taken over by the Lewis family and, with their inimitable flair and energy but not a lot of gentrification, transformed into a destination in itself. It's part of their Mhor group, which is more an approach to life than a brand; more an adventure than merely a venture: Mhor Bread and Mhor Fish (bakers and café, fish 'n' chips) in Callander and their famously fabulous boutique farmhouse hotel Monachyle Mhor, seven miles up the lochside.

So if you decide to motor west, take the highway stop that's the best. At dusk you might see the brazier burning outside the door. Pull over – a laid-back, very personal welcome awaits. You won't want to move on.

PHOTOGRAPH **KANE RUTHERFORD**

FIND | WALK | EAT | SLEEP **PAGE 226**

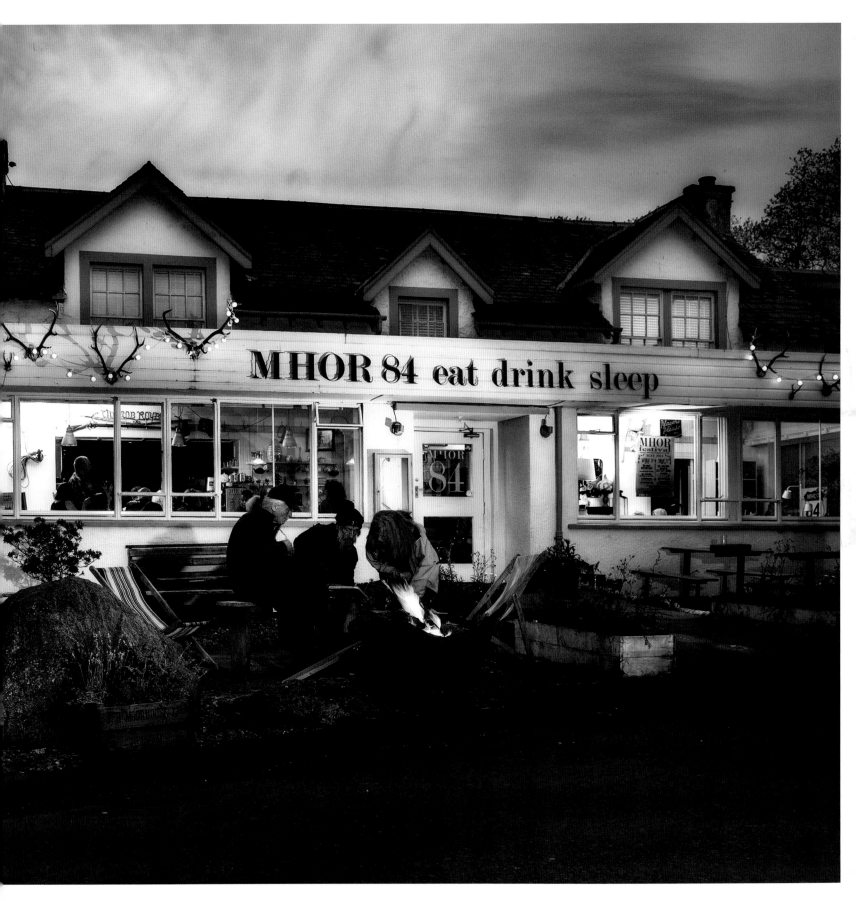

MOUNT STUART
ISLE OF BUTE

One of Scotland's secret jewels, this astounding Victorian Gothic house on the Isle of Bute, with magnificent gardens and woodlands that stretch to the Clyde, makes for a perfect day out. The House echoes the passion for mythology, astronomy, astrology and religion of the third Marquis in fascinating detail. Contemporary art commissions in the grounds and the strikingly modern visitor centre complement the Bute collection of masterpieces. The restaurant is a notable champion of local food; the Courtyard tearoom, just right. And the Gardens: Kitchen, Rock, 'The Wee' and the Pinetum are all a joy too. Leave your humdrum life behind, everything here is in the best possible taste.

PHOTOGRAPHS **PHILIP LOVEL**

FIND | WALK | EAT | SLEEP **PAGE 227**

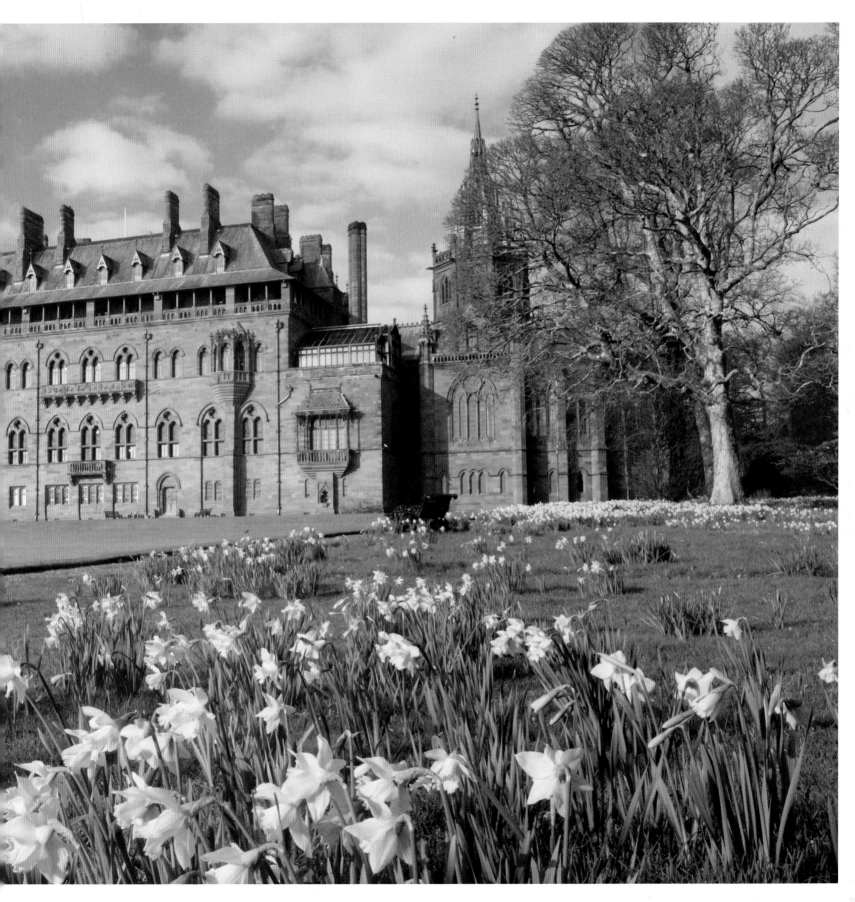

NECROPOLIS
GLASGOW

The Necropolis, built when Glasgow was the 'Second City of the Empire' on a low but prominent hill to the east of the medieval city, presents a tantalizing record of Victorian mores, architecture and ambition. Often compared with the Père Lachaise cemetery in Paris, a staggering 50,000 souls have been buried here in tombs, mausoleums and under monuments, some on a spectacular scale by all the significant architects of the day, such as Charles Rennie Mackintosh and Alexander 'Greek' Thomson.

It's not only the potent atmosphere of a great historical graveyard that makes this such a fascinating place to visit (there are walking tours); it's an aesthetic and harmonious experience, and from a lofty perspective you might consider the propinquity of the Cathedral, the Infirmary and the mighty Tennent's brewery: pure dead Glasgow.

PHOTOGRAPH **BOB LAWSON**

FIND | WALK | EAT | SLEEP **PAGE 227**

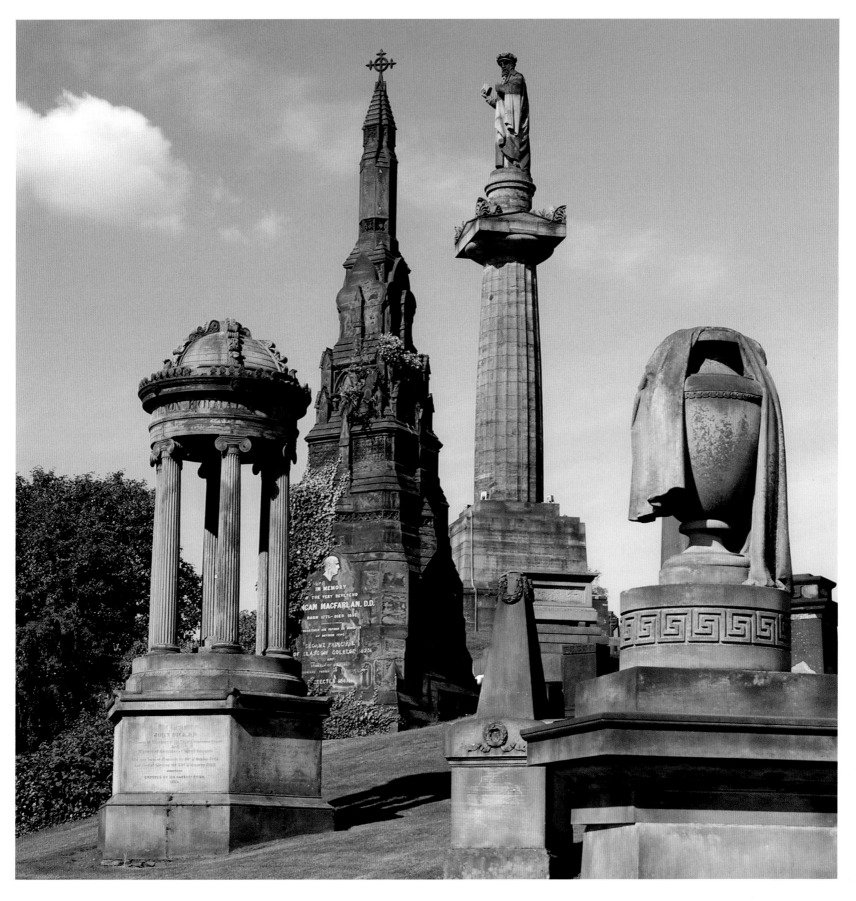

PUCK'S GLEN AND BENMORE, COWAL PENINSULA
ARGYLL

The Cowal Peninsula and the Argyll Forest Park between Loch Fyne and the Clyde Estuary encapsulate Argyll; here, among woods and gorges, lochs and sea lochs and never far from a view of a spectacular coastline, you are roaming in the best of the west. In the heart of this natural wonderland, yet not far from the ferry at Dunoon back to Glasgow, is Puck's Glen and, contiguous, its horticultural counterpoint, the Benmore (Younger) Botanic Gardens.

The Glen is a moist and mysterious gorge; sprites may be expected to dance around the pools and tumbling waterfalls. Hidden birds and snuffling creatures attend your well laid-out paths. Benmore, one of Scotland's great botanic gardens, with magnificent trees, including redwoods, is one mile along the road.

PHOTOGRAPH OSCAR VAN HEEK

FIND | WALK | EAT | SLEEP PAGE 227

RANNOCH MOOR
WEST HIGHLANDS

It may not have a conspicuous magnificence but Rannoch Moor has mystique and a revered, austere beauty throughout its fifty square miles that stretch from Perthshire to Lochaber. Lochans, rivers, rocky outcrops and distant mountains shape its wilderness credentials. And the blanket of bog.

In this challenging landscape, deer, curlews, grouse and several rare species flourish in their uncommon and protected habitat. Many walkers pass by (including on the West Highland Way, page 186). But at Rannoch Station at the end of the road, you can jump on a train to Euston.

PHOTOGRAPH **FRAN HALSALL**

FIND | WALK | EAT | SLEEP **PAGE 227**

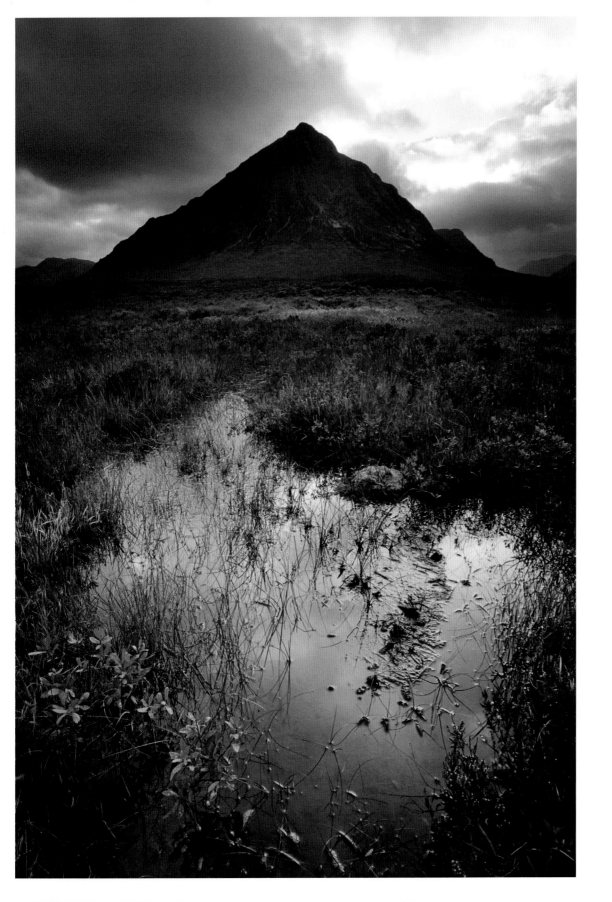

ROB ROY'S BATHTUB
STIRLINGSHIRE

A mecca for wild swimmers and other water adventurers, Rob Roy's Bathtub is a perfect pool carved out by a waterfall on the Falloch River, which flows into Loch Lomond. On the edge of the Highlands, it is actually in Stirlingshire and part of the Loch Lomond and the Trossachs National Park. It's also on the West Highland Way (page 186), so walkers join swimmers and kayakers toppling over the waterfall, in an all-round natural outdoor activity centre deep in Glen Falloch's splendid woods. To further confirm its must-go-there status, the Bathtub is only two miles north of the historic wayside inn, The Drovers (page 146), with its roasting fire, and a dram – a reward for those bold enough to take the often icy plunge.

PHOTOGRAPH JANEANNE GILCHRIST

FIND | WALK | EAT | SLEEP **PAGE 227**

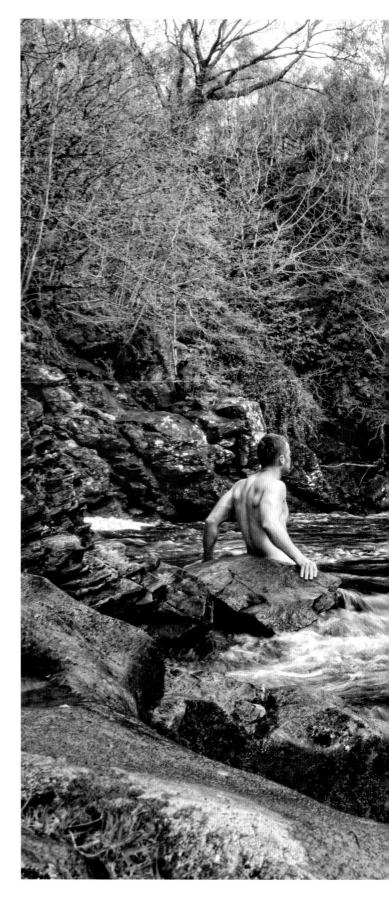

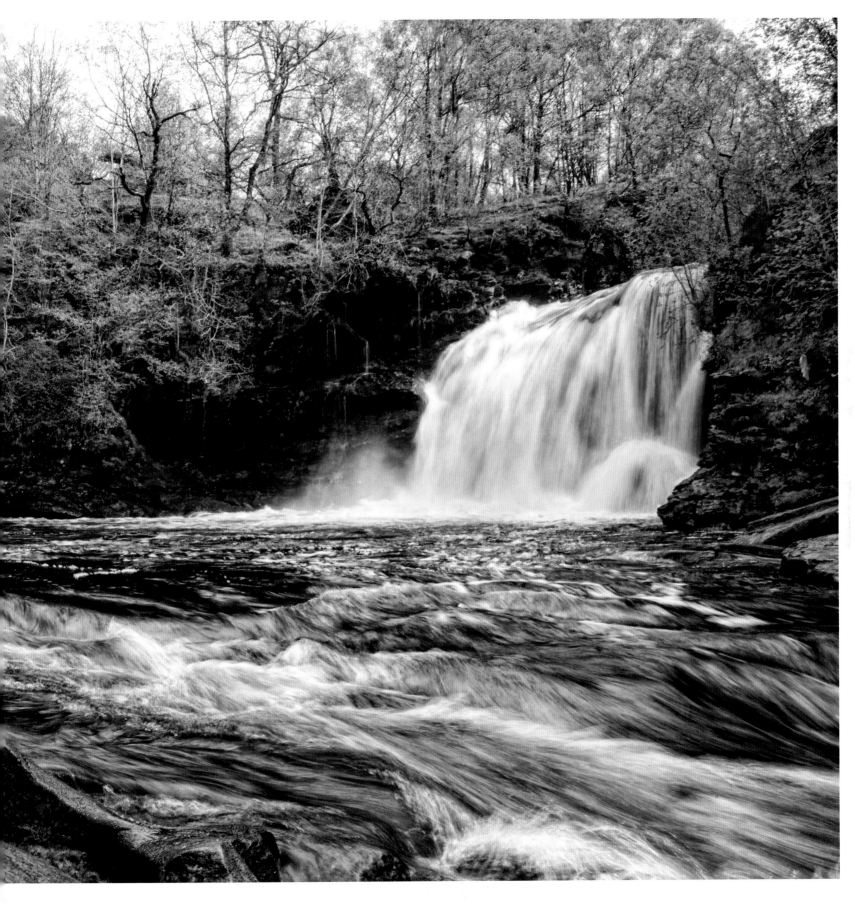

ST CONAN'S KIRK
ARGYLL

St Conan's isn't one of those churches that stands out from afar, rather you come upon it round a corner on the A85, the road around the head of Loch Awe to Oban. Surrounded by trees in a garden down to the loch, the glory-to-God scale and detail and splendid eccentricity are all the better for being gradually revealed.

This edifice was the obsession of one man, Walter Campbell, who, in 1907, designed and built it (all from boulders hewn from local hillsides) for his mother who had difficulty getting to the church in the village. Both she and Walter himself, and his sister, who later took on the job, all died before it was completed by a trust in 1930. Campbell had incorporated every kind of ecclesiastical style into his grand vision: spires, gargoyles, turrets, chapels and cloisters. There's even a huge effigy of Robert the Bruce (and a bit of his bone). The result is a unique building of remarkable presence and ethereal light, with a powerful atmosphere that evokes a deep sense of what it means to be religious.

PHOTOGRAPHS **ANGUS MCCOMISKEY**

FIND | WALK | EAT | SLEEP **PAGE 227**

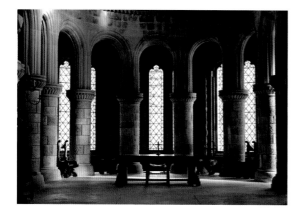

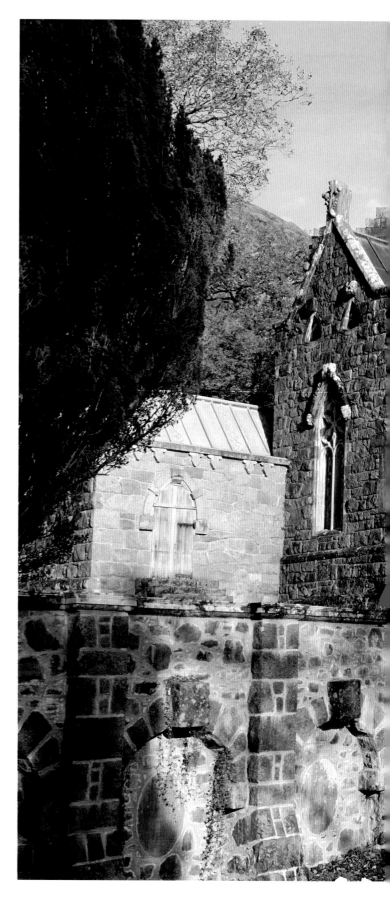

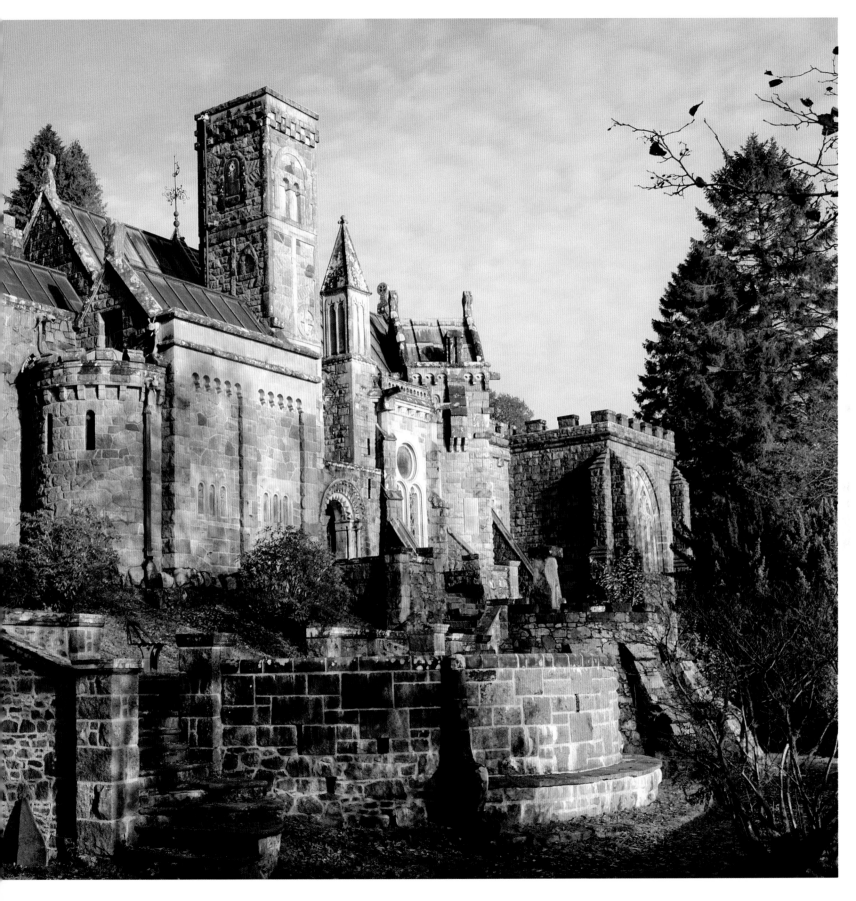

THE TROSSACHS
WEST HIGHLANDS

The Trossachs is the picture-postcard Scotland of Rob
Roy and the romantic novels of Sir Walter Scott. North
of Stirling, not yet the Highlands, its landscape, both
rugged and soft, defines it: hills clothed in forests, heather
and bracken, and lochs the way lochs should be. This is
countryside to hike and climb, tootle around in a car in,
or even, as folk do, explore by bus – it is famously easy
on the eye.

Within an hour of Edinburgh and Glasgow, the Trossachs
is where to go for that day out or camping/boutique hotel
stopover that can sum up Scotland like a calendar of
Callander. The Trossachs can summon memories even if
you've never been before: those bluebells in early summer,
the vibrant leaves of autumn, the purple remembered hills.

PHOTOGRAPH **MICHAEL STIRLING-AIRD**

FIND | WALK | EAT | SLEEP **PAGE 228**

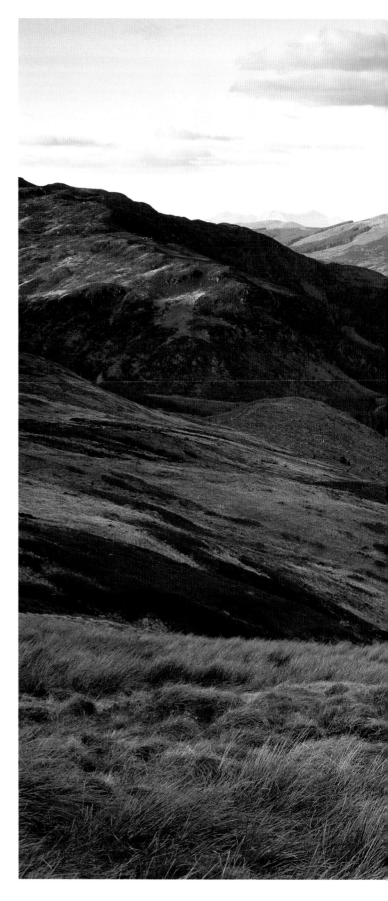

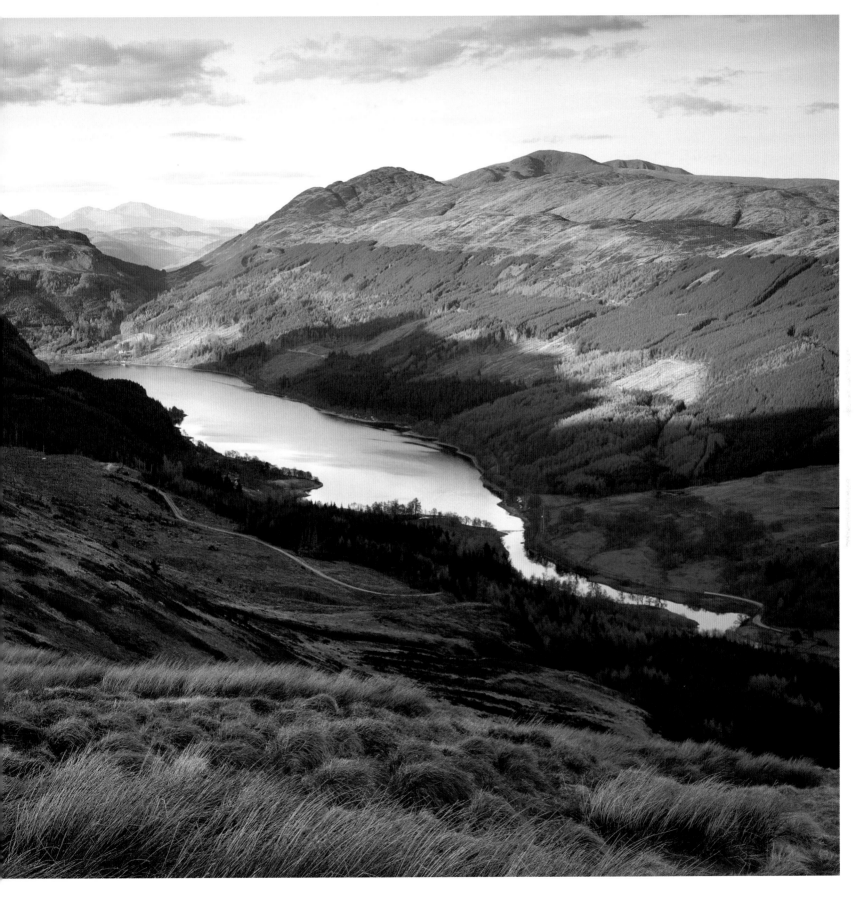

UBIQUITOUS CHIP
GLASGOW

The pioneering creation of one Ronnie Clydesdale, now in the hands of his family, this has been, for over 40 years, one of Scotland's signature restaurants. Once in a quiet back lane, now full of other restaurants and Glasgow folk, 'The Chip' was a foodie destination long before the revolution. Under its vines, superb wine, a menu famed for its impeccable Scottish provenance and an all-embracing bonhomie.

PHOTOGRAPH PAUL TOMKINS

FIND | WALK | EAT | SLEEP PAGE 228

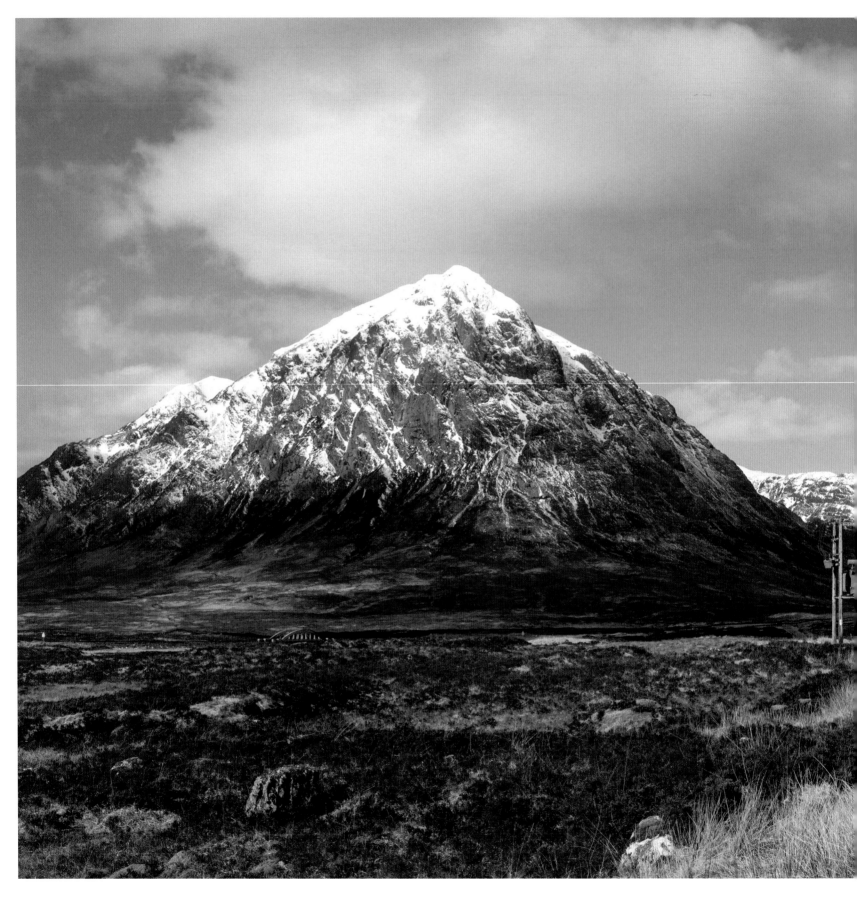

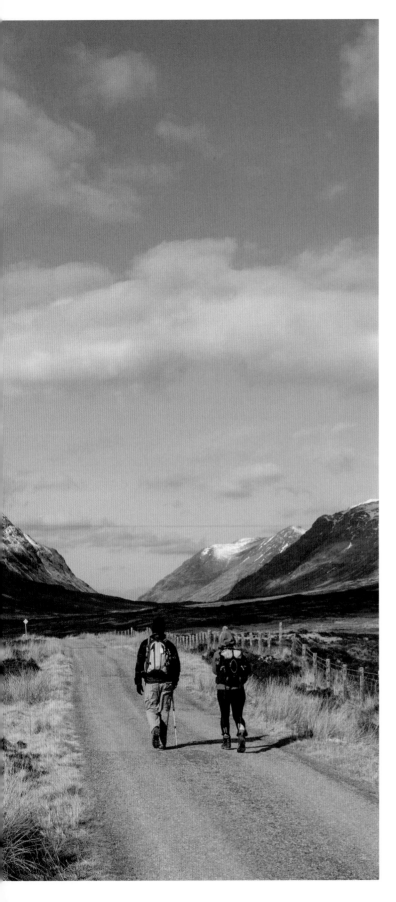

THE WEST HIGHLAND WAY
GLASGOW TO FORT WILLIAM

The West Highland Way was Scotland's first long-distance walking route. Though there are many others now, it remains the most popular. At just under a hundred miles, it's usually done from south to north in about eight stages of between four and seven hours; most folk take a week.

The Way was carefully planned to pass some of Scotland's most celebrated scenery, including Loch Lomond, Rannoch Moor, Glen Coe and Ben Nevis. It starts in Milngavie, a suburb of Glasgow, then through Mugdock Country Park; you can sample it on an afternoon walk from the city. The other end is by Fort William, in glorious Glen Nevis.

Almost anyone can take this hike and you can arrange to have your bags transported to your next overnight stay. Well-trodden it may be, but The Way is one of the best *ways* to see Scotland.

PHOTOGRAPH RICHARD CROSS

FIND | WALK | EAT | SLEEP **PAGE 228**

CAERLAVEROCK
DUMFRIESSHIRE

The epitome of a medieval fortress, Caerlaverock overlooks the Solway – and England. Besieged, destroyed and raised again many times over a turbulent history, what's left is one of the most distinctive and imposing ruins in Scotland. A twin-towered gatehouse, a double moat and a triangular shape are interesting from all angles, especially above.

What makes this place so compelling is that it's on the edge of one of the most notable waterfowl reserves in Britain, which is laid out for easy observation and probable awe at the sheer numbers of waders and, particularly, the far travelled barnacle geese. There are also natterjack toads, badgers and owls in a site managed by the Wildfowl & Wetlands Trust. It is a place where nature watching is an absolute pleasure.

PHOTOGRAPH **KATHY COLLINS**

FIND | WALK | EAT | SLEEP **PAGE 228**

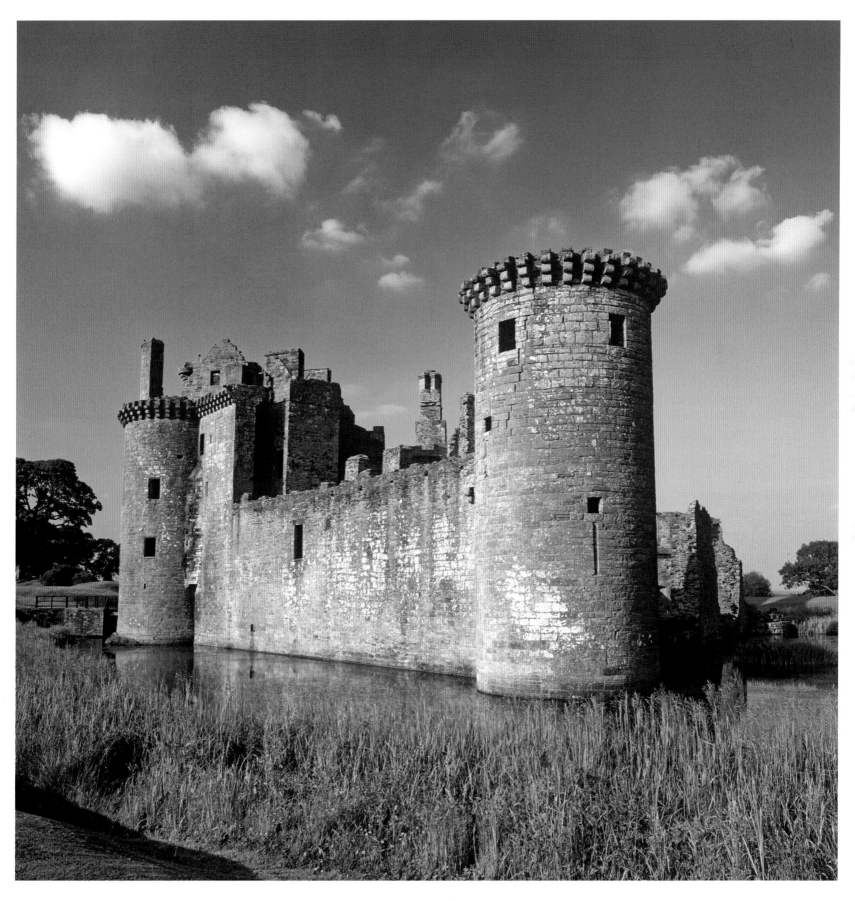

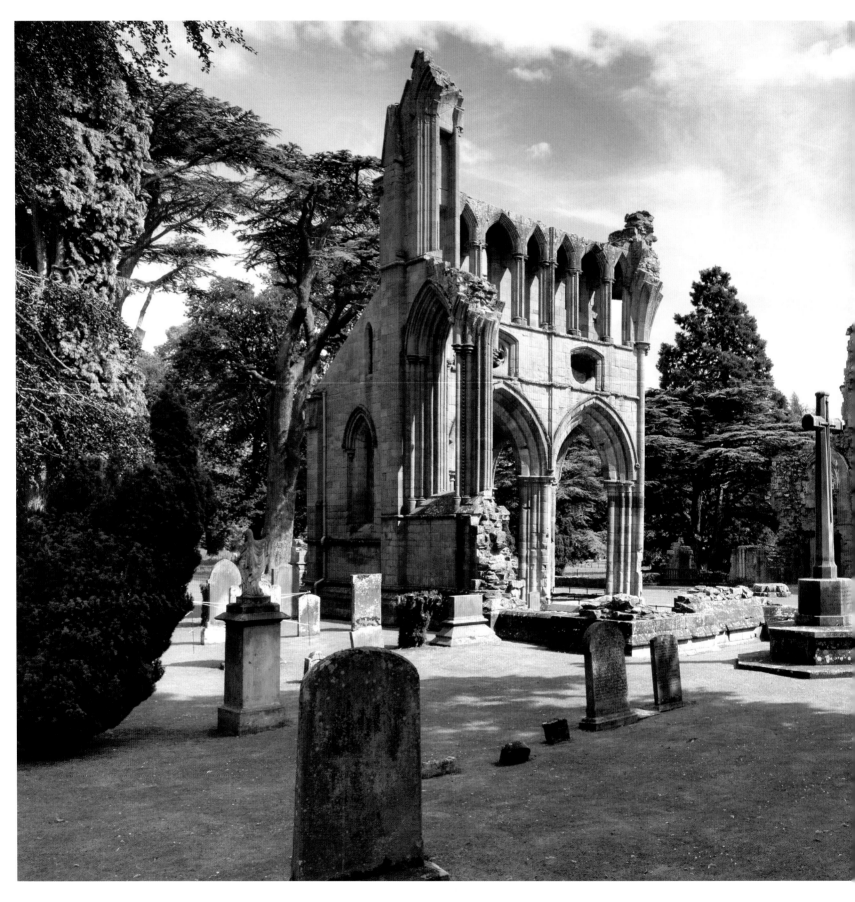

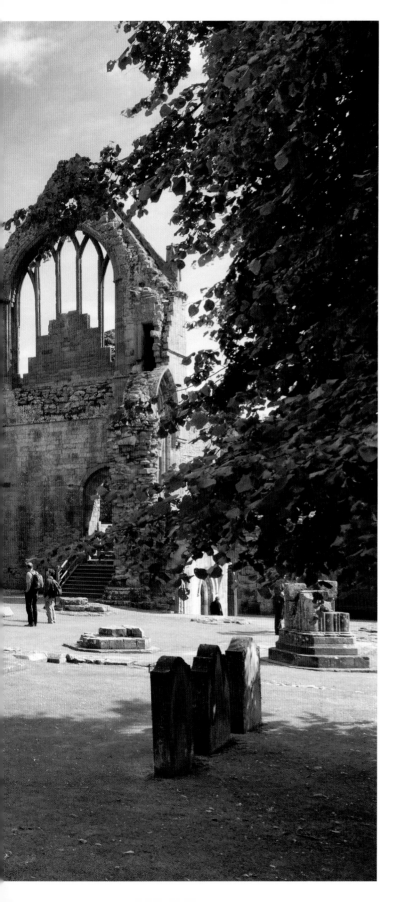

DRYBURGH ABBEY
BORDERS

One of Scotland's most evocative ruins, Dryburgh is also the most romantic of the Border abbeys recognized and celebrated by Sir Walter Scott, who is buried here, with his biographer Lockhart at his feet. Founded in the 12th century, it sustained two major trashings in the 14th and was finally destroyed in 1544. But what's left for us is a ruin of great elegance and aesthetic that somehow defines the hapless history of the Borders in its centuries of skirmish with the English. The Abbey ruins, serenely set on the banks of the mighty Tweed among giant cedars, are especially enchanting at dusk and in moonlight.

PHOTOGRAPH **PETER SCOTT**

FIND | WALK | EAT | SLEEP **PAGE 228**

THE GARDEN OF COSMIC SPECULATION
DUMFRIESSHIRE

This extraterrestrial garden of bridges, landforms, sculptures, terraces and architectural works laid out around Portrack, a Georgian farmhouse north of Dumfries, is a concept best left to its creator, the American architectural theorist and landscape artist Charles Jencks, to describe:

'Nature celebrates nature both intellectually and through the senses including a sense of humour. A water cascade of steps recounts the story of the universe, a terrace shows the distortion of space and time caused by a black hole; a Quark Walk takes the visitor on a journey to the smallest building blocks of matter and a series of landforms and lakes recall fractal geometry.'

The Garden was laid out in 1988 and remains a memorial to Jencks' wife, Maggie Keswick, who gave her name to the Maggie Cancer Caring Centres. These and the gardens, both ground-breaking, are a legacy of remarkable people.

This is a private garden. Open one day through the Scottish Garden Scheme (SGS), usually the first Sunday in May. Please check the latest information from SGS before visiting.

PHOTOGRAPH MR CHARLES JENCKS

FIND | WALK | EAT | SLEEP PAGE 229

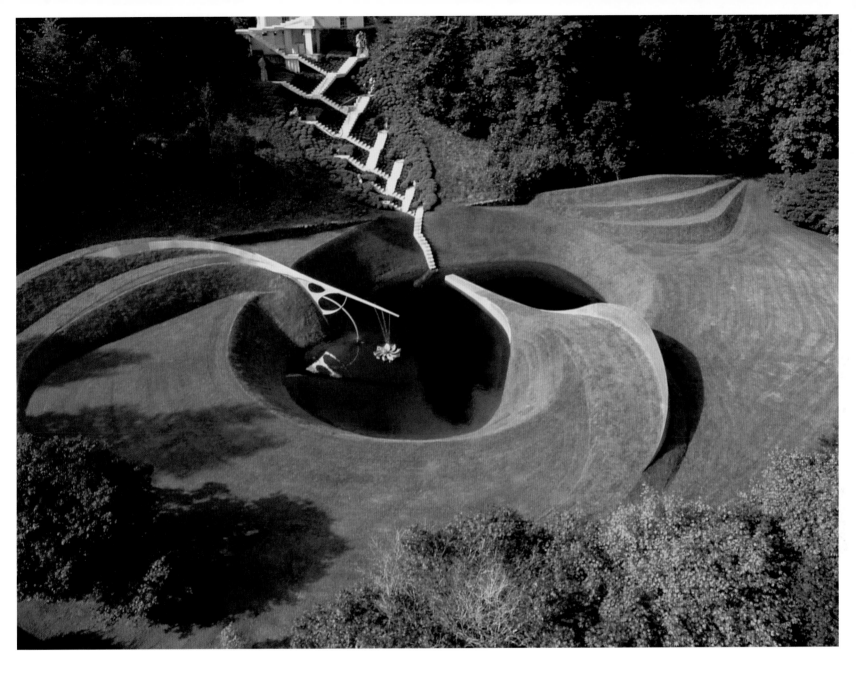

HORNEL GALLERY/ BROUGHTON HOUSE
KIRKCUDBRIGHT

The town house in Kirkcudbright of Edward Atkinson Hornel, one of Scotland's most prolific and recognizable 20th-century painters, is so enchanting and redolent of its time and place, you'd want to live and paint here too. And you may have that feeling not only in his well-conserved, comfortable house, with its lofty atelier, but also in the beautifully proportioned and planted (and almost secret) garden that stretches down to the strangely tidal river. Neither is it hard to see what he and other artists saw in this refined Solway town where the light and the sea so prevail.

MAIN PHOTOGRAPH **DOUGLAS CORRANCE**
INSET PHOTOGRAPH **BRIAN & NINA CHAPPLE**

FIND | WALK | EAT | SLEEP **PAGE 229**

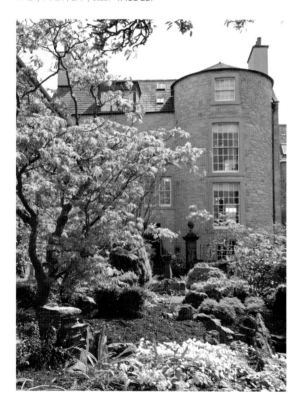

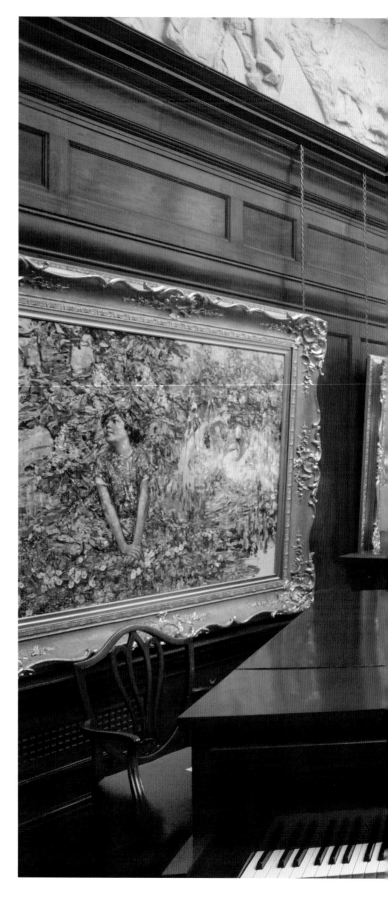

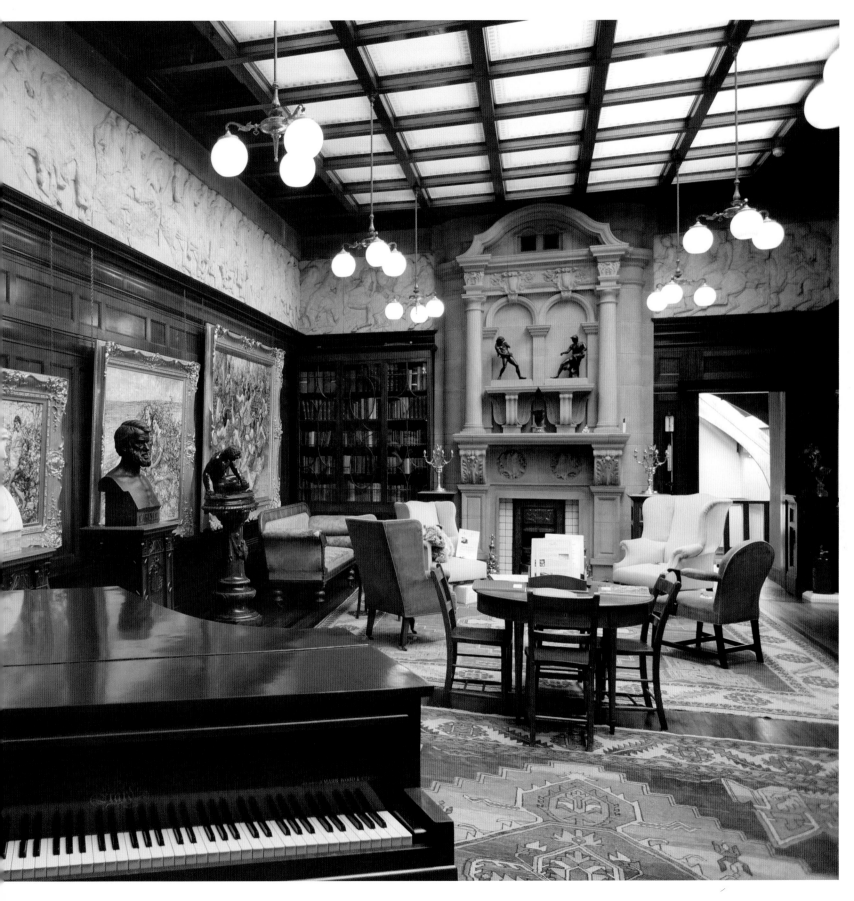

ISLE OF WHITHORN
WIGTOWNSHIRE

Confusingly perhaps, the Isle of Whithorn isn't an island at all but a village on the southern peninsula (the Machars) of the Solway coast which hangs into Wigtown Bay. Here in the far south, it is as much on the edge of Scotland as villages in the more obviously remote northwest. This informs its inscrutable character: the Solway tides and the southern light; the sea and the mud; the sea and sky. And here is a community that adheres to its harbour and to each other.

As is well marked, St Ninian, a missionary of the 4th century, who brought Christianity to the southern Picts, walked this way. While his shrine and visitor experience are four miles north at Whithorn itself, his chapel is here, a short walk on the headland. On the way, you pass the poignant memorial to the seven-man crew of the ill-fated *Solway Harvester*, who perished during a storm in 2000. Fishing is still the business of this place, the harbour at its heart, filling and emptying dramatically with the tide.

PHOTOGRAPH **PAUL TOMKINS**

FIND | WALK | EAT | SLEEP **PAGE 229**

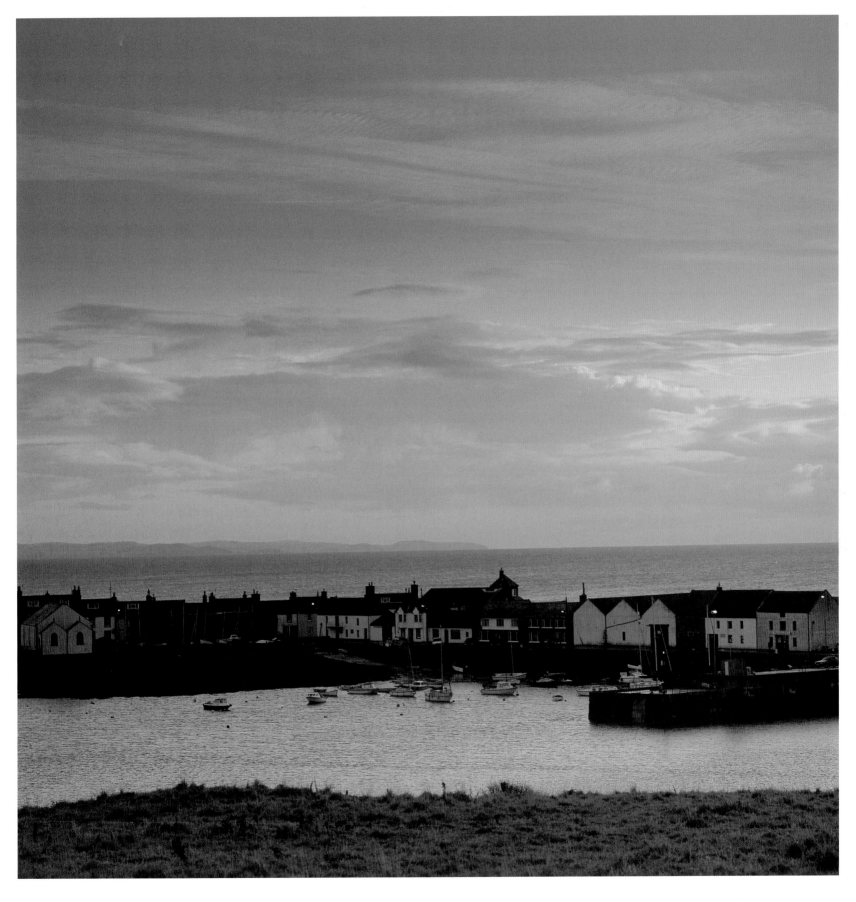

LITTLE SPARTA
SOUTH LANARKSHIRE

Carved and claimed from the Southern Upland empty quarter south of the Pentlands, this is not a conventional garden. Rather, it is the world through the lens of the visionary conceptual artist, poet and national treasure, Ian Hamilton Finlay, whose home this was for forty years. Over 250 sculptural pieces are to be come across in a carefully nurtured and watered garden that merges into the bare landscape. Finlay's signature irony is softened but not lost. He died in 2006 and the garden is administered by a trust. What now would be called in gallery speak, an 'intervention', is a life's work of art, utterly of its time and place. Open in summer only. www.littlesparta.org.uk

PHOTOGRAPH **ROBIN GILLANDERS**

FIND | WALK | EAT | SLEEP **PAGE 229**

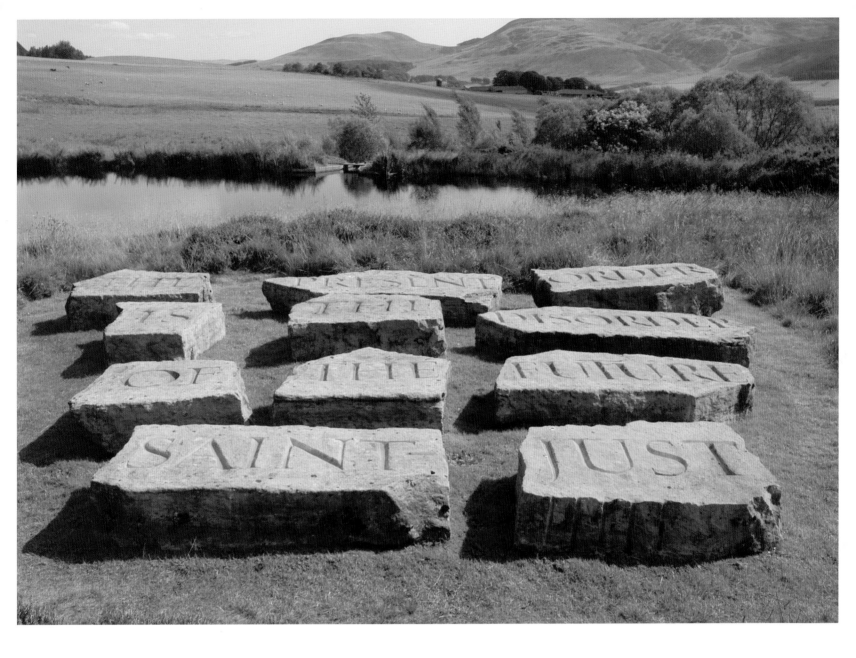

NEIDPATH
BORDERS

There is much to love about the Tweed and sunny Peebles town. Here, on its outskirts, on the road west to Blyth Bridge, is an old but occupied castle on a bluff overlooking a stretch of the river – one of the best places near Edinburgh to picnic and swim. There are good delis in the town to stock up; it's not far to walk.

Although the nature and mood of the river can change, and you must take care, people have been swimming here for centuries. There's usually a rope hanging from a branch from which to launch oneself into the deeper bit. Further down, under the castle at a wide bend, the river slows; so simple are the delights of a picnic by this river on a summer's day!

PHOTOGRAPH STEPHEN FINN

FIND | WALK | EAT | SLEEP PAGE 229

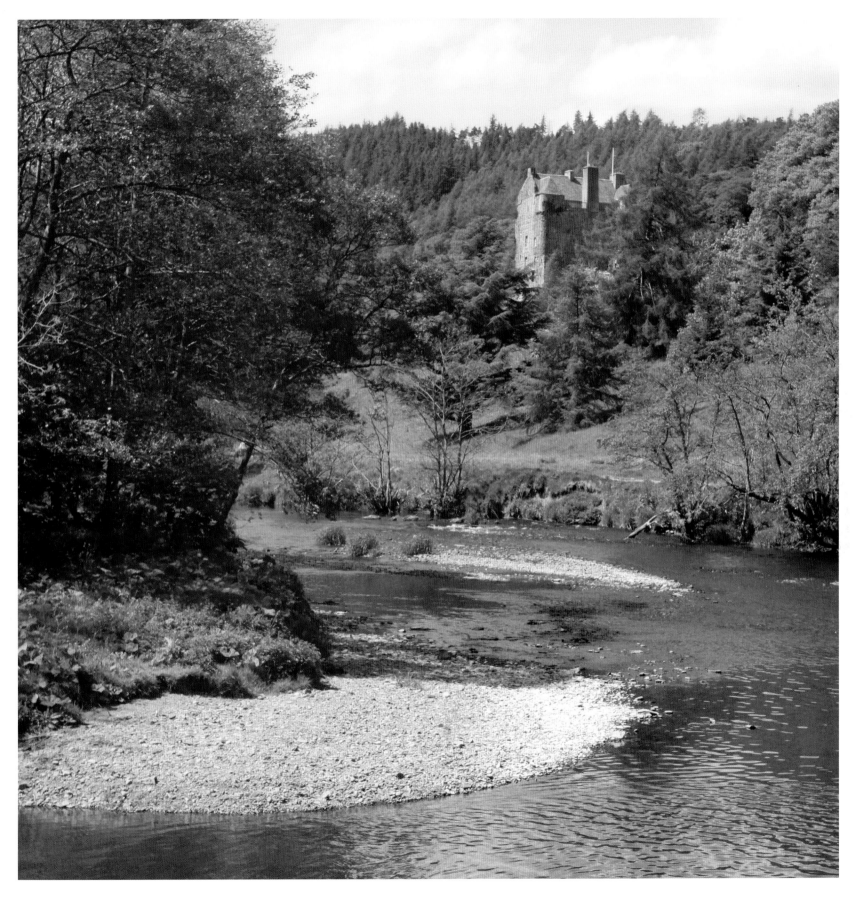

PORTPATRICK
WIGTOWNSHIRE

Here in the middle of the hammerhead peninsula, the Rhins of Galloway, way southwest of everything else, Portpatrick clusters round its crescent-shaped harbour, a haven from the sea. Twenty miles away, and often visible from the clifftops, is the coast of County Down; Portpatrick used to be Scotland's most important link with Ireland.

Now Portpatrick, as recognized by its legions of admirers and ever-returning visitors, is a village with a distinctly amiable air; bars and restaurants along the waterfront, a centre for roaming the Rhins or starting out on the 212-mile Southern Upland Way. Or more likely, just hanging out shooting the southern breeze.

PHOTOGRAPH **ALLAN DEVLIN**

FIND | WALK | EAT | SLEEP **PAGE 229**

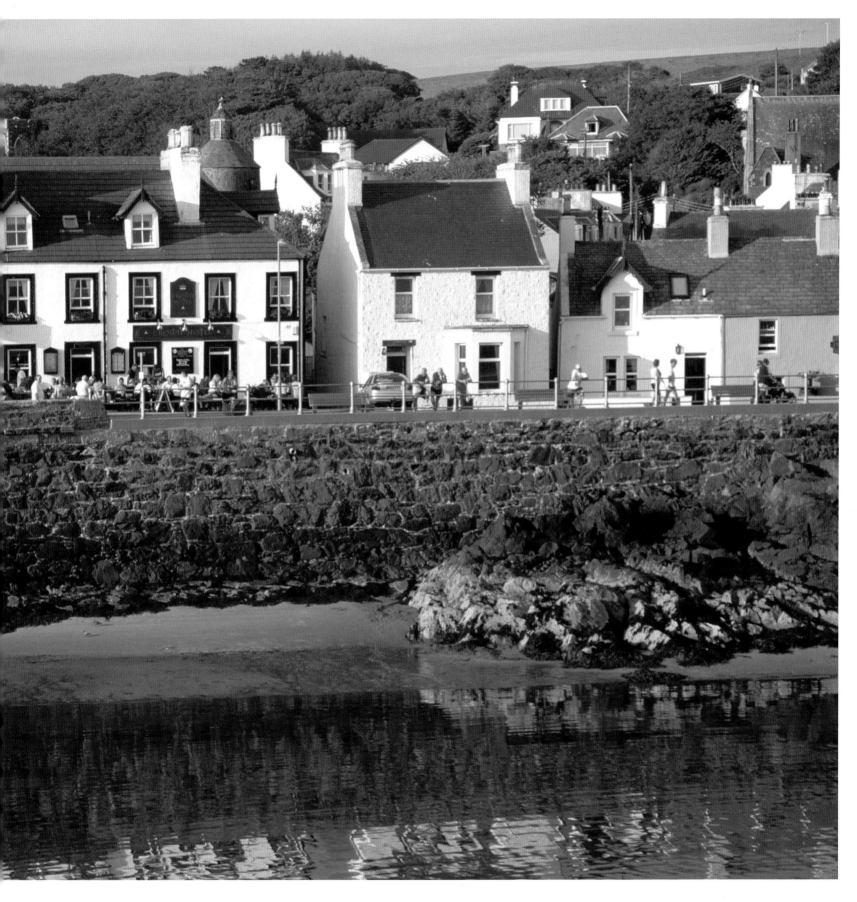

SAMYE LING
DUMFRIESSHIRE

This corner of Tibet in Scotland is simply extraordinary. The monastery of Kagyu Samye Ling sits by the road in these Border parts, a village of temples, stupas and many, many buddhas. The real retreat is over the hill but the public part is a welcoming community and a world centre of Tibetan Buddhism, under the supervision of Tibetan masters. There is accommodation for daily and longer stays, and courses in meditation, t'ai chi, yoga and spiritual matters. As surprising as it is, it seems perfectly natural in this remote setting. Samye Ling is an edifying, levelling and unique place.

PHOTOGRAPH **COLIN MCPHERSON**

FIND | WALK | EAT | SLEEP **PAGE 230**

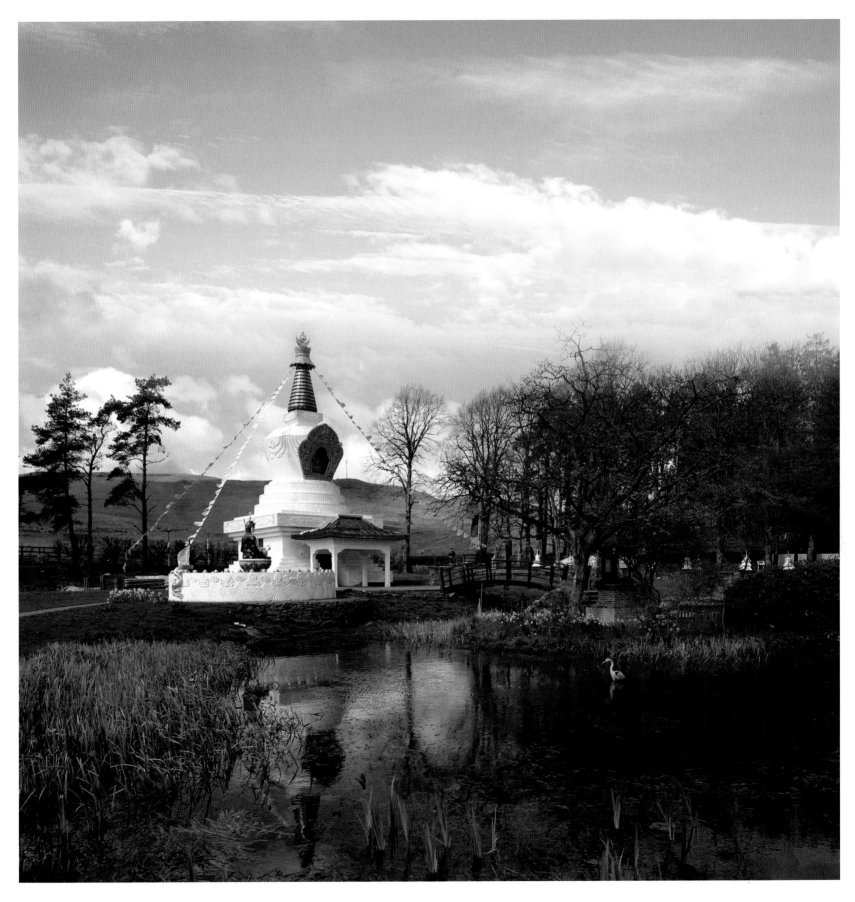

SMAILHOLM TOWER
BORDERS

Smailholm is the classic Borders peel tower, built originally in the 15th century as protection against English raiders. It was destroyed three times in the 16th century alone – clearly they never gave up. Restored in the 1980s, it got a new turf roof in 2010/11.

Although a museum, it is perhaps more a place to go to get a sense of the Borders landscape: historical, geographical and romantic. For it was frequented by Sir Walter Scott (whose family lived here) and was made famous in two of his works. He brought the artist Turner to Smailholm and later it was a subject for WH Fox Talbot, the pioneer of photography, who included it as a homage to both Scott and Turner in his 'Sun Pictures in Scotland', essentially the first coffee-table photographic book. Here it is again in this one!

PHOTOGRAPH **KATHY COLLINS**

FIND | WALK | EAT | SLEEP **PAGE 230**

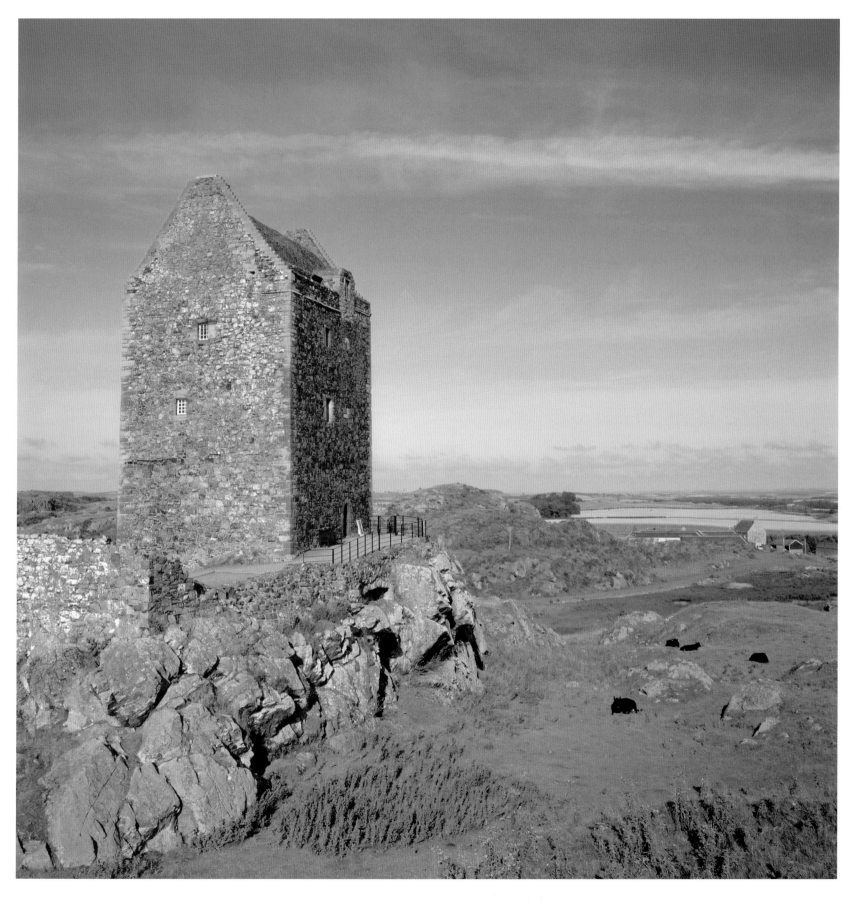

THE TWEED VALLEY
BORDERS

Not just any old river – from the wild Southern Uplands to Berwick upon England – the graceful, unobtrusive, yet Mighty Tweed, along with its tributaries, the Teviot, the Jed, the Yarrow and Esk, has nurtured strong, individual valley communities like Hawick and Jedburgh, Melrose and Galashiels, defining a very particular region of Scotland: the Borders.

This writer is from the Borders and I know that it is the river, not the sea or the mountains, or even my adopted city, that has made the man. It is, of course, impossible to choose one photograph that encapsulates the history, the particularity of this diverse topography or the landscape of one's own youth, so here are two pictures: one of a classic view and one of how it is often experienced now. Looking forward rather than back, a more recent perception of the Borders is as a place you might enjoy on a bike; there are trails and challenges at all levels of enthusiasm. There's even a cycling festival in June called Tweedlove.

MAIN PHOTOGRAPH JAS GIBSON
INSET PHOTOGRAPH IAN LINTON

FIND | WALK | EAT | SLEEP **PAGE 230**

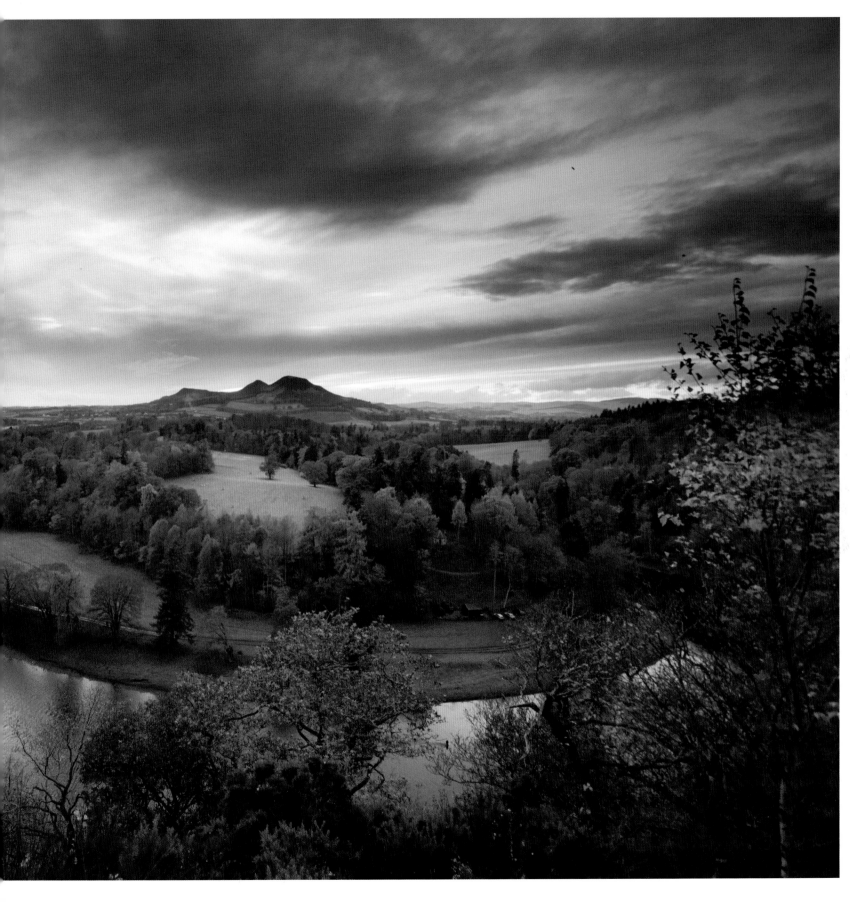

WALKING THE EILDONS
BORDERS

We say the Eildons but what we mean is the triple peak of Eildon Hill, the landmark row of shapely peaks that, with the River Tweed in the plain below, define Border Country. These are gentle, not rugged or demanding hills; an excellent half-day hike, usually from Melrose, with views of the whole of the Borders and, on a clear day, England.

The mid top is the highest at 1385 ft, with a monument to Sir Walter Scott – whose presence you are never far from in this rolling landscape (see The Tweed Valley, page 208) – and there are older historic reminders on the north hill and at Trimontium ('the three peaks'), an important Roman fort down below, by the river. It is easy, walking these well-worn paths, to feel connected to this land through all its ages.

FIND | WALK | EAT | SLEEP **PAGE 230**

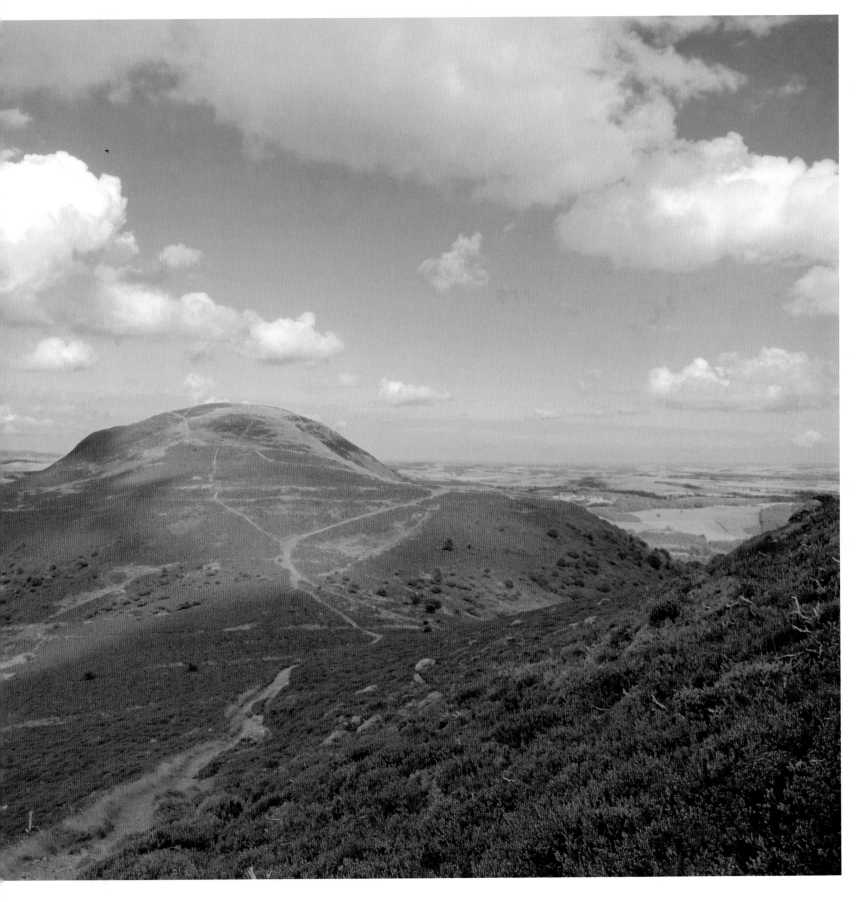

FIND | WALK | EAT | SLEEP

A DIRECTORY OF THE 100 PLACES AND HOW TO MAKE THE BEST OF VISITING THEM

For consistency all directions given for
walks within this section are from the named
'place' itself and not from the nearest town.

All recommendations are personal, tried and
tested selections. They are not chosen because
they are adjacent or convenient but because
they are good.

EDINBURGH AND EAST OF SCOTLAND

FIND | WALK | EAT | SLEEP

ARBUTHNOTT CHURCH EAST PAGE 12

FIND Arbuthnott is signed from the A90 N of Laurencekirk and from the coastal A92 N of Inverbervie: it's on the B967 • The Grassic Gibbon Centre is also well signposted and the church is at the end of the village.

WALK Walks nr Arbuthnott are recommended in the Grassic Gibbon Centre www.grassicgibbon.com 01561 361668 • Classic view of the Mearns from the Hill of Garvock, 908 ft, 1½ mls SE of Laurencekirk by the B9120 • A pleasant and surprising river walk by 'Rocks of Solitude' (2 mls) awaits thro the wooden door at the Gannochy Bridge 1 ml N of Fettercairn on the B966. There are other ambles in the grounds of Fasque House here.

EAT/SLEEP www.tolbooth-restaurant.co.uk 01568 762 287. 10 mls N of Arbuthnott in Stonehaven • www.theberviechipper.co.uk 01561 361310 in Inverbervie; 2 mls • Best go sleep in Banchory, especially Raemoir House Hotel www.raemoir.com 01330 824884.

ARTHUR'S SEAT EAST PAGE 14

FIND Arthur's Seat is visible from all over the city and is commonly approached from the foot of the Royal Mile by the Parliament and the Palace, where there's parking.

WALK The usual ascent of Arthur's Seat begins at the main entrance to Holyrood Park by the Palace. Cross the rd and take either the diagonal path that ascends under Salisbury Crags (the 'Radical Road'), or the path to the left, which is less arduous. Both from this side reach the Crags first, thence to Arthur's Seat, the highest point • An easier, more direct climb from the E side starts at Dunsapie Loch.

EAT Holyrood Palace has a large cafeteria with outdoor seating • A great tearoom at the foot of the Royal Mile is Clarinda's www.clarindastearoom.co.uk 0131 557 1888. 69 Canongate • www.sheepheid.co.uk 0131 661 7974. The pub in Duddingston Village on S side of hill; 1 ml.

SLEEP The nearest: www.macdonaldhotels.co.uk 0844 8799028. Holyrood Rd • The exceptional www.prestonfield.com 0131 225 7800. Priestfield Rd. It looks onto the hill across Duddingston Loch. 2 mls • Other Edinburgh recommendations page 231.

BIRKS O' ABERFELDY EAST PAGE 16

FIND Off the A827 between Dunkeld & Pitlochry, 10 mls W of the A9.

WALK The walk is way-marked all the way. Start either from the town square (½ ml), or the car park (2 mls, circ). Steep at the furthest stretch • The 77-ml (or 92-ml depending on the route) Rob Roy Way from Drymen to Pitlochry goes thro Aberfeldy to Grandtully (5 mls on riverside path starting at Dewar's World of Whisky), then via the golf course, 5 mls to Pitlochry • For other walks in the area see Glen Lyon page 215 and South Loch Tay page 218.

EAT www.aberfeldywatermill.com 01887 822896. Café (daytime only), gallery, bookshop, homeshop and all-round top place • www.logieraitinn.co.uk 01796 482423. Off the A9 at Aberfeldy turn-off; 8 mls • www.highlandchocolatier.com 01887 840775. Sublime chocs/coffee shop. Grandtully; 5mls.

SLEEP www.kenmorehotel.com 01887 830205. Historic village inn; 6 mls • www.theinnonthetay.co.uk 01887 840760. Contemporary inn overlooking River Tay rapids at Grandtully.

THE BOTANICS EAST PAGE 18

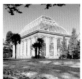

FIND The Royal Botanic Garden is in the Inverleith area to the N of the city about 2 mls from Princes St. There are 2 main entrances, Inverleith Row and Arboretum Place (café, shop, some parking).

WALK Paths and routes round the Gardens are clearly marked; you can while away hours here • There's access to the Water of Leith Walkway (which follows Edinburgh's hidden river from the Pentlands in the S to Leith) 150 yds away from the Inverleith Row entrance. www.waterofleith.org.uk

EAT www.gatewayrestaurant.net 0131 552 0606. At the main gate (there's another café by Inverleith House) • www.earthy.uk.com 0131 556 9696. Canonmills. 150 yds Inverleith Row entrance. Ethical restaurant. Home-made and home-grown • www.theorchardbar.co.uk 0131 550 0850. Howard Place. 100 yds Inverleith Row entrance. Gastropub.

SLEEP Edinburgh recommendations page 231. City centre hotels, etc 1 ml.

CALTON HILL ON DECEMBER 30TH EAST PAGE 20

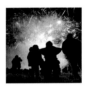

FIND Go E from Princes St up Waterloo Place. There are steps to the left after the Waterloo Restaurant, but following the Procession you will go further and ascend the Hill by the road. To carry a torch or for details of the route and programme: www.edinburghshogmanay.com.

WALK The Procession route is just over 1 ml • For walks in Edinburgh city centre, including Calton Hill www.visitscotland.com/walking.

EAT www.howies.uk.com 0131 556 5766. Airy bistro right on the corner below the Hill • www.giulianos.co.uk 0131 556 6590. Union Place opp Playhouse Theatre. 200 yds as the crow flies. The tratt to trust.

SLEEP www.apexhotels.co.uk 0131 523 1819. Waterloo Pl, en route to Hill. Good all-rounder • www.theglasshousehotel.co.uk 0131 525 8200. Below the Hill next to Playhouse Theatre and Omni Mall. Superb views from rooms around the rooftop lawn • Other Edinburgh recommendations page 231.

COMRIE CROFT EAST PAGE 22

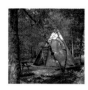

FIND Just off (250 yds) the A85, 1 ml from Comrie on the way in from Crieff (5 mls).

WALK Walks and trails are way-marked around and from the site. Ben Chonzie (3054 ft, 4 hrs) is not difficult from Glen Lednock by the single-track road N from Comrie. Ben Vorlich (3232 ft, 5 hrs) is another great Munro climbed from the road to the S of Loch Earn, 15 mls W of Comrie • The famous Deil's (or Devil's) Cauldron gorge walk from Comrie also starts on the Glen Lednock rd – and can include the ascent to the Melville Monument and the view (4½ mls, 3 hrs, circ) • For walks from Crieff, see Crieff Hydro this page.

EAT Two possibilities in Comrie: www.deilscauldron.co.uk 01764 670352. Well-loved restaurant in an 18th-century inn at start of the walk • www.royalhotel.co.uk 01764 679200. Great village hotel/restaurant and real ale pub • www.mhor.net 01877 384646. Mhor 84 restaurant and 'motel'. W on the A85 to Lochearnhead then S on the A84. 15 mls. V special, See page 168.

SLEEP Arcadia. www.comriecroft.com 01764 670140.

CRATHES GARDEN EAST PAGE 24

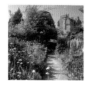

FIND Crathes is about 15 mls from Aberdeen on the A93 Royal Deeside Rd, just outside Banchory.

WALK Many way-marked walks around the 240-hectare estate through woodland and by the Coy Burn • Easy walk for a Deeside view is to Scolty Hill from marked car park on the B974 S of Banchory, with a tower to climb at the top.

EAT NTS Courtyard restaurant by the house • www.themiltonbrasserie.com 01330 844566. Reputable restaurant on Deeside Rd at gates to Crathes • www.finzean.com 01330 850710. Farm shop and great tearoom on the B976, the Aboyne Rd from Banchory; 11 mls • www.thefallsoffeugh.com 01330 822123. Tearoom on the B974 1 ml S of Banchory • www.cowshedrestaurantbanchory.co.uk 01330 820813. Excellent restaurant 1 ml N of Banchory.

SLEEP www.raemoir.com 01330 824884. Superb, informal country house hotel. 2 mls N of Banchory, 5 mls Crathes.

CRIEFF HYDRO EAST PAGE 26

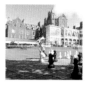

FIND Crieff is on the A85 11 mls W of Perth. Ferntower Rd, ½ ml from the High St.

WALK The Hosh and Knock. A figure of eight walk, although both parts can be done separately. Climb The Knock with its sweeping views, and the woody Hosh by Glenturret Distillery, home of Famous Grouse (distillery tours and retail www.thefamousgrouse.com). Both from the car park just past the hotel entrance • For the River Earn walk to Muthill see Drummond Castle Gardens walks below. Drummond Castle Gardens 3 mls S of Crieff.

EAT/SLEEP www.crieffhydro.com 01764 651670. Over 200 rooms, over 50 lodges. 5 restaurants, including The Meikle and the timeless Winter Garden • www.yannsatglenearnhouse.com 01764 650111. Small boutique hotel and restaurant on road in/out of Crieff • www.delivino.co.uk 01764 655665. Wine bar and restaurant in Crieff centre.

DR NEIL'S SECRET GARDEN EAST PAGE 28

FIND The Garden is at the southern, Duddingston Village entrance to Holyrood Park about 1½ mls from the Palace and the Parliament. There is a car park opposite the lochside nature reserve, 100 yds from the Manse where you enter the gates. Turn right and go thro a gate in the corner. Open from dawn till dusk.

WALK Walks in the Park are described in the Arthur's Seat and St Margaret's Loch entries on pages 213 and 217 respectively • The garden itself takes less than an hour to walk round. But linger.

EAT www.sheepheid.co.uk 0131 661 7974. The Sheep Heid pub in Duddingston Village, 200 yds away, has had mixed reports over the years (it dates from the 18th century), but it has history and atmosphere; it's right to repair here after Garden or Hill.

SLEEP Edinburgh is all around you. See Edinburgh recommendations page 231 • Nearby, on the other side of the loch, the exceptional Prestonfield: www.prestonfield.com 0131 225 7800, a historic country house boutique hotel in the city. Afternoon tea, and Rhubarb, their restaurant, p 62.

DRUMMOND CASTLE GARDENS EAST PAGE 30

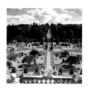

FIND Between Crieff and Muthill on the A822, the main public gate 1 ml from Muthill. Open May–October. The Castle is not open to the public.

WALK Various bucolic strolls around the estate and a satisfying river walk along the Earn, circular between Muthill village at the bend and the southern edge of Crieff (at the bridge or in the corner of the car park at the Crystal Glass Visitors Centre). The route follows this surprisingly characterful river and from 1 ml outside Muthill goes thro beautiful woods. Using two vehicles avoids the 2-ml hike on the main road. 6 mls total.

EAT/SLEEP In Muthill: www.barleybree.com 01764 681451. A stylish village inn with a great gastropub restaurant • In Crieff: www.yannsatglenearnhouse.com 01764 650111. Highly regarded restaurant and bespoke guest house • In Comrie: www.royalhotel.co.uk 01764 679200. Hotel and excellent dining, with real ale pub alongside in central square of couthy Perthshire town. 7 mls.

DUNNOTTAR CASTLE EAST PAGE 32

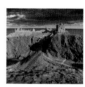

FIND Highly visible, Dunnottar is easy to find from the A90, the main road from the S to Aberdeen as you head into Stonehaven. A smaller road connects the town directly to the car park.

WALK The walk from Stonehaven harbour where you can find refreshment is a good excursion; using the road as well as the path it can be circular (3½ mls) • Further S at Crawton off the coastal A92 (3 mls), there are cliff walks around the Fowlsheugh Nature Reserve (and seabirds) • Also around Catterline (another 2 mls) and its atmospheric bay.

EAT www.tolbooth-restaurant.co.uk 01569 762287. Notable seafood restaurant upstairs at Stonehaven harbour • www.marinehotelstonehaven.co.uk 01569 762155. Pub grub also on the harbourside • www.thecreelinn.co.uk 01569 750254. Catterline, 5 mls S. Destination for gastropub food.

SLEEP Nowhere recommended in Stonehaven. Nearest good hotel is in Aberdeen: the Malmaison www.malmaison.com 01224 327370.

EDINBURGH GRAVEYARDS EAST PAGE 34

FIND Warriston is 2 mls from Princes St via either Broughton St to Inverleith Row, or Frederick/Dundas St to Ferry Rd • Access from the walking/cycle path (formerly the Edinburgh, Leith and Newhaven Railway, which divided the graveyard) has been blocked up, though you can see into it (200 yds from the Tesco store on Broughton Rd) • The main entrance is reached at the end of Eildon St, this upper, most westerly section is better maintained.

WALK Warriston is on the walk that uses the old railway track, part of the Water of Leith Walkway, which follows the river from the Pentlands, Currie and Balerno in the S of the city to Leith docks. There is a spur close to where the path crosses above the cemetery that goes to Newhaven and also W to Roseburn and Cramond. www.waterofleith.org.uk.

EAT Warriston is close to Leith (½ ml) and its many restaurants: The Shore Bar 0131 553 5080 and Fishers 0131 554 5666, both www.fishersbistros.co.uk • www.restaurantmartinwishart.co.uk 0131 553 3557. Top in town.

SLEEP www.malmaison.com 0844 693 0652 • Other Edinburgh recommendations page 231.

FALKLAND EAST PAGE 36

FIND Falkland is 8 mls from the M90, junction 8, or 1½ mls from the A92 between Dunfermline, further S on the M90, and St Andrews.

WALK Falkland nestles in the Lomond Hills: East Lomond (the nearest), West and Bishop Hill. None are difficult. Craigmead car park 1 ml from the fountain is a good place to start for East Lomond (5 mls) or East and West together (8 mls). East (with a tremendous view) can be climbed more easily by driving up to the car park by the radio masts 1½ mls from the village off the A912 • Leisurely walk through the village past Falkland House up the gorge to Maspie Den under a waterfall (2 mls). The path connects to the hill walks further up.

EAT www.campbellscoffeehouse.com 01337 858738. In the square • www.pillars.co.uk 01337 857749. Organic farm shop, nursery and café. 1 ml from village by the A912 or walk via Falkland House. Daytime only • Kind Kyttock's Kitchen 01337 857477 (no website). Tearoom. Daytime only. Closed Mondays (except July & August).

SLEEP www.covenanterfalkland.co.uk 01337 857163. Village inn opposite Palace.

THE FORTH BRIDGE EAST PAGE 38

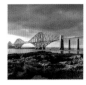

FIND Most easily found on a train journey from Edinburgh Waverley or Haymarket to Fife and all points N • Viewing from below at South or North Queensferry signed from the A90. SQ offers more perspectives and options, incl bars and restaurants • A good view from nr Newton 1 ml along the A904 signed M9/Linlithgow just before the Road Bridge. For steam train excursions www.srps.org.uk.

WALK Best walking on the S side. From S Queensferry esplanade beyond the pier, follow the shore for walks in the Dalmeny Estate • Thro the village and off the A904, follow signs for the Hopetoun Estate • Good shore and woodland walk between Blackness Castle and Abercorn Church; park either end, signed. 3 mls non-circ.

EAT/SLEEP The Dakota www.dakotahotels.co.uk 0870 423 4293. Superb designer roadhouse hotel just before the Road Bridge, with excellent brasserie • Orocco Pier www.oroccopier.co.uk 0131 331 1298. Contemporary hotel with views and busy bar-restaurant in S Queensferry High St.

GLENEAGLES EAST PAGE 40

FIND Gleneagles is just outside Auchterarder off the A9 midway (13 mls) between Dunblane and Perth. It is well signed • Nearest airport is Dundee (27 mls) • It has its own station on the line from Edinburgh N to Inverness and between Stirling and Perth.

WALK Many walks round the Gleneagles estate (dodging golf balls). Ask at reception • Notable easy walk nearby is the 'Provost's Walk' around Auchterarder (known as the 'Lang Toun' because of the length of its main street). Walk is mostly on quiet country roads. Around 5 mls circ from the Crown Inn Wynd car park • Nearest hills are the splendid Ochils to the S • Many glen and gorge starts from the villages on the A91: Alva, Tillicoultry, Dollar; well signed.

EAT www.gleneagles.com 0800 389 3737. 4 restaurants including Deseo the Mediterranean 'family' restaurant, The Strathearn fine dining and the 2 Michelin star 'Andrew Fairlie' • InDulge 01764 660033 (no website). 22 High St in Auchterarder. Excellent cooking and cake café; 2 mls.

GLEN LYON EAST PAGE 42

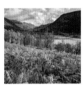

FIND Usual approach from Aberfeldy (and the A9): cross the bridge to Weem on the B846, then to Fortingall at the mouth of the Glen. At Bridge of Balgie halfway up (8 mls), continue to lochs at the head or turn S to Loch Tay (5 mls) and the A827 Killin to Aberfeldy road.

WALK Munros to walk aplenty. Meall Buidhe (3058 ft) and Stuchd an Lochain (3150 ft) are often climbed on the same trip. Both start at the car park at the Giorra Dam on Loch an Daimh at the head of the Glen. Both around 5¼ mls, not difficult • A rewarding Glen Lyon taster is the walk from Innerwick (car park) by Bridge of Balgie thro the Ben Meggernie birchwoods; an ascent of only 500 ft affords great views of the mountains.

EAT The Glen Lyon Tearoom, Bridge of Balgie. 01887 866221 (no website). Seasonal, daytime only. It's just what you want • www.aberfeldywatermill.com 01887 822896. Aberfeldy, 10 mls. Restaurant, gallery; A' things to a' folk.

SLEEP www.fortingall.com 01887 830367. Fortingall Hotel and pub (the 'Ewe') next to the famous 5000-yr-old yew tree. Boutique-standard inn and dining.

GOSFORD HOUSE EAST PAGE 44

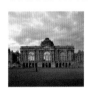

FIND www.gosfordhouse.co.uk 01875 870808. 2 mls E of Longniddry on the A198 to Aberlady and North Berwick. When House is open, use main gate. For grounds: take road on the right just before Aberlady, signed Bothy Farm Shop (100 yds). Park behind it.

WALK Walks in the grounds are up to you, there are no signboards or marked trails. Just follow paths (about 1½ mls, circ) • Nearby are the East Lothian beaches (see page 218). Nearest is the Aberlady Bay Nature Reserve on road out of the village towards Gullane. Or Gullane Bents up the road to the left at the first crossroads by Falko.

EAT Gosford Farm Shop, aka The Bothy 01875 871234 (no website). Shop and tearoom until 5pm • www.falko.co.uk 01620 843168. Gullane main street. Master cake-maker; tearoom until 5pm • www.oldclubhouse.com 01620 842008. Gullane gastropub.

SLEEP www.greywalls.co.uk 01620 842144. See page 46 or 216 for more details.

GREYWALLS EAST PAGE 46

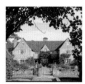

FIND Greywalls sits discreetly behind a wall beside Muirfield (members only) golf course on the eastern edge of Gullane off the A198. It is 4 mls from North Berwick and 22 mls from Edinburgh by the A1.

WALK Many East Lothian beaches are nearby: Gullane Bents in the village, Tyninghame and Seacliff E of North Berwick and Yellowcraigs (see page 218) • North Berwick Law, the conical volcanic hill, sits above the East Lothian landscape behind the town. Remnants of an Iron-Age fort and a replica of its famous whalebone are at the top. 614 ft; go by Law Rd • The other E Lothian hill, Traprain Law is higher (724 ft); this citadel home of the legendary Gododdin is signed from the A1.

EAT/SLEEP www.greywalls.co.uk 01620 842144. The hotel, an Albert Roux restaurant and afternoon tea • www.falko.co.uk 01620 843168. The 'Kaffeehaus' and amazing cake tearoom in Gullane • www.la-potiniere.co.uk 01620 843214. Excellent fine dining in Gullane Main St.

THE INTERNATIONAL BOOK FESTIVAL EAST PAGE 48

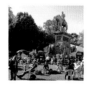

FIND Charlotte Square is at the W end of George St, one block from the end of Princes St.

WALK New Town walks aplenty with notes on history, architecture, etc in an array of books and guides on sale in the vast Book Festival bookshop • An online suggested walk route from the AA www.theaa.com/walks • A pleasantly surprising river walk (the Water of Leith) from the bridge at the corner of Hamilton Place and Deanhaugh St, 1 ml N of Charlotte Sq. It can include (up steps from the gorge) a visit to the Gallery of Modern Art. 2 mls non-circ.

EAT www.contini.com 0131 225 1550. Spacious, individual top tratt/restaurant at 103 George St; 100 yds • www.thecambridgebar.co.uk 0131 226 2120. In Thistle St. Less obvious than George St chain restaurants so may get fed when all else full. Burgers, etc.

SLEEP www.thebonham.com 0131 226 6050. Boutique west end hotel, good restaurant. ½ ml • www.tigerlilyedinburgh.co.uk 0131 225 5005. Stylish hotel/restaurant in George St. 200 yds. Other Edinburgh recommendations page 231.

JUPITER ARTLAND EAST PAGE 50

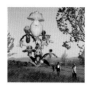

FIND The gates of Jupiter Artland on the B7015 are best reached via Wilkieston. You can approach from the Newbridge Roundabout at the end of the M8 just outside Edinburgh (3 mls), or from Edinburgh via Sighthill, the A70 and the A71. It's about ½ hr from Edinburgh city centre.

WALK There are pathways throughout the grounds. Most tours take 2 to 3 hrs • Also nr Wilkieston there's a pleasant walk through glen and woods at Almondell. Take the B7015 for Camps or East Calder. 2 mls circ.

EAT Café in the courtyard from the Silver Streak caravan. Daytime only.

SLEEP Nearest good hotels, B&Bs, etc in Edinburgh; 10 mls. Edinburgh recommendations page 231.

THE KELPIES EAST PAGE 52

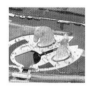

FIND The Kelpies are highly visible from the M9. From Edinburgh leave the M9 at junction 5, take first roundabout exit, follow the A9 to Etna Rd roundabout at entrance of park • From Glasgow exit the M80, junction 8 for the M876, then join the M9, leave at junction 6 to the A9.

WALK The Helix (www.thehelix.co.uk 01324 590900) is a 350-hectare parkland with new trails and walkways that connect existing landmarks, including the other enormous man-made attraction around here, the Falkirk Wheel www.thefalkirkwheel.co.uk. The Wheel joins the two great canals: the Union and the Forth and Clyde. Towpaths in either direction www.scottishcanals.co.uk.

EAT www.wheelhousefalkirk.com 01324 673490. Café/restaurant by the Falkirk Wheel • www.livingstons-restaurant.co.uk 01506 846565. Linlithgow is nearest place to go for selection of good bars and restaurants. Livingston's has long been the best. Open Tues to Sat.

SLEEP www.champany.com 01506 834532. Roadside (the A904) comfortable inn with rooms, renowned restaurant and the less expensive 'Chop and Ale House'. 10 mls S nr Linlithgow.

MORAY FIRTH VILLAGES EAST PAGE 54

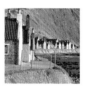

FIND The Moray Firth Villages are found between Fraserburgh and Macduff off the B9031 which follows the coast shadowing the main A98 • Crovie is at the end of the minor rd from Gardenstown • W of Macduff are Portsoy (a classic harbour) and Cullen (a sweep of beach: a larger town, but still characterful).

WALK Walk to Troup Head from Crovie off the B9031 (3½ mls return) or from same rd signed Northfield following RSPB signs for 1 ml to car park (2½ mls return) • For Sunnyside Beach take Sandend turn-off from the A98 between Portsoy and Cullen following signs for Findlater Castle. Park in farmyard (1 ml return) • A longer walk to Sunnyside starts to the E of the harbour in Cullen (5 mls return).

EAT Portsoy Coffee Shop 01261 842804 (no website). Probably the best casual food hereabouts • Dine at the County Hotel (below).

SLEEP www.thecountyhotel.com 01261 815353. The only hotel to recommend is halfway along the coast in the main street of Banff. A love letter from France!

MURRAYFIELD EAST PAGE 56

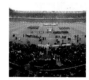

FIND In the Murrayfield area W of the city centre via Roseburn St where there is now a tram stop. It is 1 ml from Haymarket station.

WALK Walking tours of the Stadium. 0131 346 5160 • The Water of Leith Walkway which links the docks of Leith and Balerno to the W is a great way to traverse the city. It goes thro Roseburn Park behind the stadium; walk in either direction. Going E to eg the Dean Village and the Gallery of Modern Art is an especially fine section; 2 mls. www.waterofleith.org.uk.

EAT/SLEEP Edinburgh recommendations page 231.

OLD ST PAUL'S EAST PAGE 58

FIND Old St Paul's sits discreetly behind Waverley Station in Jeffrey St under the high North Bridge. It can also be approached by Carrubbers Close from the Royal Mile, 100 yds down from North Bridge.

WALK Easily included tho oft forgotten in a walking tour of the Old Town. Nr the lower end of the Royal Mile this could include Canongate Kirk and Graveyard, John Knox's House and Holyrood Palace • For walks in Holyrood Park see St Margaret's Loch below.

EAT www.monteithsrestaurant.co.uk 0131 220 0730; 200 yds • www.blackfriarsedinburgh.co.uk 0131 558 8684; 500 yds.

SLEEP www.motel-one.com/en/ 0844 693 1077; 250 yds • www.radissonblu.co.uk 0131 557 9797; 250 yds • Edinburgh recommendations page 231.

THE PALM COURT EAST PAGE 60

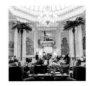

FIND The Palm Court is through the revolving door and the foyer on the ground floor. The Balmoral is the building with the clock tower at the E end of Princes St. Everybody in Edinburgh knows where it is.

WALK The Balmoral is directly between the Old Town and the New Town, both of which are best navigated on foot. It's 200 yds from the steps to Calton Hill and within easy reach of Holyrood Park and Arthur's Seat (page 14).

EAT/SLEEP www.thebalmoralhotel.com 0131 556 2414. A top hotel; afternoon tea should be booked. It also has one of the best restaurants in the city, Number One Princes St • www.caferoyaledinburgh.co.uk 0131 556 1884. 50 yds across and behind Princes St. The Café Royal Oyster Bar and also a local pub; same period, similar legendary status to the Balmoral.

PRESTONFIELD EAST PAGE 62

FIND 2 mls S of the city centre. Approach via Old Dalkeith Rd then Priestfield Rd.

WALK For nearby walks in Holyrood Park on the other side of the Loch see Arthur's Seat page 213 (though you will have to go round the Loch via Duddingston Village) • Dr Neil's Secret Garden is very much worth a visit (page 28).

EAT/SLEEP www.prestonfield.com 0131 668 3346. Rhubarb is the fine dining restaurant • Edinburgh recommendations page 231.

PRINCES STREET GARDENS EAST PAGE 64

FIND Find Princes St, look up at the Castle, and the gardens are between, mainly below street level. The East Gardens are the ones with the prominent 200-ft-high Scott Monument.

WALK The 287 steps of the Scott Monument can be climbed www.edinburghmuseums.org.uk • Edinburgh city centre offers much to explore on foot, not only in the Old Town. Princes St is a mile long. At one end there's St Cuthbert's Graveyard, and at the other, and 200 yds beyond the Balmoral Hotel up Waterloo Place, there are steps to Calton Hill and panoramic views.

EAT www.thescottishcafeandrestaurant.com 0131 226 6524. Underneath the National Gallery, entry within and overlooking the Gardens.

SLEEP www.thebalmoralhotel.com 0131 556 2414. The landmark Balmoral Hotel 150 yds from the Gardens, see page 60 • www.motel-one.com/en/ 0844 693 1077. Corner of Market St and Cockburn St. Budget hotel overlooking Gardens • Other Edinburgh recommendations page 231.

ROSSLYN CHAPEL EAST PAGE 66

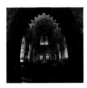

FIND 10 mls S of the city centre, head for the ring road via Newington or Straiton, then take the A703 for Penicuik. Roslin village is 1 ml from the Gowkley Moss roundabout; the Chapel and parking are 500 yds from the village crossroads.

WALK The popular walk here (with or without the Chapel) is Roslin Glen, easily found from the car park. There's a ruined castle (1½ mls) • You can also approach via the B7003 to Rosewell, signed Rosslynlee Hospital • More energetic and less populated walks on the Pentland Hills start from various places on the A702. Nearest: signed for Castlelaw Fort (1–5 mls), starts 1 ml from the road.

EAT/SLEEP www.rosslynchapel.org.uk. Café in the Visitor Centre. Nowhere nearby to recommend • See Edinburgh recommendations page 231.

ST MARGARET'S LOCH EAST PAGE 68

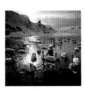

FIND Holyrood Park surrounding Arthur's Seat is hard to miss but the usual approach is from the foot of the Royal Mile by the Palace where there's parking. All the Park is within easy walking distance from the Old Town, St Margaret's Loch and also Dunsapie up the hill. Duddingston Loch is a little further (1½ mls), see Dr Neil's Garden on p28.

WALK It's an easy amble to St Margaret's Loch and up to the chapel • Coming from the car park by the Palace it's about 1 ml return • There are numerous walks around Arthur's Seat further described on page 213 • The walk to the E of the Park close to St Margaret's Loch includes 'Hunter's Bog', which, along with 'Volunteer's Walk' starting opposite the car park, takes you to the top and the view.

EAT Holyrood Palace has a large cafeteria with outdoor seating • A great tearoom at the foot of the Royal Mile is Clarinda's www.clarindastearoom.co.uk 0131 557 1888. 69 Canongate. 200 yds from Park car park • An excellent restaurant (tho not close but appropriate after a walk in the Park) is www.thegardenerscottage.co 0131 558 1221; 15 mins walk.

SLEEP www.macdonaldhotels.co.uk 0844 8799028. Holyrood Rd • Main Edinburgh recommendations page 231.

SOUTH LOCH TAY EAST PAGE 70

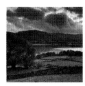

FIND Turn off A9 at Aberfeldy, the A827 for Kenmore • A spectacular approach from further S on the A9 at Dunkeld, the A822 to Amulree, then the high, unclassified single-track road (on the right just beyond Amulree), dropping down to Kenmore from the S • Killin is off the A85 Lochearnhead to Crianlarich.

WALK On the Amulree road (above) 1 ml from Kenmore there's a car park with a trailboard. Kenmore Hill is an easy circular route with great views of the Loch (3 mls) • A dramatic view from the N is from Black Rock. Start ⅔ ml from Kenmore by the minor road to the right after Kenmore Bridge (4 mls, circular) • The wonderful Falls of Acharn are on a (steep at first) circular walk from Acharn village 2 mls from Kenmore (1½ mls). And there's always Ben Lawers!

EAT www.aberfeldywatermill.com 01887 822896. Café (daytime only), gallery, bookshop, homeshop and all-round good place. 5 mls from the Loch • www.logieraitinn.co.uk 01796 482423. Off the A9 at Aberfeldy turn-off; 13 mls • www.highlandchocolatier.com 01887 840775. Sublime chocs/coffee shop. Grandtully; 9 mls.

SLEEP www.kenmorehotel.com 01887 830205. Historic village inn • www.theinnonthetay.co.uk 01887 840760. Inn overlooking rapids of the river. Grandtully; 9 mls.

STONEHAVEN POOL EAST PAGE 72

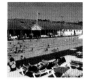

FIND Just off (and visible) from the A90 on the way out of town to Aberdeen.

WALK The most notable walk hereabouts would be the easy stroll to the impressive ruins of Dunnottar Castle (also in the book, page 32) www.dunnottarcastle.co.uk. 1 ml S of town; a cliff walk there and a quiet country road back; 4 mls.

EAT The Tolbooth by the harbour. www.tolbooth-restaurant.co.uk 01569 762287. Fresh imaginative seafood in a historic room overlooking the boats • Sandy's in the town square and The Bay on the esplanade by the Pool are both famous for the real fish 'n' chips.

SLEEP Alas, nowhere to highly recommend in Stonehaven itself. Nearest good hotel is in Aberdeen: The Malmaison www.malmaison.com 01224 327370.

SUMMERHALL EAST PAGE 74

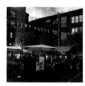

FIND www.summerhall.co.uk 0131 560 1581. Summerhall Place by the SE corner of the Meadows.

WALK Summerhall is nr Holyrood Park and its walks around Arthur's Seat (page 213) • Also (and 4 mls further S), there are woody and airy walks around Blackford Hill and the Hermitage of Braid (up to 6 mls, circ). Park/walk from Cluny Gardens, Morningside or Braid Hills Drive.

EAT/SLEEP Royal Dick Bar and Restaurant off the central courtyard. Food until 10pm • Café on outside corner, daytime only • The nearest good restaurant is Hanedan in W Preston St. www.hanedan.co.uk 0131 667 4242; 200 yds. Closed Monday • Edinburgh recommendations page 231.

YELLOWCRAIGS EAST PAGE 76

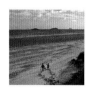

FIND Head for Dirleton nr North Berwick off the A1. From Edinburgh best take second Tranent turn-off and hit the coast at Longniddry, following to Aberlady then Gullane. 15 mls. The 1 ml of road to the beach and busy car park is on the left at the eastern end of Dirleton village.

WALK From the car park it's only 100 yds to the dunes, walking is easy, the beach stretches 1 ml to North Berwick or equally you can go W to Gullane • Other great beach walks are at Tyninghame: look for the turn for the village on the A198 North Berwick road off the A1, go 1 ml further, take the farm road on the right to the end (1 ml) and park.

EAT Gullane is the nearest place for good food: www.la-potiniere.co.uk 01620 843214. Top dinner • www.greywalls.co.uk 01620 842144. Great afternoon tea and an Albert Roux dining room. See page 46 • www.oldclubhouse.com 01620 842008. Gastropub • www.falko.co.uk 01620 843168. Superb tearoom.

SLEEP Greywalls (as above) • In North Berwick, the Marine www.macdonaldhotels.co.uk 01620 892406.

HIGHLANDS, ISLANDS AND NORTH OF SCOTLAND

FIND | WALK | EAT | SLEEP

THE BLACKHOUSE VILLAGE NORTH PAGE 78

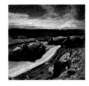

FIND 20 mls W of Stornoway by the A858, 6 mls N of the well-signed Callanish Stones and nr the Carloway Broch.

WALK Bracing, way-marked and notable coastal walk starts from the Village where you can park. Signboarded, non-circular, up to 10 mls • There's a shorter circular walk via Loch Garenin and Laimishader • The Village teashop can recommend other walks.

EAT/SLEEP The Village is in itself self-catering accom. www.gearrannan.com 01851 643416. Teashop/café • Nearest recommended places in W Lewis (tho 30 mls SW to Uig) are the wonderful Auberge: www.aubergecarnish.co.uk 01851 672459. Good rooms and dining. And the view! • Also nr Uig www.bailenacille.co.uk 01851 672242. On the famous Timsgarry Beach • On the way to Uig: Loch Croistean Coffee Shop & Restaurant 01851 672772 (no website). Home-made with love.

CASTLE TIORAM NORTH PAGE 80

FIND The Castle on its island is 3 mls from the A861, the beautiful drive between the Ardnamurchan Peninsula and the A830, the Road to the Isles, between Fort William and Mallaig. There's a car park at the end of the road. You can only cross the 100-yd causeway at low tide.

WALK The walk from the car park to the ruin is short, but this peninsula is too good not to explore. There's a 3-ml moderate circular walk from Cul Doirlinn where you park. Go N following the coast, then cross inland and back to the coast; great views of Loch Moidart and the distant Hebrides. It links to the well-signed 'Silver Walk' that starts on the A861 nr Kinlochmoidart (there is a route board), from which there are brilliant views incl the Castle. Non-circ, up to 8 mls.

EAT/SLEEP www.glenuig.com 01687 470219. On the A861 6 mls N. Comfortable rooms, a bunkhouse, decent food with good green credentials and many activities, especially kayaking. Seaside and roadside location.

THE CEILIDH PLACE NORTH PAGE 82

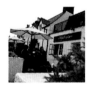

FIND They say that the Ceilidh Place is 'at the end of the A835 and the centre of the universe'. This is partly true. The A835 goes N and S thro Ullapool, 56 mls from Inverness. It's on W Argyle St one street back from the waterfront and the ferry pier to Lewis.

WALK The Ceilidh Place is in every way the social/activity hub of Ullapool, take their advice on local walks. Books in the bookshop offer innumerable suggestions • Walking around Assynt, it's coast and hills, splendid at all levels • See also Stac Polly page 120.

EAT/SLEEP www.theceilidhplace.com 01854 612103. You would of course stay and eat here. Hotel has rooms at various prices; the bunkhouse over the road is much cheaper • www.thearchinn.co.uk 01854 612454. Pub and hotel on the waterfront, well known for good grub and friendly folk • www.theteastore.co.uk 01854 612995. Daytime café along Argyle St. No frills, home-made.

GLEN COE NORTH PAGE 84

FIND The A82 between Crianlarich/Tyndrum and Ballachulish/Fort William goes thro Glen Coe. The Glen itself, between Kings House and Glencoe village, is about 11 mls long.

WALK Aonach Eagach is a major expedition: take advice (6 mls, allow up to 9 hrs) • Lost Valley, where the Macdonalds famously hid their cattle, from an always busy car park on the A82 is 6 mls from Kings House (2½ mls, but allow 2/3 hrs) • Signal Rock from Glencoe Visitor Centre (and many other walk options), 1½ mls.

EAT www.craftsandthings.co.uk 01855 811325. Daytime coffee shop on the A82 1 ml from Glencoe village • www.clachaig.com 01855 811252. Legendary walkers' pub: food, drink and rooms. 1 ml off the A82 nr Glencoe Visitor Centre.

SLEEP Clachaig Inn (above) • www.bridgeoforchy.co.uk 01838 400208. On A82, 14 mls S. The landmark Bridge of Orchy Hotel with bar and restaurant.

HEBCELT FESTIVAL NORTH PAGE 86

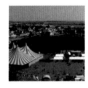

FIND Once you arrive in Stornoway, you can't miss it! In July. Main ferry route from Ullapool takes 2 hrs 40 mins • Another ferry to Tarbert in the S of Harris (1 hr drive) is from Uig in N of Skye; 1 hr 40 mins. Both www.calmac.co.uk 0800 066 5000 • Flights to Stornoway from Glasgow/Edinburgh/Inverness www.flybe.com.

WALK There's great walking in the landscaped grounds of Lewis (Lews) Castle. Orientation boards at the main gates • Willowglen Trail (2 mls) or River Creed Trail (3 mls) or combine • There's a longer and unforgettable coastal walk 10 mls N of Stornoway via the B895 to Tolsta Head (car park at Traigh Ghearadha) and the 'Bridge to Nowhere', extending to the N coast at Sgiogarstaigh (Skigersta) nr Port Nis (up to 10 mls, non-circ).

EAT www.digbychick.co.uk 01851 700026. Bank St. Long-established favourite bistro • www.thai-cafe-stornoway.co.uk 01851 701811. Surprisingly good Thai food.

SLEEP www.royalstornoway.co.uk 01851 702109. Best hotel in town • www.theparkguesthouse.co.uk 01851 702485. Best guest house.

INSHRIACH POTTING SHED NORTH PAGE 88

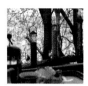

FIND Inshriach Nursery is on the back road (from the main A9), the B970 between Kingussie and Coylumbridge/Aviemore, 2 mls S of the Rothiemurchus Centre at Inverdruie. www.inshriachnursery.co.uk. Open Mar–Oct, Wed to Sun.

WALK There is a huge network of walks in and around the Rothiemurchus and neighbouring estates. • Walks around magnificent Loch an Eilein start from the car park signed off the B970, 1 ml towards Inverdruie (and Aviemore) • 3 mls off the same rd (signed to Glen Feshie), but less frequented, is the wonderful walk by the Uath Lochans.

EAT www.inshriachnursery.co.uk 01540 651287. On the B970, 2 mls Coylumbridge. Tearoom • www.rothiemurchus.net 01479 812345 Druie Café Restaurant and deli/farm shop at Rothiemurchus Centre • www.oldbridgeinn.co.uk 01479 811137. Between Coylumbridge and Aviemore. All-round great pub and restaurant. 3 mls.

SLEEP www.hiltonaviemore.com 01479 810661. Good for families (also called the Coylumbridge Hotel) • www.corrourhouse.co.uk 01479 810220. Luxury B&B. At Inverdruie; 2 mls • www.inshriachhouse.com 01540 651341. Lovely, comfy mansion for house parties; 1 ml.

ISLEORNSAY NORTH PAGE 90

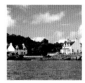

FIND Isleornsay is ½ ml from the A851, the main road in the S of Skye (and one of the best bits of road on the island). It connects Armadale (6 mls and the ferry from Mallaig) and Broadford (10 mls) on the A87 from Kyle of Lochalsh and the Skye Bridge.

WALK The mountain hikes and hill walks are to the N. On the Sleat peninsula walks are gentler. The Point of Sleat, the most southerly point, has a 5 ml coastal walk that includes lovely Camas Daraich beach (circ from car park at Aird of Sleat, the end of the road) • From the car park at Armadale there's a short but interesting walk (1 ml circ) with views to Mallaig.

EAT/SLEEP www.eilean-iarmain.co.uk 01471 833332. The hotel at the quayside. Great atmos in all rooms and the bar. Decent dining • www.kinloch-lodge.co.uk 01471 833333. Top country house hotel, home of Lord and Lady Macdonald, Michelin restaurant. 3 mls • Toravaig Hotel www.skyehotel.co.uk 01471 833231. 5 mls • Duisdale House www.duisdale.com 01471 833202. Same owners as Toravaig. 4 mls. Both excellent small hotels on same A851.

KISIMUL CASTLE AND BARRA NORTH PAGE 92

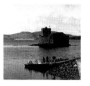

FIND Ferries to Barra from Oban, Lochboisdale in S Uist and from Eriskay, the small island to the N www.calmac.co.uk 0800 066 5000 • A daily flight from Glasgow to Barra lands on Cockleshell Beach. www.flybe.com.

WALK Tangasdale Beach (where Barra Live is held in July), 1 ml from Castlebay by the Isle of Barra Hotel to Seal Bay 1 ml further round: a great beach and a rocky Hebridean shore (with seals) • Other beach walks in the N of Barra by the landing strip (3 mls from Castlebay) • Heaval, Barra's mini-Matterhorn (1257 ft), from Castlebay (about 2 hrs), has the view.

EAT/SLEEP www.castlebayhotel.com 01871 810223. The hotel you see from the ferry as you approach, with views back over the Castle and the bay. Great bar • www.isleofbarrahotel.co.uk 01871 810383. The other hotel beside its own beautiful bay. By Tangasdale Beach. Not an architectural triumph; restaurant Ok tho.

KNOYDART NORTH PAGE 94

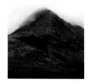

FIND For visitors there's no way to Knoydart by car. There are 2 ferry services from the 'Knoydart Steps' at Mallaig Pier. The MV Western Isles takes 45 mins from Apr–Oct, around 5 a day www.westernislescruises.co.uk 01687 462233. They also do scenic cruises on Loch Nevis • A smaller but faster ferry service has up to 8 a day from Mallaig, 30 mins. www.knoydartferry.com 01687 462916 • Or walk 17 mls from Kinloch Hourn.

WALK Ferry from Knoydart to Tarbet on Loch Nevis allows a walk to Bracorina, then Loch Morar on the Mallaig road (3 mls) • On Knoydart there are walks of all kinds incl low level. Four Munros (above 3000 ft) and 3 Corbetts (2500–3000 ft). Good website: www.walkhighlands.co.uk.

EAT www.knoydart-foundation.com 01687 460191 Pottery tearoom • www.theoldforge.co.uk 01687 462267 Mainland Britain's remotest pub. Visit essential.

SLEEP www.doune-knoydart.co.uk 01687 462667. 5 mls Inverie then ¾ ml track, but they collect you from Mallaig. Superb remote accom, great dining room overlooking the bay • www.knoydarthouse.co.uk 01687 460012. Exceptional de-luxe 5 room cabin • www.knoydart-foundation.com. Details of 5 bunkhouses and 2 very good B&Bs.

THE MACHAIR NORTH PAGE 96

FIND To get to the Uists from the mainland take a ferry to Stornoway, Lewis from Ullapool or Uig in N Skye to Tarbert in S Harris, then a ferry from Leverburgh to Lochmaddy. Alternatively to S Uist direct (Lochmaddy) from Oban or via Barra. www.calmac.co.uk 0800 066 5000 • There are flights to Benbecula (from Glasgow), Stornoway and Barra. www.flybe.com.

WALK Dalabrog (Daliburgh), 2 mls from the ferry at Lochboisdale in S Uist, to the N of Benbecula, the causewayed island between S and N Uist, is 22 mls • The A865 is never more than 1 ml from the W coast and the Machair; it's almost one continuous beach, which you can follow by road or pathways (the Machair Way). In the middle, a good place to start is at Tobha Mòr (Homore) 6 mls S of the Benbecula causeway.

EAT/SLEEP www.hamersayhouse.co.uk 01876 500700. Lochmaddy, N Uist • www.langasslodge.co.uk 01876 580285. 4 mls S of Lochmaddy. Same ownership, both good modern hotels with decent restaurants • www.orasayinn.com 01870 610298 East of S Uist off the A865. Reputation for pub food.

OLD MAN OF STORR NORTH PAGE 98

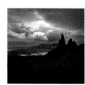

FIND On the A855 Staffin road about 6 mls N of Portree.

WALK The walk to the Old Man itself is one of Skye's most rewarding. Car park clearly marked. Height climbed is about 1000 ft; 2½ mls there and back • The Ridge especially going N offers a longer hike • See also page 106: The Quiraing 8 mls further up the A855.

EAT The Small and Cosy Teahouse 01470 562471 www.smallandcosyteahouse.co.uk is on the Staffin road 10 mls N. Lovely soup, bread and cakes • Ellishadder Art Cafe is 7 mls N nr the 'Kilt Rock', 300 yds W of the road. www.ellishadderartcafe.co.uk 01470 562734. Both daytime only • For dinner, the Glenview (below) is a must.

SLEEP The Glenview www.glenviewskye.co.uk 01470 562248. On same Staffin road, the A855 N of Portree. Simple, stylish, friendly (but small) inn • Dun Flodigarry www.hostelflodigarry.co.uk 01470 552212. Top, independent eco-hostel 15 mls N.

PETE'S BEACH NORTH PAGE 100

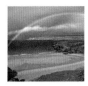

FIND On the N coast main road, the A838, 5 mls E of Durness • If you're coming from the E, from the Thurso direction, it's where the road hits the coastline again after the long circuit of Loch Eriboll. There's a lay-by.

WALK The beach is across the road from the lay-by – a short, simple walk down the grassy slope • A proper stroll starts 200 yds along the road to Durness: the Ceannabeinne Township Trail. There's a marker board. A great historical and outdoor introduction to this coast.

EAT/SLEEP Both for food, shelter and sustenance you can't find better than Mackay's – in their family for generations, yet stylish, friendly, contemporary. They think this is their beach too! www.visitmackays.com 01971 511202. Next door to Mackay's and also theirs is the Lazy Crofter Bunkhouse (same contact) • And at the opposite end of the spectrum, Croft 103: top eco-lodges overlooking Loch Eriboll www.croft103.com 01971 511202 • Campsite in Durness: www.sangosands.com 01971 51172.

PLODDA FALLS NORTH PAGE 102

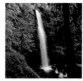

FIND From Drumnadrochit on Loch Ness 12 mls W to Cannich, then 5 mls to Tomich. Woodland track 3 mls to car park, then ¼-ml walk.

WALK A board at the car park shows the 'Tweedmouth Trail', a 1½-ml loop • In Glen Affric itself, 4 mls from Cannich, a superb woodland walk takes in another waterfall, Dog Falls, and the perfect lochan, Coire Loch: From Dog Falls car park follow way-marking, the red route (among others) is 3¾ mls circ.

EAT/SLEEP www.tomichhotel.co.uk 01456 415399. Perfect highland hideaway in nearby village • www.staylochness.co.uk 01456 450991. The Loch Ness Inn. Great roadside stop and sleep S in Drumnadrochit 21 mls E.

PLUSCARDEN NORTH PAGE 104

FIND From the A96 7 mls W of Elgin, follow signs S • From the W (Nairn), take the B9010 S from Forres turning left at Briach.

WALK Easy coastal walk between Findhorn and Burghead by a sweeping beach (Burghead Bay). Part of the Moray Coast Trail. You can start in Forres and extend to Lossiemouth or beyond (5–15 mls). The Burghead to Hopeman circ is 4 mls • A circular woodland walk that starts from S Forres at the Leanchoil Hospital (6 mls from the Abbey) or its shorter version starting at Rafford on the B9010 (4 mls) both include the Califer viewpoint with a marvellous view of the Moray coast.

EAT www.bakehousecafe.co.uk 01309 691826. Findhorn. Exceptional • www.1629lossiemouth.co.uk 01343 813743. Italian and seafood on the bay.

SLEEP www.pluscardenabbey.org. The Abbey Retreat • www.boath-house.com 01667 454896. Superb country house hotel with Michelin restaurant • www.mansionhousehotel.co.uk 01343 548811. Elgin.

THE QUIRAING NORTH PAGE 106

FIND About 20 mls N of Portree by the main A855 • Or more spectacularly, first by the A87 (a better road) to Uig, then 4 mls on the unclassified road to Staffin.

WALK Part of the Trotternish Ridge so walks either side of the car park, but for the Quiraing itself there's a well-signposted route among the formations. The full circular is 6 mls but there are many shorter options • There's another start from the A855 2 mls N from the Uig junction. Rough terrain, max climb 1400 ft.

EAT/SLEEP These recommendations the same as for the Old Man of Storr which is 10 mls S, see page 220 • www.thesmallandcosyteahouse.co.uk 01470 562471 • www.ellishadderartcafe.co.uk 01470 562734 • www.glenviewskye.co.uk 01470 562248. A destination roadside inn and restaurant • www.hotelflodigarry.co.uk 01470 552212. Great eco-hostel with views.

RAASAY NORTH PAGE 108

FIND Regular car ferry from Sconser, 12 mls N of Broadford, 13 mls S of Portree. Ferry arrives nr Raasay House. www.calmac.co.uk 0800 066 5000.

WALK Walk guides at the ferry or the House • Walk to Dun Caan via old iron mine nr Inverarish village ('official' walk starts at Suishnish Pier – the old ferry landing) signed up the old railway track • Or start from the road to the North End; 10 mls. Can be circ. 1453 ft. Views of all E Skye, Kintail and beyond on the mainland.

EAT/SLEEP www.raasay-house.co.uk 01478 660300. Hotel and hostel accom in a grand historic house (once stayed in by Boswell and Johnson) from suites to bunkrooms. Bistro/café and bar. Exemplary island facilities.

ROTHIEMURCHUS NORTH PAGE 110

FIND The Rothiemurchus Centre from which activities emanate, is on the B970 Coylumbridge rd 2 mls from Aviemore, which is on the A9 30 mls S of Inverness. Aviemore railway station is a 30-min walk.

WALK There is a huge network of walks in and around the estate. The famous Lairig Ghru, the ancient right of way, starts/ends here at Coylumbridge (19 mls, usually a whole day) • Walks around Loch an Eilein start from the car park signed off the B970 between Coylumbridge and Kingussie • 1½ mls off the same rd (signed to Glen Feshie) but less frequented is the wonderful walk by the Uath Lochans.

EAT www.oldbridgeinn.co.uk 01479 811137. Between Coylumbridge and Aviemore. All-round great pub and restaurant • www.inshriachnursery.co.uk 01540 651287. On B970, 3 mls Coylumbridge. Superb tearoom (see page 220) • www.rothiemurchus.net 01479 812345. Druie restaurant and deli/farm shop at Rothiemurchus Centre.

SLEEP www.hiltonaviemore.com 01479 810661. Good family hotel (also called the Coylumbridge Hotel) • www.coignashee.co.uk 01540 670109. Great guest house. Newtonmore; 16 mls S.

SCARISTA BEACH NORTH PAGE 112

FIND The A859 S from Tarbert hits the coast at Luskentyre and follows it to Rodel (23 mls). Scarista is about halfway, 12 mls from Tarbert. Ferry from Uig in Skye to Tarbert www.calmac. co.uk 0800 066 5000.

WALK All the beaches have car parks; walk as you will. Scarista 1–2 mls • For Northton Beach, head 2 mls S from Northton turn-off, take a right nr the end of the village strip to beach 250 yds • 3 mls N of Tarbert (N Harris) take the single track B887. 4 mls from the turn-off at Meavaig car park, a 1½-ml track (Glen Meavaig) leads to the N Harris Eagle Observatory. The longest single (and spectacular) path in the Western Isles, Meavaig to Bogha Glas is also here (10 mls, non-circ).

EAT Temple Cafe 07876 340416 (no website). 2 mls S of Scarista at Northton turn-off after the village. Home-made food incl pizzas.

SLEEP www.scaristahouse.com 01859 550238. Across the rd from the beach, an idyllic small country house hotel with great restaurant (for dinner) • www.hotel-hebrides.com 01859 502364. In Tarbert where the ferry comes in. Contemporary hotel with good café/bar/restaurant • www.harrishotel.com 01859 502154. Also in Tarbert, more trad but friendly island hotel with bar/restaurant and lovely garden.

SECRET BEACH/OLD MAN/DRUMBEG NORTH PAGE 114

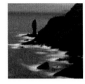

FIND The road is the B869 immediately on the left leaving Lochinver on the A837 if you are heading N away from the coast; or from the other direction, on the right ½ ml S of Kylesku. About 22 mls • The Old Man is by unclassified rd signed from Stoer village (3 mls) • Secret Beach 2 mls N of the Achmelvich turn-off (2 mls from Lochiver) and 250 yds beyond sign for Cathair Dhubh Estate. Park on the right, cross the road; discreet sign for 'the Mill'. Follows the burn.

WALK The impressive 200-ft high sea stack, the Old Man of Stoer, is off the B869 road from Stoer village. 3 mls to the car park at the lighthouse. Various walks here but notably the 2-ml circ or the full 4¼-ml hike. The path to the beach is about ½ ml from the road • Much of the coast can be followed around Achmelvich (and you can walk from Lochinver via Ardroe) and Clachtoll • A lovely 'peat walk' from Drumbeg village encircles the loch with fine views. 3 mls.

EAT/SLEEP www.thelittlesoapandcandlecompany.co.uk selling soap and candles has a lovely, secluded garden tearoom serving tea and cake in the middle of Drumbeg village. Seasonal • www.blarnaleisg.com 01571 833325. Fabulous boutique guest house in Drumbeg House in the village • www.thealbannach.co.uk 01571 844407. Lochinver. Top, tho small, hotel hereabouts. Michelin dining • www.kyleskuhotel.co.uk 01971 502231. Great seafood.

SINGING SANDS NORTH PAGE 116

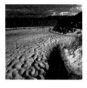

FIND The A861 goes S from the A830 Road to the Isles at Lochailort to Salen and Strontian in Ardnamurchan. From the N, turn off at Arivegaig just before Archachle. Car park at the end of the township, follow track thro a metal gate and across a bridge. Track skirts Kentra Bay. Cross a wooden bridge past stone houses into the forestry plantation, then 5 mls to the beach. 6 mls total.

WALK Apart from the walk to the beach itself, there are many great walks in Ardnamurchan, especially thro woodlands: around Strontian (the Ariundle Oakwoods, 2 mls circ, and to the lead mines, 6 mls) and Loch Sunart (the Salen Oakwoods, 1 ml).

EAT/SLEEP www.glenuig.com 01687 470219. 6 mls N. The Glenuig Inn, for food and accom incl a bunkhouse • www.kingairloch.co.uk 01967 411232 (Restaurant) or 01967 411242 (accom self-catering on the estate). The Boathouse Restaurant in remote, spectacular setting. Well worth finding via Salen and Strontian then A884; 18 mls • www.thewhitehouserestaurant.co.uk 01967 421777. Adjacent to the ferry to Mull, Lochaline. Great home-made food. Across Ardnamurchan and Morvern by A884; 28 mls.

SKARA BRAE NORTH PAGE 118

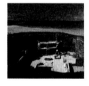

FIND 17 mls W of Kirkwall on the A965 via Finstown and Dounby; 7 mls N of Stromness via Voy • www.northlinkferries.co.uk. Main ferry to Stromness from Scrabster W of Thurso, 2/3 times a day; 2¼ hrs. Northlink ferry from Aberdeen (once a day, overnight) to Kirkwall • www.pentlandferries.co.uk. Quickest route from Gills Bay, nr John O'Groats, to St Margaret's Hope (32 mls) 3/4 a day; 1 hr • The village is 400 yds from the visitor centre.

WALK Situated on the Bay of Skaill, there are short beach walks nearby • The walk from/to Stromness via the Yesnaby Stacks and the Broch of Borwick is around 9 mls one way (there are buses to Skara Brae from Stromness and Kirkwall in summer).

EAT The visitor centre has a café • www.thecreel.co.uk 01856 831311. Restaurant with rooms 15 mls S of Kirkwall on the A960 via the Churchill Barriers. Best in Orkney Islands • www.helgis.co.uk 01856 879293.

SLEEP www.merkister.com 01856 771366. Hotel and restaurant 5 mls E • www.balfourcastle.co.uk 01856 711282. On Shapinsay, 5 mls Kirkwall. Exclusive luxury.

STAC POLLY NORTH PAGE 120

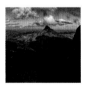

FIND Many vantages and perspectives from around Achiltibuie. The car park from where to gaze on it or climb up it is 7 mls from the main A835 N of Ullapool on the road W to Achiltibuie.

WALK You can do the 2008-ft ascent and back from the car park on Loch Lurgainn in less than 3 hrs. It's rough ground; the (new) path is circular (after the initial ascent), clear and well travelled. Follow the ridge at the top for breathtaking views (tho actual summit needs nerve and scrambling skills; most people don't bother) • Other walks nearby include the easy 1-hr Knockan Crag trail from the visitor centre on the A835 S of Elphin.

EAT In Altandhu nr Achiltibuie, the Fuaran Bar www. amfuaran.co.uk 01854 622339. Great pub grub • www.summerisleshotel.co.uk 01854 622282. Both hotel dining and bar food famously good.

SLEEP Has to be The Ceilidh Place in Ullapool. www.ceilidhplace.com 01854 612103. 15 mls S. Legendary! See page 82 • Superb camping by the Fuaran pub (above).

STANDING STONES OF STENNESS NORTH PAGE 122

FIND The Stones and Maeshowe are 10 mls from Kirkwall on the A695 road to Stromness. Well signed • www.northlinkferries.co.uk. Main ferry to Stromness from Scrabster W of Thurso, 2/3 times a day, 2¼ hrs. Northlink ferry from Aberdeen (once a day, overnight) to Kirkwall (10 mls) • www.pentlandferries.co.uk. Quickest route from Gills Bay, nr John O'Groats, to St Margaret's Hope (25 mls) 3/4 times a day; 1 hr • 500 yds from the interpretation/visitor centre.

WALK For coastal walks around Stromness and the island of Hoy see page 223.

EAT www.helgis.co.uk 01856 879293. Best grub in Kirkwall • www.thecreel.co.uk 01856 831311. Restaurant with rooms 15 mls S of Kirkwall on the A960 via the Churchill Barriers.

SLEEP www.alberthotel.co.uk 01856 876000. Refurbed hotel in Kirkwall • Merkister Hotel www.merkister.com 01856 771366. Hotel and restaurant 5 mls N of the Stones • www.balfourcastle.co.uk 01856 711282. On Shapinsay, 5 mls from Kirkwall. Exclusive luxury.

STROMNESS NORTH PAGE 124

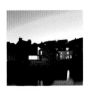

FIND www.northlinkferries.co.uk. Main ferry to Orkney to Stromness from Scrabster W of Thurso, 2/3 times a day, 2¼ hrs. Northlink ferry from Aberdeen (once a day, overnight) to Kirkwall (14 mls E) • www. pentlandferries.co.uk. Quickest route from Gills Bay, nr John O'Groats, to St Margaret's Hope (31 mls) 3/4 a day, 1 hr.

WALK The surrounding coastal scenery is spectacular. Walk out of Stromness via the golf course and Warebeth Beach along the cliffs to Yesnaby (4 mls) or 1½ mls further to Skara Brae (see page 118) • Take the 25/30 min ferry to Hoy (and Graemsay) for famously fine walking on the N coast, including the Old Man of Hoy (10 mls, can be circular).

EAT/SLEEP www.merkister.com 01856 771366. 6 mls. Hotel overlooks loch • www.stromnesshotel.com 01856 850298. By the harbour. Some charm.

SUILVEN NORTH PAGE 126

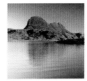

FIND Suilven is visible from afar including (though not its most distinctive perspective) from the main A835 N of Ullapool • Best sightings are from the remarkably scenic roads S and particularly the Drumbeg road (page 114), N of Lochinver.

WALK The walk to, up and along the top of the mountain is a serious proposition though not hard. Terrain rough, with a famously long walk-in, allow 7–10 hrs.
There are various approaches but the most usual is from Glencanisp Lodge outside Lochinver • An easy circular walk with views starts from the bridge over the Inver, a 2½-hr round trip emerging at the Lodge at the other end of the village • Another is to Kirkaig Falls from Achins Bookshop, 4 mls S of Lochinver on the 'wee mad road'.

EAT Essential to stock up on pies at the Riverside Bistro in Lochinver www.piesbypost.co.uk. Superior sweet and savoury • Best dinner in the region at The Albannach (below).

SLEEP The Albannach www.thealbannach.co.uk 01571 844407. Boutique hotel and Michelin dining; Suilven from the terrace! • Glencanisp Lodge www.glencanisp-lodge. co.uk 01571 844100. Activity centre accom.

THE SUMMER ISLES NORTH PAGE 128

FIND The Summer Isles are 22 mls NW of Ullapool via the A835, the unclassified road from Drumrunie. • Daily 2/4 hr boat trips from Ullapool www.summerisles-seatours.co.uk and www.summerqueen.co.uk, and from Achiltibuie www.summer-isles.com. Most land on Tanera Mòr • The classic (sunset) view is N of Altandhu, turn inland gaining height; a bench and a lay-by, a hillock behind with a cairn on top. 1 ml further along this road round the corner is a jaw-dropping view of the Assynt mountains.

WALK Tanera Mòr, the only Summer Isle where a walk is possible, 1½ mls circ; a slight hill, Meall Mor • Other walks around Achiltibuie are The Peat Road from Polbain to the Hill of the Fairies and Fox Hill, then the viewpoint on Meall an Fheadain (666 ft) • Achnahaird Beach.

EAT Café on Tanera Mòr, seasonal, open for boat passengers • www.summerisleshotel.co.uk 01854 622282. Achiltibuie. Fine dining room and gastrobar with the view • www.amfuaran.co.uk 01854 622339. Great bar food and atmos.

SLEEP www.summerisleshotel.co.uk 01854 622282. A top hotel in the NW. Fine dining • www.portabhaigh.co.uk 01854 622239. Brilliant campsite by the Am Fuaran Bar (above), same owners.

THE TORRIDON MOUNTAINS NORTH PAGE 130

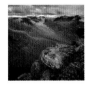

FIND The finest initial approach to the Torridon Mountains is by the A896 from Shieldaig along Upper Loch Torridon. From Torridon village, at the head of the loch, the same road to Kinlochewe passes by the foot of the main peaks. Many views on this road • Slioch rises above Loch Maree on the A832 between Gairloch and Dingwall • An Teallach is by Dundonnell on the A832 between Gairloch and Ullapool.

WALK These are serious hills; route planning is essential. The main Torridon peaks can be approached from the Glen Torridon road: Beinn Alligin, the furthest W, from the single-track extension to Diabaig; and An Teallach from the A832 nr Dundonnell. At Torridon village crossroads a visitor centre offers info on all walks • A simpler walk from the Glen road (3 mls W of Kinlochewe) is around Loch Clair in the Coulin Forest; splendid views.

EAT Whistle Stop Cafe, Old Village Hall, Kinlochewe. 01445 760423 (no website). Great home cooking from breakfast to teatime at the E end of the Glen. Also eat below.

SLEEP www.thetorridon.com 01445 700300. Superb hotel overlooking loch and mountains 1 ml W of Torridon village. Top dining, whisky bar, activities and rangers. The Torridon Inn with cheaper accom, bar and restaurant is adjacent.

TRESHNISH ISLANDS NORTH PAGE 132

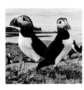

FIND Usual boat trips to the Treshnish are from Mull. www.turusmara.com 01688 400242 from Ulva Ferry, 60 mins Tobermory or 45 mins Craignure (the ferry port from Oban) • www.staffatours.com (no number) from Fionnphort or Iona in the S of Mull. Daily sailings Easter until Oct (puffins leave August), around 5 hrs. Trips usually include Staffa. Staffa Tours also leave from Oban.

WALK Much good walking on Mull. These in the S: classic coastal walks from Carsaig Pier nr Pennyghael to Lochbuie • 3 gentle walks on beautiful Ulva, the island is 5 mins from Mull at Ulva Ferry (9am–5pm, not Sat, summoned by flicking a board, non-bookable). Walks marked from The Boathouse café on arrival • Calgary Beach and walks on the bay not to be missed, 3 mls S of Dervaig on way to Treshnish ferries.

EAT www.ninthwaverestaurant.co.uk 01681 700757. Near Iona ferry, 3 mls from Fionnphort. Award-winning restaurant • www.thecafefish.com 01688 301253. Great fish place on Tobermory Bay.

SLEEP www.tiroran.com 01681 705232. Small boutique country house. 21 mls Fionnphort; 24 mls Ulva Ferry • www.highlandcottage.co.uk 01688 302030. Top stay (and restaurant) in Tobermory.

UP HELLY AA NORTH PAGE 134

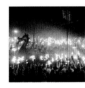

FIND www.northlinkferries.co.uk 0845 600 0449. Overnight from Aberdeen Mon/Wed/Fri at 7pm direct to Lerwick, and Tues/Thur/Sat/Sun at 5pm via Kirkwall • www.flybe.com. From Aberdeen, Glasgow, Edinburgh, Inverness.

WALK www.walkshetland.com. Comprehensive guide to walks at all levels on Mainland and the other islands (linked by ferries, www.shetland.gov.uk/ferries).

EAT www.haysdock.co.uk 01595 741596. Part of Shetland Museum, Lerwick • www.frankiesfishandchips.com 01806 522700. Award-winning F&C, Brae.

SLEEP www.burrastowhouse.co.uk 01595 809307. 40 mins from Lerwick. A top place in Shetland, alas not in January. Perfectly peaceful • www.bustahouse.com 01806 522506. At Brae, 30 mins Lerwick.

GLASGOW AND WEST OF SCOTLAND

FIND | WALK | EAT | SLEEP

ANGUS'S GARDEN WEST PAGE 136

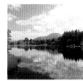

FIND At Taynuilt 12 mls from Oban on the A85, take the Glen Lonan unclassified road (the picturesque back road to Oban). The Garden is the first right after Barguillean Farm about 3 mls from Taynuilt.

WALK Taynuilt is close to the shore of mysterious and long Loch Etive (2/3 hr cruises from the jetty 01866 822430). Great walking in Lochaweside woodlands. Nearest is the Glen Nant Woods, 5 mls S on the B845, car park. 2½ mls circular.

EAT www.robinsnesttearoom.co.uk 01866 822429. Tearoom like it says, but a good one. On the main st towards Loch Etive.

SLEEP www.ardanaiseig.com 01866 988366. Luxury country house hotel on Loch Awe 11 mls S by the B845 then unclassified road • www.roineabhal.com 01866 833207. Excellent B&B and dinner. Kilchrenan 7 mls S towards Loch Awe.

BARROWLANDS WEST PAGE 138

FIND Barrowlands is in the Gallowgate in Glasgow's East End about 300 yds from Glasgow Cross, the tower at the foot of High St. When there's a gig on the whole front of the building is lit with a massive distinctive neon sign; you can't miss it!

WALK If you're going to a gig here you're probably not out, or up, for a walk, but a stroll to the Necropolis (page 172), only 250 yds away, would make a more than interesting diversion.

EAT The Merchant City, ¼ ml away, is where to go eat: www.guysrestaurant.co.uk 0141 552 1114. 24 Candleriggs • www.centralmarketglasgow.com 0141 552 0902. 51 Bell St • www.cafegandolfi.com 0141 552 6813. Includes Bar Gandolfi upstairs, the pub food version 0141 552 9475, and Gandolfi Fish next door, the seafood restaurant 0141 552 9475.

SLEEP www.cathedralhousehotel.co.uk 0141 552 3519. 500 yds, by the Cathedral, overlooking the Necropolis • Glasgow recommendations see page 231.

CELTIC CONNECTIONS WEST PAGE 140

FIND www.celticconnections.com. Box Office 0141 353 8000. Held every year in the second half of January. Tickets and programme announced November. Main venue is the Royal Concert Hall. The City Halls and the Old Fruitmarket are both in the Merchant City. Other venues vary year to year.

WALK Venues are generally walkable between each other. For a note of walking in the old part of the city, see walks listed under The Necropolis page 227.

EAT/SLEEP For Glasgow recommendations see page 231.

CITIZENS THEATRE WEST PAGE 142

FIND www.citz.co.uk 0141 492 0022. The Citizens Theatre S of the river in the Gorbals district can be reached via the Victoria Bridge from the city centre.

WALK Walks S of the river via Pollokshaws Road to Pollok Park, the city's biggest 'Country Park', home to the Burrell Collection, Pollok House and various trails www.glasgow.gov.uk.

EAT/SLEEP Glasgow recommendations page 231. Merchant City over the Victoria Bridge (⅓ ml) is nearest concentration of good choices.

CRARAE GARDEN WEST PAGE 144

FIND Crarae (a National Trust property, www.nts.org.uk) is open 9.30am–sunset. 10 mls from Inverary on the A83 to Lochgilphead.

WALK Trails round the garden are well marked • From Inverary, the most obvious (but well worth it) walks are around the Castle estate, particularly the ascent to the monument Dun na Cuaiche (800 ft, 2¾ mls circ) or the Forest Circuit (6¼ mls). All signed.

EAT/SLEEP www.thegeorgehotel.co.uk 01499 302111. Main St, Inverary. A *Scotland the Best* favourite hotel both for rooms and to eat, and hanging out in the bar. 10 mls Crarae • www.crerarhotels.com 01499 302980. The Loch Fyne Hotel. Overlooking loch, more corporate than above with pool and spa. 9 mls.

THE DROVERS INN WEST PAGE 146

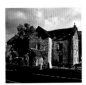

FIND This and the following recommendations also apply to Rob Roy's Bathtub 2 mls N on the A82 (page 178). The Drovers actually is in Inverarnan between Crianlarich and (4 mls from) Ardlui at the top of Loch Lomond, on the A82 to Glasgow.

WALK The woodland walk to Rob Roy's Bathtub, aka the Falls of Falloch is 2 mls, or 500 yds from the car park on the A82 • For the walk to Beinglas Falls above and behind Inverarnan, go past the campsite (2 mls). This is also the start of the hike to Ben Chabhair (3061 ft), 8¾ mls • 2 other Munro walks start here; Inverarnan is a base for many baggers. Inverarnan is at the start of the middle section (stage 4) of the West Highland Way (page 186), 12 mls to Tyndrum. The preceding section skirts Loch Lomond.

EAT/SLEEP www.thedroversinn.co.uk 01301 704234 is everything you want it to be. Rooms in hotel are 'characterful', highly individual. The Lodge House across the rd, around a courtyard is more modern, more uniform. Good pub grub. Nowhere else to recommend within 20 mls • www.beinglascampsite.co.uk 01301 704281. Campsite, 'cosy cabins' and B&B.

DUNADD WEST PAGE 148

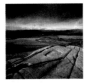

FIND Dunadd is 500 yds and instantly recognizable from the A816 S of Oban, 3 mls N of Lochgilphead.

WALK The walk up the hill isn't much more than a scamper (30 mins) • Kilmartin Glen arranged below has many walks that take in the stones, chambers and burial cairns for which it's famous. Walks can start at Kilmartin House Museum which is where to orientate to the ancient times and have a cup of tea.

EAT www.kilmartin.org 01546 510278. Attached to the Museum, a lovely café. Daytime and summer only • The Crafty Kitchen 01852 500303 (no website). Ardfern, 5 mls N via the main A816. All home-made. Daytime only.

SLEEP www.crinanhotel.com 01546 830261. 5 mls S in spectacular location overlooking Jura; a hotel, restaurant, bar and coffee shop of legendary status.

GEORGE SQUARE WEST PAGE 150

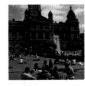

FIND Signed off the M8. Queen St Station on the corner of George Square. Train passengers from Edinburgh and the E arrive here. Main bus station 300 yds.

WALK George Square would probably be included in any walk of the old part of Glasgow (see page 172, The Necropolis) or the Merchant City restaurant and cultural quarter.

EAT The Merchant City area begins at George Square. It's where to eat: www.guysrestaurant.co.uk 0141 552 1114. 24 Candleriggs • www.centralmarketglasgow.com 0141 552 0902. 51 Bell St • www.cafegandolfi.com 0141 552 6813. Includes Bar Gandolfi upstairs, the pub food version 0141 552 9475, and Gandolfi Fish next door, the seafood restaurant 0141 552 9475.

SLEEP www.millenniumhotels.co.uk 0141 332 6711. Millennium Hotel on corner of the Square by the Station. Front rooms best • Other Glasgow recommendations page 231.

GLASGOW SCHOOL OF ART WEST PAGE 152

FIND www.gsa.co.uk. 167 Renfrew St. Uphill via Scott St from Sauchiehall St in the City's West End.

WALK Guided tours can be booked same day or up to a week ahead. 0141 353 4526. Or book further ahead online.

EAT/SLEEP Glasgow recommendations page 231.

GLEN ETIVE WEST PAGE 154

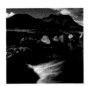

FIND Leave the A85, the main road between Crianlarich and Connel (then Fort William), at Kings House (a hotel just off the road). Coming from the S, the turn-off is 11 mls before Glencoe village.

WALK Many serious walks and Munros incl Buachaille Etive Mor itself (8 mls, allow 8 hrs) • Ben nan Aighenan is the other Etive Munro tho hidden from the floor of the glen • Low level walks and some yomping by following the river • For Glen Coe walks, see page 219.

EAT www.craftsandthings.co.uk 01855 811325. Daytime coffee shop on A82 nr Glencoe village; 11 mls • www.clachaig.com 01855 811252. Legendary Glencoe walkers' pub: food, drink and rooms. 1 ml off A82 nr Glencoe Visitor Centre.

SLEEP Clachaig Inn (above) • www.bridgeoforchy.co.uk 01838 400208. On A82, 14 mls S. The landmark Bridge of Orchy Hotel which has bar and restaurant.

GOUROCK POOL WEST PAGE 156

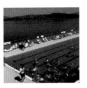

FIND On the main A770 coastal road W out of Gourock. 5 mins Gourock Station. Trains 3 times/hr, 50 mins from Glasgow Central. Pool 01475 715670.

WALK Lyle Hill, 426 ft above neighbouring Greenock, easily reached from the town gives splendid views back to Gourock and across the whole Clyde estuary • There are many walks in the Clyde Muirshiel Regional Park, including Daff Glen, a 2-ml circ walk from Inverkip 6 mls S on the A78 • Also 3½ mls from the A78 there are 3 notable walks from the Greenock Cut Visitor Centre 01475 521458 by Loch Thom, including the Cut aqueduct itself (6 mls circ) and the Kelly Cut (5 mls); great views of the Clyde.

EAT www.fusionrestaurant.org.uk 01475 633998. Best in town.

SLEEP www.gleddochhousegolfhotelspa.com 01475 540711. 12 mls E towards Glasgow at Langbank off the A8.

IONA WEST PAGE 158

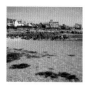

FIND Iona is reached by a ferry from Fionnphort on the SW tip of Mull. Every 15 minutes (at peak) until 6pm. No need of a car. Fionnphort is 35 mls (allow a good hour) from the main ferry at Craignure (from Oban), another 5 from Fishnish and the short ferry from Lochaline, Ardnamurchan. www. calmac.co.uk 0800 066 5000.

WALK Iona is a perfect size to walk round. There is some paved road, but mostly paths and sheep tracks. You can hire bikes at the Store. Great view from the hill (328 ft) overlooking the Cathedral. The ½-mile walk to the Bay at the Back of the Ocean is a joy.

EAT/SLEEP www.argyllhoteliona.co.uk 01681 700334. Excellent inn for food and rooms • www.stcolumba-hotel. co.uk 01681700304. Larger of the two hotels, lovely garden • www.ionahostel.co.uk 01681 700781. Great hostel in a croft • Seaview B&B, Fionnphort 01681 700235 (no website) nr ferry.

JURA WEST PAGE 160

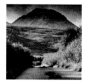

FIND By car, ferry from Port Askaig, in N of Islay, every hr, 5 mins to Feolin, 5 mls W of Craighouse. www.jurainfo. com. Ferries to Islay from Kennacraig www.calmac.co.uk 0800 066 5000 or fly from Glasgow www.flybe.com • Passenger ferry (summer only) from Tayvallich, 10 mls W of Lochgilphead to Craighouse twice a day www.jurapassengerferry.com.

WALK The big walk taking in the Paps has no set route tho usually starts at Three Arch Bridge 4 mls N of Craighouse following the Corran River to the loch • Evans Walk is signposted nr the bridge, a trail of 12 mls across the island • Easier walks from Craighouse to the Market Loch above the Distillery (2 mls, non-circ), or along the coast N to Knockrome and Corran Sands and Lowlandman's Bay (7 mls return or from Three Arch Bridge, 1½ mls).

EAT/SLEEP www.jurahotel.co.uk 01496 820243. The only hotel but just perfect: lovely, simple rooms, bar, dining room; camping outside. In Craighouse nr the Distillery • www. ardlussaestate.com 01496 820323. Superior, friendly B&B in comfy estate house. N of island, 15 mls N of Craighouse • The Antlers 01496 820123 (no website). Great café/bistro in Craighouse, seasonal.

KELVINGROVE WEST PAGE 162

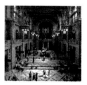

FIND Kelvingrove Art Gallery and Museum is to the W of the city centre (20 mins via Sauchiehall St) at the end of Argyle St. Nearest station is Partick (15/20 mins walk). It is open 7 days 10am–5pm (Fri/Sun from 11am) www. glasgowlife.org.uk 0141 276 9599.

WALK Apart from strolls around Glasgow's vibrant West End, a walk through the hidden underside of the city is the Kelvin Walkway. Tho this is part of a much longer route that connects the West Highland Way to the city centre and the mouth of the Kelvin on the Clyde, the best section of this as a city walk (1½ hrs) starts at the 'White House' on Maryhill Road and skirts the Botanic Garden, taking in Ruchill Park and Kelvinside with other secret gardens and the riverside path. Circular so you can join eg Kelvinbridge itself. It connects to the Forth and Clyde Canal Towpath www.glasgowcanal. co.uk.

EAT/SLEEP www.motherindia.co.uk 0141 339 9145. Opp the Museum at 1355 Argyle St. Part of Glasgow's premier group of Indian restaurants which includes right next door at 1347, The Den at Dining in at Mother India 0141 334 3815 • www.thepelicancafe.co.uk 0844 573 0670. Also opp at 1377 Argyle St, informal wine bar/restaurant • For other Glasgow recommendations see page 231.

KILORAN BEACH WEST PAGE 164

FIND Ferry from Oban runs 5 times a week in summer, 4 in winter. 2¼ hrs. There's a less frequent ferry from Islay in the S on a route between Oban and Kennacraig S of Tarbert www.calmac. co.uk 0800 066 5000 • www. hebrideanair.co.uk have a service from Oban twice a week (25 mins to 1 hr) • Kiloran Beach is 2 mls from the quay and the hotel.

WALK Easy walk from the hotel to the beach (all walks on Colonsay are easy), past the House and Garden (5 mls circ) • Great jaunt to the small island of Oronsay at the southern end – 3 mls from quay to 'The Strand'. Check times and cross at low tide, allowing 2 hrs on the island to take in the ruins.

EAT/SLEEP Hotel, bunkhouse and cottages www. colonsayestate.co.uk 01951 200316 • Cafés at Colonsay House and at the quay, The Pantry www.thecolonsaypantry. co.uk 01951 200325.

LOCH AWE WEST PAGE 166

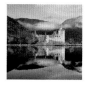

FIND On the A85 between Crianlarich and Oban, the Pass of Brander closely follows a spur of the loch, but to experience best go S from Taynuilt on the B845 to Kilchrenan (5 mls), then to the unclassified road skirting the N side W or E to the hotel and gardens at Ardanaiseig • From Inverary to the S shore (9 mls), then W to Ford.

WALK Kilchurn Castle 1 ml return from A85 nr Lochawe village • Enticing woodland walks from car parks on the Taynuilt road and N shore (Dalavich and Barnaline). Inverinan Glen. Various lengths, well signed.

EAT www.robinsnesttearoom.co.uk 01866 822429. Tearoom in Taynuilt • Kilchrenan Inn, Kilchrenan. 01866 833232. Village pub.

SLEEP www.thegeorgehotel.co.uk 01499 302111. Inverary. Brill • www.roineabhal.com 01866 833207. Boutique B&B • www.ardanaiseig.com 01866 988366. Fabulous.

MHOR 84 WEST PAGE 168

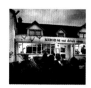

FIND The A84 is the main road W from Stirling thro Callander to Crianlarich, Oban and Fort William. Mhor 84 is visible on the right at the turn-off for Balquhidder, halfway between Strathyre and Lochearnhead.

WALK The Rallying Place of the Maclarens, a short easy ascent for a great view from behind Balquhidder Church 2 mls from Mhor 84. Can walk or park at church; walk 1 ml • Other way-marked walks start here including Kirkton Glen (5½ mls circ) • Walks from Strathyre incl the easy 1850-ft Beinn an t-Sidhean for top Trossachs views.

EAT/SLEEP www.mhor.net 01877 384646. The motel/hotel, bar and restaurant. From breakfast thro afternoon tea to supper. It's all good • Monachyle Mhor Hotel, one of Scotland's top countryside hotels. Excellent restaurant. 7 mls thro Balquhidder by Loch Voil. 01877 384622.

MOUNT STUART WEST PAGE 170

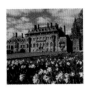

FIND Mount Stuart, 5 mls S of Rothesay on the Isle of Bute; well signposted. The main ferry route (35 minutes) is from Weymss Bay on the A78 S of Greenock • Another way onto Bute (5 minutes) from Colintraive in Argyll only makes sense if you're on the peninsula. Transport on Bute is well coordinated, you don't need a car; bikes are good.

WALK Walks in the beautiful, wooded estate are well signed and the grounds are laid out to offer all manner of ambles, most with sea views. One of the finest of Bute's many low-level walks is 'Glencallum Bay and St Blane's Church' signed from Kilchattan Bay, 5 mls S round the southern tip of the island with views to Cumbrae and Arran. 5 mls circ (2½–4 hrs).

EAT The House restaurant and tearoom are among the best on Bute • Best in Rothesay: Harry Haws www.harryhaws. com 01700 505857 • The West End Café's fish 'n' chips are famously good.

SLEEP www.visitmunros.co.uk 01700 502346. A boutique B&B.

NECROPOLIS WEST PAGE 172

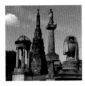

FIND The Necropolis is in an area of many visitor attractions to the E of George Square all well signed: Glasgow Cathedral, Provand's Lordship, St Mungo Museum of Religious Life and Art. The main gates are behind the Museum. There are also gates in Wishart St and opposite the Cathedral House Hotel.

WALK Walking tours of the graveyard www. glasgownecropolis.org. Walks around the medieval quarter are well signed and documented. Including visits, you could spend a day here.

EAT Many restaurants/cafés/bars in the Merchant City. 1 ml • www.drygate.com 0141 212 8810. Nearest and new in 2014, an artisan brewery, good bar and restaurant in an old box factory at the foot of the Necropolis • See Glasgow recommendations page 231.

SLEEP www.cathedralhousehotel.co.uk 0141 552 3519. Rooms look across to the graveyard and the gate to the Necropolis is opposite • www.milleniumhotels.com 0141 332 6711. Major hotel. In George Sq; 1 ml.

PUCK'S GLEN WEST PAGE 174

FIND Most easily found by following the many signs for the Benmore (Younger) Botanic Garden. 6 mls N of Dunoon past the Holy Loch on the A815 • Frequent ferries from Gourock to Dunoon: www.western-ferries.co.uk • Also www.argyllferries.co.uk • From the W/the Kintyre peninsula a short ferry from Tarbert to Portavadie, a hugely picturesque route via the Kyles of Bute (22 mls).

WALK There are two routes around the Glen, both circular. 2 mls maximum. Less than 1 ml around Benmore • Further up the A815 towards Loch Fyne there are many way-marked walks around beautiful Loch Eck.

EAT Benmore Garden café, open daytime only. www.rbge. org.uk 01369 840509 • www.chattersdunoon.co.uk. Long-established restaurant in Dunoon, best in the area • www.invercottage.co.uk. Excellent lochside restaurant 12 mls N to Strachur, then 6 mls S down Loch Fyne.

SLEEP Best bet 20 mls W at Tighnabruaich. www.kames-hotel.com 01700 811489.

RANNOCH MOOR WEST PAGE 176

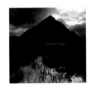

FIND Rannoch Moor is crossed by the A82, the road to Fort William, and by the West Highland Railway; there are 3 trains a day between Glasgow and Fort William stopping at Rannoch Station, and the overnight sleeper from London really does stop here at 8.48 am • The B8019 from the A9 N of Pitlochry follows Loch Tummel, then the B846 to Kinloch Rannoch and Rannoch Station (40 mls from Pitlochry).

WALK The West Highland Way crosses the SW corner of Rannoch Moor: the Black Mount to Kingshouse leg • There are walks from Kings House and Corrour (the remotest station in the UK) and around Loch Ossian (7 mls circ) thro the heart of Scotland. Train from Rannoch to Corrour (15 mins) and then walk back • Schiehallion, one of Scotland's best loved mountains and an easy Munro (3553 ft), from Braes of Foss car park, 5 mls SE of Kinloch Rannoch (the best view of the Moor); 6¼ mls.

EAT/SLEEP www.moorofrannoch.co.uk 01882 633238. Cosy inn at Rannoch Station, the sleeper from London 50 metres from the door • www.macdonaldhotels.co.uk 0844 8799059. 'Resort' type hotel, the Loch Rannoch, on the lochside by Kinloch Rannoch, swimming pool and all.

ROB ROY'S BATHTUB WEST PAGE 178

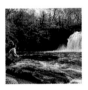

FIND Rob Roy's Bathtub, aka the Falls of Falloch, is in the Falloch Glen Woods signposted 'picnic area', 500 yds from a car park on the A82 between Crianlarich and (4 mls from) Ardlui at the top of Loch Lomond, 2 mls from Inverarnan. The directions and recommendations that follow are similar for the Drovers Inn (page 225).

WALK The woodland walk itself is short, 2 mls from Inverarnan/the Drovers Inn • For another waterfall, walk to Beinglas Falls above and behind Inverarnan, go past the campsite (2 mls). This is also the start of the hike to Ben Chabhair (3061 ft), 8¾ mls • 2 other Munro walks start here; Inverarnan is a base for many baggers. Inverarnan is at the middle section (stage 4) of the West Highland Way (page 186), 12 mls to Tyndrum. The preceding section skirts Loch Lomond.

EAT/SLEEP www.thedroversinn.co.uk 01301 704234. 2 mls S of the Falls. Historic walkers' pub and hotel (see also page 146). Atmospheric and authentic. Rooms in hotel characterful • The Lodge House across the rd, around a courtyard is more modern, more uniform. Good pub grub. Nowhere else to recommend within 20 mls • www.beinglascampsite.co.uk 01301 704281. Campsite, 'cosy cabins' and B&B.

ST CONAN'S KIRK WEST PAGE 180

FIND St Conan's Kirk overlooks Loch Awe on the left hand side of the A85 going W to Oban, 15 mls W of Tyndrum. Open dawn until dusk, free admission www.stconanskirk.org.uk.

WALK See Loch Awe (page 226) • The simple, popular walk nr St Conan's Kirk is to the ruins of Kilchurn Castle at the head of Loch Awe 1 ml E on the A85. Car park nr junction with B8077. 1½ mls • Also from this junction is the 'Dalmally Horseshoe' which can include the serious hill walk to Ben Cruachan. Up to 9 mls • Useful websites: www.incallander. co.uk; www.loch-awe.com.

EAT www.thegreenwellystop.co.uk 01838 400271. Landmark eatery and all-round road stop in Tyndrum nr the fork for Fort William or Oban. 14 mls • www. therealfoodcafe.com 01838 400235. The other great roadside caff in Tyndrum, especially for fish 'n' chips • www.robinsnesttearoom.co.uk 01866 822429. Nearest good tearoom. Taynuilt, 7 mls.

SLEEP www.ardanaiseig.com 01866 833333. Fabulous country house hotel on Lochaweside, 2 mls as crow flies but 18 mls via the A85, then the B845 from Taynuilt, then unclassified rd from Kilchrenan • www.roineabhal.com 01866 833207. Great guest house also at Kilchrenan.

THE TROSSACHS WEST PAGE 182

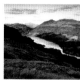

FIND The Trossachs is the National Park area to the W of Stirling and E of Loch Lomond around Callander and Aberfoyle, bounded and reached by the A84 from Stirling to Lochearnhead and the A811 from Stirling to Balloch.

WALK Some of Scotland's favourite hills are here: Ben Venue (2385 ft, 5/6 hrs), Ben A'an (1491 ft, 2½ hrs), both from the A821 off the A84 thro Callander via Loch Venacher. Superb views of Loch Katrine. Ben Ledi (2884 ft, 6 hrs) off the A84 2 mls N of Callander. Top climb. Beinn an t-Sidhean aka Ben Shian (1850 ft, 3 hrs), from Strathyre • Low-level walks from Glenfinglas car park on the A821 Callander to Brig o' Turk road; from Queen Elizabeth Park Centre 1 ml N of Aberfoyle; and on Loch Ard rd 2 mls W of Aberfoyle.

EAT/SLEEP www.mhor.net 01877 384622. Monachyle Mhor. One of Scotland's best boutique and country hotels (see page 168). And top dining • www.romancamphotel.co.uk 01877 330003. Tasteful, atmospheric hotel behind Callander Main St. Great dining • www.lake-hotel.com 01877 385258. Comfortable, airy lakeside hotel (the Lake of Menteith) in heart of the Trossachs. Conservatory restaurant and bar food.

UBIQUITOUS CHIP WEST PAGE 184

FIND Ashton Lane off Byres Road nr Hillhead underground station.

WALK The Kelvin Walkway that follows the river thro the city is not a million miles away (see Kelvingrove page 226).

EAT 'The Chip' and its sister restaurants (below) all individually are very good. Within ½ ml of one another. Upstairs from the main restaurant, The Brasserie is more casual. Both www.ubiquitouschip.co.uk 0141 334 5007 • www.thehanoibikeshop.co.uk 0141 334 7165. Vietnamese diner in the opposite Ruthven Lane • www.stravaigin.co.uk 0141 334 2665. Excellent gastropub with fusion restaurant downstairs.

SLEEP www.hotelduvin.com 0141 339 2001. Perhaps still the best hotel and bistro in the city. Off Great Western Rd. 1 ml.

THE WEST HIGHLAND WAY WEST PAGE 186

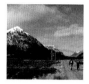

FIND The usual start of The West Highland Way is in the N of Glasgow in Douglas St, Milngavie, at the obelisk. Maps for all stages can be downloaded online www.west-highland-way.co.uk, and there are many other publications with routes and advice.

WALK The Way is the walk.

EAT/SLEEP Given that convenience and closeness to the route are probably more important than excellence, consult Way guides and recommendations online.

SOUTH OF SCOTLAND

FIND | WALK | EAT | SLEEP

CAERLAVEROCK SOUTH PAGE 188

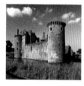

FIND The Castle is 7 mls S of Dumfries on the B725 nr Bankend. You pass the road end for the Wetland Reserve. Both are well signposted.

WALK For the walk that takes in both the Castle and the Reserve, park and start at the Wetlands Visitor Centre; it's well signed. 5.2 mls circ • Well laid-out forest tracks for walking and cycling (part of 7Stanes mountain bike network) in nearby Mabie Forest (5 mls) N of Bankend, but usual start is off the B724 • The must-do hill around here is Criffel (1870 ft); amazing views for the effort. Start S of New Abbey on the A710, 7 mls S of Dumfries.

EAT www.caerlaverockestate.co.uk 01387 770673. Caerlaverock tearoom in architectural and Solway setting, on quayside at Glencaple, 2 mls N towards Dumfries • www.wwt.org.uk 01387 770200. Café at the Wetlands Reserve Visitor Centre.

SLEEP www.wwt.org.uk 01387 770200 Eastpark Farmhouse. Basic B&B accom in the heart of the Nature Reserve • www.holidayinn.com 01387 272410. Dumfries. Better than might be expected in attractive campus on rd out of town towards Caerlaverock; 5 mls.

DRYBURGH ABBEY SOUTH PAGE 190

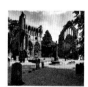

FIND In the heart of the Borders, most easily approached by the A68 from Leaderfoot at the bridge 4 mls S of Earlston, or from St Boswells. Well signed.

WALK The Abbey is at the centre of a gentle, circular river walk part of St Cuthbert's Way (a 60-ml route from Melrose to the coast at Lindisfarne). Well way-marked; 4½ mls • Extensions to Bowden and Melrose (the best bit) or south to St Boswells and Ancrum • There's also a short stroll from the adjacent hotel to the statue of William Wallace in the woods above the river and around Bemersyde House.

EAT/SLEEP Best options are in Melrose (see Walking the Eildons page 230) • www.marmionsbrasserie.co.uk 01896 822245 • www.chapters-bistro.co.uk 01896 823217 www.burtshotel.co.uk 01896 822285 • www.thetownhousemelrose.co.uk 01896 82264.

GARDEN OF COSMIC SPECULATION SOUTH PAGE 192

FIND 1½ mls from the village of Holywood off the A76, 5 mls N of Dumfries. This is a private garden. Open 1 day for 5 hrs, through the Scottish Garden Scheme (SGS), usually first Sunday in May. Please check the latest information before visiting www.scotlandsgardens.org. The landform work of Charles Jencks can also be seen in Edinburgh outside the Gallery of Modern Art and at Jupiter Artland, p 50.

WALK Garden takes 2 to 3 hrs to go round; if you are lucky enough to go, it may be crowded • Many walks along and around the River Nith (Nithsdale) www.dumgal.gov.uk (a helpful guide of many options) eg the 3-ml non-circ river walk from the lay-by 8 mls N, off the A76 at the B731 just S of Thornhill, then 2 mls on the A702 between Burnhead and Thornhill • 6 mls N of Thornhill there's a network of walks on the Drumlanrig estate www.drumlanrigcastle.co.uk.

EAT www.green-teahouse.co.uk 01848 200099. Brilliant tea-room/restaurant in Moniaive; 10 mls N by B729 • Little Italy. 01848 200057 (no website). Also in charming Moniaive.

SLEEP www.cavens.com 01387 880234. Country house comforts 17 mls S via Dumfries • www.bqahotel.com 01848 323101 Buccleugh and Queensberry Arms Hotel. Village inn; 8 mls N by the A76.

HORNEL GALLERY/BROUGHTON HOUSE SOUTH PAGE194

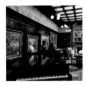

FIND By the A75, the main Solway road and then the A711 26 mls SW of Dumfries. House well signed nr the harbour at 12 High St.

WALK Kirkcudbright is a great town to explore on foot • Barhill Wood is an easy woodland walk from the caravan park via St Mary's St • The Senwick Shore Walk is also thro woodland skirting the shore with views across the bay. Car park at Dhoon shore 3 mls S via the B727 to Borgue. (2½ mls non-circ tho you can return by the main road) • There are good walks also around Gatehouse of Fleet 12 mls W.

EAT www.thecastlerestaurant.net 01557 330569 • www.selkirkarmshotel.co.uk 01557 330402 • www. kirkpatricksrestaurant.co.uk 01557 330888, Wed to Sat for dinner only.

SLEEP The Selkirk Arms (as above). Perfectly good converted townhouse hotel and gastropub • www. kirkcudbrightgladstone.com 01557 331734. Gladstone House: a very superior B&B just along the street.

ISLE OF WHITHORN SOUTH PAGE 196

FIND For the Isle of Whithorn first find Whithorn itself 4 mls to the N. From the main A75 Solway coast road from Dumfries or Stranraer, take the Wigtown turn-off at Newton Stewart; the IoW is 21 mls S by the A746.

WALK The customary walk here is along the headland E to St Ninian's Chapel (less than 1 ml return) • Another walk in His footsteps is to St Ninian's Cave W of IoW, but more often reached from the car park by the Visitor Centre in Whithorn up the road: a stroll thro pleasant woods to Port Castle Bay, signed (3 mls).

EAT/SLEEP www.steampacketinn.biz 01988 500334. A destination and all-round good pub for ale and eats, with 7 inexpensive rooms above, 5 of which overlook the harbour.

LITTLE SPARTA SOUTH PAGE 198

FIND From Edinburgh: Take the A702 Biggar road to Dolphinton then right turn to Dunsyre. Park 1 ml beyond the village • From Glasgow: Leave the M8 at junction 6 for the A73, then the A721 at Carluke to Newbigging, taking a left for Dunsyre.

WALK Pleasant 2-ml circ woodland walk 'Carnwath Moss' at Carnwath 6 mls W • 8 mls further W by A70 to Lanark, then following signs for New Lanark, the celebrated walks around the Falls of Clyde and the conservation village itself • Tinto Hill, the highest point in Central Scotland, is the must-do hill walk around here. Go via the A702 beyond Biggar then 7 mls to the B7065, joining the A73 Lanark Road. Park at Falburn nr Thankerton. 5 mls. Allow 3 hrs. 2319 ft.

EAT La Vigna www.lavigna.co.uk 01555 664320. A top Italian restaurant in Lanark.

SLEEP www.newlanarkhotel.co.uk 01555 667200. 'Wake up in a World Heritage Site' by the Falls of Clyde • www.skirlinghouse.com 01899 860274. 2 mls E of Biggar, 10 mls S of Dunsyre. An excellent guest house.

NEIDPATH SOUTH PAGE 200

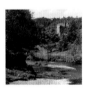

FIND From main st of Peebles not crossing the bridge, head on the A72 towards Blyth Bridge and Dawyck. Hay Lodge Park and car park are on the left. Follow river path • Or, 1 ml from the last house, there's a gateway on the left, the private entrance to Neidpath Castle. Park on the road (where safe) 200 metres further on. You are above the river, walk down.

WALK From Hay Lodge Park, 'The Sware Circuit' takes in the river bank walk past the Castle to a viaduct then by a stile to a minor rd and the Old Manor Brig. Signed. 3½ mls circ • An offshoot of this walk takes in the Lyne Water and Barns Tower. 7 mls circ back to same car park.

EAT www.coltmans.co.uk 01721 720405. Deli counter/ caff and restaurant • www.ossorestaurant.com 01721 724477. Highly regarded restaurant.

SLEEP www.cringletie.com 01721 725750. Off Edinburgh Rd at Eddleston. Great country house comforts and fine dining • www.horseshoeinn.co.uk 01721 730225. At Eddleston on the road. Gastropub and rooms.

PORTPATRICK SOUTH PAGE 202

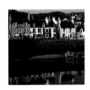

FIND Most likely approached via the A75, then the A77, 8 mls S of Stranraer or 7 mls further E towards Dumfries.

WALK A walk round the village should include the pull up to Dunskey Castle which starts with a staircase from the car park at the S end of the seafront. Views to Ireland; 1¼ mls, circ back via the disused railway line • A longer coastal walk to Knockinaam Lodge (see below) with spectacular coastal scenery; 8 mls, non-circ, but especially good if you're staying there • The Southern Upland Way begins at seafront N end; 212 mls to Cockburnspath on the E coast but a taster to Port Mora and adjacent Port Kale may suffice; 5 mls non-circ • Great gardens: (Logan) www.rbge.org.uk, 16 mls S, and www. castlekennedygardens.co.uk, 9 mls E, for exotic botanical ambles.

EAT 2 good waterfront restaurants: www.campbells restaurant.co.uk 01776 810314 and www.crown portpatrick.com 01776 810261. Also rooms.

SLEEP www.knockinaamlodge.com 01776 810471. Best in the SW. Country house hotel on mystic bay. Michelin dining; 8 mls.

SAMYE LING SOUTH PAGE 204

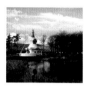

FIND Kagyu Samye Ling is by Eskdalemuir, Dumfries and Galloway. Take the A74, coming off at Lockerbie, and follow the B723 to Eskdalemuir, then left on the B709 for 1½ mls. Monastery is on the right. Around 2-hr drive from Edinburgh and Glasgow.

WALK Walks around the community • In the wider area there are sections of the Southern Upland Way which goes thro Eskdalemuir • The walk to Bessie's Hill starts 1½ mls S of the village (5½ mls circ) and links Iron-Age hilltop forts; there are open views.

EAT Vegetarian meals in the Dining Hall. There are no recommended restaurants nearby. Nearest is www.hartfellhouse.co.uk 01683 220153 in Moffat (20 mls) • www.del-amitri.co.uk 01461 201999 in Annan (30 mls).

SLEEP www.samyeling.org 01387 373232. Accommodation in guest house of single and twin rooms, dormitories or camping spaces. They can recommend alternative local B&Bs etc and family accom.

SMAILHOLM TOWER SOUTH PAGE 206

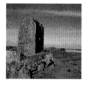

FIND Smailholm is 6 mls W of Kelso on the B6404 off the B6397. The tower is open in summer only until 5.30pm but is good to visit at any time, especially if you take the well-signposted route between Dryburgh Abbey and Scott's View: Scott country.

WALK Only minutes from the car park with a slight elevation • At Dryburgh there are walks along the Tweed (see The Tweed Valley page 230) • A nearby walk (18 mls away) that offers a great panoramic view of the same Border country is from Peniel Heugh, the Waterloo Monument. Take the B6404 to St Boswells joining the A68 S to the Ancrum/Nisbet turn-off. 2 mls towards Nisbet after Monteviot House, a steep unclassified road to the left (1 ml) takes you to a wood. Park and follow the path to the right up towards the Monument. 2 mls return.

EAT www.thecobbleskelso.co.uk 01573 223548. Decent pub grub in Kelso • www.woodsidegarden.co.uk 01835 830315. Cool caff in walled garden nr Peniel Heugh.

SLEEP www.clintlodge.co.uk 01835 822027. Great Border guest house. 3 mls • www.edenwaterhouse.co.uk 01573 224070. Ednam, 8 mls. Boutique B&B with excellent dinner and wine list • www.roxburghe.net 01573 450331. The famous country house hotel (and golf course).

THE TWEED VALLEY SOUTH PAGE 208

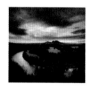

FIND The Scottish Borders are reached from central Scotland or the N of England by the A7, the A68, the A1 and the A(M)74. These photographs of Scott's View, nr Dryburgh and Glentress, off the A72 nr Peebles, are both in the Central Borders.

WALK Tweed Valley walks from Melrose, Dryburgh (page 190) and Peebles. St Cuthbert's Way www.stcuthbertsway.net connects the Central Borders with the coast • Great views of the Valley from the Eildons (page 210) and Peniel Heugh (see Smailholm Tower page 206).

EAT www.marmionsbrasserie.co.uk 01896 822245. Melrose • www.ossorestaurant.com 01721 724477. Peebles • www.coltmans.co.uk 01721 720405. Peebles.

SLEEP www.burtshotel.co.uk 01896 822285. Melrose • www.cringletie.com 01721 725750. Peebles • www.edenwaterhouse.co.uk 01573 224070. By Kelso.

WALKING THE EILDONS SOUTH PAGE 210

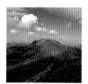

FIND The Eildons lie to the S of Melrose 4 mls off the A68. Starting from the main square go uphill towards the old station, the Dingleton Rd. After 120 yds a path begins between two pebbledash houses; you climb the smaller top first.

WALK The start of the main walking route is described above. The ascent is about 1000 ft. Returning by the golf course, the circ route is 5¼ mls • Another start is from Bowdenmoor Reservoir • Borders Council have a good booklet of walks: Paths Around Melrose, which you can download www.scotborders.gov.uk.

EAT www.marmionsbrasserie.co.uk 01896 822245 • Long established bistro nr the Abbey • www.chapters-bistro.co.uk 01896 823217. Across the Tweed in Gattonside, 15 min walk. Lovely.

SLEEP www.burtshotel.co.uk 01896 822285. In Market Sq. Quintessential Melrose. Best dining room and bar food • www.thetownhousemelrose.co.uk 01896 822645. Across the st from Burt's (same owners). A more contemporary version.

EDINBURGH
EAT | SLEEP

RESTAURANTS

FINE DINING www.martin-wishart.co.uk 0131 553 3557. On 'The Shore' in Leith. Chef Martin Wishart's eponymous, never less than excellent restaurant • www.thekitchin.com 0131 555 1755. Also in Leith, celebrity and TV chef Tom Kitchin's Michelin garlanded destination restaurant • www.thewitchery.com 0131 225 5613. At the top of the Royal Mile nr the Castle. Edinburgh's most atmospheric restaurant • www.ondinerestaurant.co.uk 0131 226 1888. Ondine, nr the corner of the Royal Mile and George IV Bridge with chef Roy Brett. Top for seafood.

CASUAL DINING www.scranandscallie.com 0131 332 6281. By the people with The Kitchin, above. In Stockbridge, Edinburgh's leading gastropub. You may wait! • www.thehonours.co.uk 0131 220 2513. Uptown brasserie type restaurant by Martin Wishart. His hallmark light touch • www.contini.com 0131 225 1550. Aka Centotre, at 103 George St, this Italian ristorante in a lofty beautiful room by the Contini family who also have the Scottish Cafe in the National Gallery on the Mound • www.fishersbistros.co.uk 0131 553 5080. The Shore Bar along with Fishers next door (for seafood), are 2 of the destination bistros in Leith.

INEXPENSIVE www.motherindia.co.uk 0131 524 9801. Imported from Glasgow, the reliably easy to get into top Indian restaurant. Nr the University • www.hendersonsofedinburgh.co.uk 0131 225 2131. An Edinburgh institution; one of the best and longest established vegetarian restaurants in the UK • www.giulianos.co.uk 0131 556 6590. Opposite the Playhouse Theatre. From the outside just another tratt, but this is the one to trust in town • www.thedogsonline.co.uk 0131 220 1208. Upstairs in Hanover St, The Dogs is a great value, honest-to-goodness bistro with character.

HOTELS

TOP END www.waldorfastoriaedinburgh.com 0131 222 8888. The Caledonian (aka 'The Cally'), the landmark hotel at the W end of Princes St. Galvin's Brasserie is v good • www.thegeorgehoteledinburgh.co.uk 0131 225 1251. 'The George', an Edinburgh institution at the E end of 'stylish' George St. Forth views from upper 'de-luxe' rooms • www.sheratonedinburgh.co.uk 0131 229 9131. Reasonable version of the Sheraton brand in Festival Sq. Some rooms with Castle views. Famously good spa with pool.

MID RANGE www.malmaison-edinburgh.co.uk 0131 468 5000. One of the first of the Mals in the UK, here in Leith, so some way from uptown; many bars and restaurants nearby • www.hotelduvin.com 0131 247 4900. Imaginative conversion of historic building nr the University and National Museum just S of the Old Town. V French 'Bistro' is ok • www.thebonham.com 0131 226 6050. Boutique townhouse hotel in quiet crescent in the 'West End'. Some views over the New Town. Good restaurant.

INEXPENSIVE www.tenhillplace.com 0131 662 2080. Address as is. Part of the Royal College of Surgeons nr University. Serviceable and contemporary. Quiet corner. Good caff • www.23mayfield.co.uk 0131 667 5806. In Mayfield Gardens, a main rd S of city centre. Boutique guest house with 9 rooms. Attention to detail • www.motel-one.com/en/ 0131 220 0730. First UK Motel One in Market St by Waverley Station, another in E Princes St. Best of modern city centre budget hotels.

GLASGOW
EAT | SLEEP

RESTAURANTS

FINE DINING www.brianmaule.com 0141 248 3801. The long-established Chardon d'Or: best for fine dining in city centre. French influence. Great wine list • www.hotelduvin.com 0844 736 4256. The de-luxe 'Bistro' of the Hotel du Vin (right), a top dinner in the West End • www.twofatladiesrestaurant.com 0141 221 8188. At 652 Argyle St (easy to get lost) W of Sauchiehall St, trad dining rooms (and downstairs bistro). Two Fat Ladies at the Buttery: the best of their triumvirate of restaurants • www.roganoglasgow.com 0141 248 4055. Glasgow's most famous and original stylish restaurant from the 1930s. Still great atmos and service: steaks and seafood.

CASUAL DINING www.number16.co.uk 0141 339 2544. Small, reliable and much loved bistro nr end of the restaurant mile of Byres Rd • www.crabshakk.com 0141 334 6127. First and poss still the best in the emerging restaurant strip on W end of Argyle St. Intimate. Seafood • www.centralmarketglasgow.com 0141 552 0902. In Bell St in Merchant City. Great service, food with integrity; a good-looking joint.

INEXPENSIVE www.delizique.com 0141 339 7180. Actually called Cafezique, café and restaurant: a must to eat and hang out in. In Hyndland, the heart of the West End • www.kemberandjones.co.uk 0141 337 3851. In Byres Rd, deli/bakery and mezzanine café. Usually a queue to eat • www.cafegandolfi.com 0141 552 6813. Mentioned elsewhere but with Bar Gandolfi upstairs and Gandolfi Fish next door (in Albion St), you can't go wrong in this corner of the Merchant City.

HOTELS

TOP END www.radissonblu.co.uk 0141 204 3333. Best of the big city centre chain hotels. Nr Central Station. Contemporary urban style as other Blus • www.hotelduvin.com 0844 736 4256. Top example of the HduV chain. Townhouses that were once the first boutique hotel in the UK. 1 Devonshire Gardens. 2 mls city centre • www.blythswoodsquare.com 0141 248 8888. To W of centre, one side of elegant square. Contemporary conversion of old RAC Club. Good spa and brasserie.

MID RANGE www.malmaison-glasgow.com. 0141 572 1000. Nr Blythswood (above) in quiet off square st. Usual Mal design values • www.thegrandcentralhotel.co.uk 0141 240 3700. Old, long corridored station hotel (literally on Central Station). Heart of the matter! • www.arthouseglasgow.co.uk 0141 221 6789. In Bath St, busy with bars and nightlife, the Art House Hotel has rooms (and a lift) with character (they do vary).

INEXPENSIVE www.citizenm.com 0141 404 9485. First in UK of the Citizen Ms: cool design and online approach to budget hotel accom. Convenient and intimate • www.hotelindigoglasgow.com 0141 226 7700. Boutique-ish chain from Intercontinental Group here in a sympathetic conversion • www.15glasgow.com 0141 332 1263. Elegant boutique B&B W of city centre but walkable (and to W end restaurants etc). Only 5 rooms.